Volume 2. Issue 1. March 2006

david goa,
david morgan,
crispin paine
and s. brent plate

material religion

the journal of objects, art and belief

From Shinto temples to rosary beads, thangka paintings to missionary tracts, mass-produced posters to gravestones, religion is a material process. Charged with culturally-specific sacred meanings, religious objects have been used for purposes of worship, commemoration, art, and even subversion, and have been at the root of some of the world's most hotly contested struggles.

Material Religion seeks to explore how religion happens in material culture—images, devotional and liturgical objects, architecture and sacred space, works of art and mass-produced artifacts. No less important than these material forms are the many different practices that put them to work. Ritual, communication, ceremony, instruction, meditation, propaganda, pilgrimage, display, magic, liturgy and interpretation constitute many of the practices whereby religious material culture constructs the worlds of belief.

David Goa
University of Alberta, Canada
davidgoa@telusplanet.net

David Morgan
Valparaiso University, US
david.morgan@valpo.edu

Crispin Paine, UK
University College, Chichester
crispinp@ntlworld.com

managing editor
S Brent Plate
Texas Christian University, US
b.plate@tcu.edu

submission
Should you have an article you would like to submit, please write to:
Brent Plate
Material Religion
Department of Religion
Box 298100
Texas Christian University
Fort Worth
TX 76229, USA
b.plate@tcu.edu

editorial board

Chris Arthur
University of Wales, UK

Annette Becker
University of Paris-X /Nanterre, France

Barry Cunliffe
Oxford University, UK

William Dalrymple
London, UK

Brian Durrans
British Museum, UK

Elizabeth Edwards
University of the Arts, London, UK

David Freedberg
Columbia University, US

John Harvey
University of Wales, UK

John Hinnells
University of Derby, UK

Graham Howes
University of Cambridge, UK

Lily Kong
National University of Singapore

Robert Nelson
Yale University, US

Vivian-Lee Nyitray
UC—Riverside, US

Robert Orsi
Harvard University, US

Sally Promey
University of Maryland, US

Allen F. Roberts
UCLA, US

Earle Waugh
University of Alberta, Canada

Angela Zito
New York University, US

inquiries
editorial
Kathryn Earle, Managing Editor
email: kearle@bergpublishers.com

production
Ken Bruce
email: kbruce@bergpublishers.com

advertising
Veruschka Selbach
email: vselbach@bergpublishers.com

subscription information

Three issues per volume.

One volume per annum.

2006: Volume 2

www.bergpublishers.com

Berg Publishers
C/o Customer Services
Turpin Distribution Services
Stratton Business Park
Pegasus Drive
Biggleswade SG18 8TQ
UK

+44 (0)1767 601640

+44 (0)1767 604951

custserv@turpin-distribution.com

Institutions' subscription rate
£155/US$279

Individuals' subscription rate
£45/US$79*

*This price is available only to personal subscribers and must be prepaid by personal cheque or credit card

Free online subscription for print subscribers

Full color images available online

Access your electronic subscription through
www.ingenta.com or
www.ingentaselect.com

reprints for mailing
Copies of individual articles may be obtained from the publishers at the appropriate fees.

write to:
Berg Publishers
1st Floor, Angel Court
81 St Clements Street
Oxford OX4 1AW
UK

Typeset by JS Typesetting Ltd,
Porthcawl, Mid Glamorgan

Printed in the UK

material religion
contents

articles

04 Seng-Guan Yeoh, Religious Pluralism, Kinship and Gender in a Pilgrimage Shrine: The Roman Catholic Feast of St. Anne in Bukit Mertajam, Malaysia

Julius N. Tsai, Opening Up the Ritual Casket: Patterns of Concealment and Disclosure in Early and Medieval Chinese Religion

Klemens Karlsson, The Formation of Early Buddhist Visual Culture

in conversation

Jane Samson, An Historical Pilgrimage among "The Last Heathen"

Crispin Paine, Whose Sacred Place? Response to Samson

book reviews

Barbara Freitag, Sheela-na-gigs: Unravelling an Enigma, reviewed by Juliette Wood

Glenn Peers, Sacred Shock: Framing Visual Experience in Byzantium, reviewed by Cecily Hillsdale

Simon Coleman and John Eade, Reframing Pilgrimage: Cultures in Motion, reviewed by Alan Morinis

Timothy Insoll, Belief in the Past: The Proceedings of the 2002 Manchester Conference on Archaeology and Religion, reviewed by Mike Parker Pearson

P.J. Godrej and Panthakey F. Mistree, A Zoroastrian Tapestry: Art, Religion and Culture, reviewed by Tehmina Goskar

Anna Suvorova, Muslim Saints of South Asia, reviewed by Ron Geaves

David Morgan, The Sacred Gaze: Religious Visual Culture in Theory and Practice, reviewed by Stephen Pattison

Miranda Aldhouse-Green, An Archaeology of Images: Iconology and Cosmology in Iron Age and Roman Europe, reviewed by Martin Henig

John Kieschnick, The Impact of Buddhism on Chinese Material Culture, reviewed by Shreena Gandhi

outlook

Alison Sheridan, Creating *Heaven & Hell— and Other Worlds of the Dead*: The Curator's View

Sharman Kadish, Jewish Heritage UK

Gregory Price Grieve, The Rubin Museum of Art: Re-framing Religion for Aesthetic Spirituality

Ed Gyllenhaal, Glencairn Museum, Bryn Athyn, Pennsylvania

Paul Faber, All About Evil

Henry Brownrigg, New Christian Museums in Kerala

Jerry Cullum, Howard Finster Retrospective Exhibition, Lehigh University, Pennsylvania, USA, October 2004

religious pluralism, kinship and gender in a pilgrimage shrine: the roman catholic feast of st. anne in bukit mertajam, malaysia

seng-guan yeoh

monash university

Most Holy Saint Anne, filled with compassion for those who invoke you, and with love for those who suffer, heavily laden with troubles, we implore you to take the petition which we recommend to you under special protection (mention it). Recommend it to your daughter, the Blessed Virgin Mary, and lay it before her son Jesus Christ our Lord so that he may bring visible and speedy help where it is most needed.

Cease not to intercede for us until our request is granted. Above all, obtain for us the grace of one day beholding our God and, with you and Mary and all the Saints, praising and blessing him for all eternity...[1]

Seng-Guan Yeoh has a PhD from the University of Edinburgh. He is currently Senior Lecturer at Monash University, Malaysia, Sunway Campus. His research interests are in the anthropologies of the city, religion, gender, and media with particular focus on the South-East Asian region.

Introduction

Each year, in the last weekend of July, churches that have her as their patron saint celebrate the feast of St. Anne worldwide.[2] The event marks the Roman Catholic commemoration of a woman saint who has enjoyed mixed fortunes in Western Christianity. Although St. Anne is universally acknowledged to be the historical mother of the Virgin Mary—and by implication, the grandmother of Jesus Christ—little else is known about her due to the paucity of biographical details in the canonized version of the Christian Bible.[3] Nevertheless, many textual gaps have been filled by parochial legends inserting her into the devotional landscapes of her devotees. Her daughter, in comparison, has been the preferred dominant figure in Roman Catholic theology and devotionalism for many centuries, particularly in nineteenth-century modernizing Europe.[4]

In Bukit Mertajam, Malaysia, the sheer size and diversity of the crowds coupled with the media coverage make this particular feast arguably the most well-known, anticipated, and well-attended Roman Catholic festive event in the country.[5] As a highly visible public event, the patronal feast changes dramatically the locality's usual character and routines. For a few religiously charged days, the compact, predominantly Chinese market town swells with a flood of

FIG 1
Pilgrims and beggars asking for alms.
Source: Author, 1998

FIG 2
White candles and flowers are popular offerings to the saint. Source: Author, 1998

pilgrims and visitors from various parts of Malaysia. Pilgrims from the neighboring countries of Thailand and Singapore, and even further afield, have been drawn to the event as well. Simply stated, the "spiritual magnetism"[6] of the shrine is particularly salient during the special time of the patronal feast celebrations. Many of the pilgrims and visitors whom I spoke to during my fieldwork in 1997–8 find the multiplicity and carnivalesque collage of sounds, sights and smells generated by the multitude of street vendors and multi-ethnic crowds to be a memorable and uplifting experience. On Saturday night, there is a particularly striking visual spectacle. Thousands of flickering candles (of varying lengths or heights) lit by devotees create a glowing hillock behind the shrine and a moving sea of light during the procession. This spectacle is commonly portrayed as the distinguishing trademark of the event, and the phrase "a fairyland of wonder" recurs in newspaper reports and tourist brochures.

Nevertheless, its widespread popularity has also engendered a range of criticisms and feelings of ambivalence. At one end of the spectrum are Roman Catholic detractors who perceive the event to be a throwback to a piety of the "superstitious" variety that is discordant with the reforming spirit of the landmark *Vatican II Council* meetings held in the early 1960s. Of particular relevance is the subtle revision to centuries-old practices of the veneration of the saints. The delicate theological question of the centrality of Jesus Christ vis-à-vis these mediating saints forms the backdrop

of these tensions.[7] Protestant Christians, by contrast, have been more forthright and singular in their critique. Following the European Protestant Reformation's repudiation of the spiritual role of saints since the sixteenth century, phenomena like this are portrayed as superfluous and an index of the spiritual immaturity and misguidedness of the devotee.[8] On a similar note, the feast of St. Anne is sometimes described by Christian detractors as resembling the polytheistic practices and carnivalesque atmosphere of the Hindu festival of Thaipusam. Both these kinds of purists are particularly ambivalent about the syncretic religious genealogies of the pilgrims who turn up at the shrine to seek the favours of St. Anne. They contend that many pilgrims are not Roman Catholics or even Protestant Christians but, instead, are devotees drawn from outside the Christian fold. Nevertheless, extensive claims by pilgrims that St. Anne has indiscriminately answered their prayers regardless of their religious adherence complicate these detractors' version of the moral economy of salvation.

This essay maps ethnographically the various trajectories of pilgrims at the pilgrimage shrine in order to explicate zones of encounters and spiritual transactions. Their devotional gestures and postures are given particular semiotic attention as they index an array of culturally embodied knowledge about the analytical categories of gender and kinship. My account does not of course exhaust the range and variability of subjectivities of various pilgrims, and my attempt is necessarily fragmentary, incomplete and indeterminate. Moreover, while I recognize that going on pilgrimage has been characterized as a universally shared ritual practice, the pilgrimage field as a dense "forest of symbols" (recalling Victor Turner's memorable phrase) and interactional convergences is also marked by diversity, inconsistency, and eclecticism. Thus, in taking a contrary position to Turner's influential characterization of the pilgrimage experience as one of an anti-structural "communitas," John Eade's and Michael Sallnow's contention is that varied discourses constitute a pilgrimage shrine—"equally, a cult might be seen to be constituted by mutual misunderstandings, as each group attempts to interpret the actions and motives of others in terms of its own specific discourse" (Eade and Sallnow 1991, 5).[9] In other words, multiple meanings, understandings, and experiences are brought to bear on the cult by different categories of pilgrims, residents and religious specialists.

"The Patron Saint of Bukit Mertajam"

Before I turn my ethnographic attention to the pilgrimage shrine, it would be pertinent to present an abbreviated and selective historical account of the arrival of Roman Catholicism to Bukit Mertajam. Essentially, it is a narrative that indexes the changing contexts in which devotion to the saint has become embedded into the local cultural fabric and social imagination of the town.

In 1988, the Church of St. Anne in Bukit Mertajam commemorated its 100th anniversary. A colorful float

FIG 3
Undated photograph of St. Anne's church structure built in 1888. Source: 100th anniversary souvenir magazine

procession around the town at night was one of many events organized for the feast celebrations that year. Record crowds were reported to be at the shrine paying homage to a woman saint who is synonymous with the thriving market town of Bukit Mertajam, situated in Seberang Perai (formerly known as Province Wellesley). Indeed, enthusiastic Roman Catholics sometimes identify her as the "patron saint of Bukit Mertajam" despite the fact that Christians, let alone Roman Catholics, comprise a small minority of the town's population. Nevertheless, on a wider religious canvas, Roman Catholics constitute the oldest and largest component of a spectrum of Christians in multi-religious and multi-ethnic Malaysia.[10, 11]

Before the present neo-Gothic building was constructed in 1888, there had been a small wooden chapel outpost set up as early as 1846 by a French priest, Father Couellan, to gather the pioneering Chinese Catholic farmers in the bucolic locality for regular worship. The chapel was probably dedicated to St. Anne as Father Couellan was a native of provincial Brittany, a region where St. Anne had been the patron saint for centuries already. Father Couellan had also belonged to the pioneering missonary body (Paris Foreign Missionary Society), which had been working in Asia since at least the sixteenth century.[12] Expelled from the Buddhist Kingdom of Siam in 1781, MEP priests together with their

small flock eventually found their way to Georgetown on the "Prince of Wales Island" (present-day Pulau Pinang) at the invitation of Francis Light. A representative of the East India Company, Light had taken possession of the island from the Sultan of Kedah in 1786 for the purpose of setting up a strategic British trading port between India, China, and the Malay Archipelago. Some years later (in 1800), an additional strip of land facing Georgetown on the mainland was acquired and renamed Province Wellesley (present-day Seberang Perai).

From their base in Georgetown, MEP priests gradually expanded their missionary and pastoral work further afield onto the mainland. Many followed the peripatetic movements of their flock. For the priests, the harsh frontier conditions did not only pose threats for corporeal survival because of the ravages of diseases (like malaria and dengue fever) and fatal attacks by wild animals but equally so spiritual threats. An indication of this can be found in the report of Father Paris, the newly assigned resident priest in neighboring Matang Tinggi:

> On February 7th [1860], I arrived in this district for which I have so longed—Batu Kawan, Mant Tingi (Matang Tinggi) and Buket Ajam (Bukit Mertajam). My journey from Singapore to Penang took twelve days. Since my arrival, I have been visiting the 190 Christians who are dispersed over these three districts. There are only 190 of them in the whole Province and what kind of Christians they are! Scarcely any of them approach the sacraments. Complete ignorance of virtue contributes to the three great vices which some of our Christians are prone to—impurity, drinking and gambling. There is scarcely a family here that is not addicted to one of these vices. The majority fall victim to all three. This mission is already the despair of dear Father Couellan. And since January 1859, it has been almost abandoned completely.[13]

In the following years, however, missionary persistence fomented a more favorable outlook, and by the late nineteenth century, sufficient pastoral progress and changes in social circumstances warranted the establishment of a permanent local church looked after by resident priests. The economic fortunes and social well-being of Chinese-Catholic farmers, traders and merchants—as with other residents in the locality of Bukit Mertajam—were closely intertwined with the fluctuations of market forces and the cultivation of reciprocal social networks. In particular, this was a period of expansive economic opportunities with both European and local industries and consumption habits fuelling demands for a range of cash and food crops. The completion of the Federated Malay States railway line linking regions to the south and north, and also westwards to Butterworth—the mainland port facing Georgetown—at Bukit Mertajam subsequently raised its status to that of an important "junction town", that is, a center for collecting and redistributing goods. The attendant effects of these disparate changes are succinctly reflected in the following missionary report:

> The station of Buket-Martajam [sic] has a school and an orphanage for girls where Father Grenier maintains the fervour. He throws the good seed around him and in spite of the Chinese he addresses being rich and consequently more concerned about the pleasures of life than the salvation of their souls, he has obtained 27 baptisms of adults and more than 2,000 communions of devotions among the Christians.[14]

Parish records suggest that while the feast of St. Anne was celebrated annually after the inception of the church, it was essentially a localized affair. However, when the church received its first local Chinese priest, Father Michael Seet, the seeds of change were planted. In 1918, he began to invite the Bishop and priests and Roman Catholics of neighboring parishes to join in the celebration. Widespread publicity and the improved transportation links of rail and road in no small measure helped to make the shrine increasingly more accessible and to facilitate the movement of pilgrims from distant parishes. By 1939, the feast of St. Anne in Bukit Mertajam had become an established annual event in both the parish and local calendars as suggested by the following contemporary account:

> There was a large gathering of fervent pilgrims of all castes and creeds from all parts of British Malaya. Thousands poured into Bukit Mertajam since Saturday and many from the southern settlement arrived by the night express at daybreak on Sunday. The 6.40 am pilgrim special from Penang to Bukit Mertajam conveyed about 600 passengers, and the other two booked trains, which left Penang at 6.55 am and 7.25 am respectively, were fully loaded. Besides this, the many pilgrims from Penang, Province Wellesley, Perak, Kedah and suburbs travelled overland by cars and buses. This year's gathering was the biggest.
> Ideally situated on a hill, the Church presented an inspiring scene when an unprecedented number of pilgrims flocked fervently to fulfil their vows immediately after the High Mass. The Church, the open-air altar, and the procession route were beautifully decorated for the occasion and its compound and surroundings were studded with flags, evergreens, banners and fonts. This year's decoration arrangements were in experienced hands and excelled all previous years' decorations.
> Reverend Father L. Riboud gave a striking sermon in Tamil inside the Church about the life of St. Anne, while Reverend Father Koh did likewise at the open air Holy Mass in Chinese.
> After the vespers the procession of the statue of St. Anne, which is the largest that has ever been seen at Bukit Mertajam, was held from the Church along the parochial house compound, which was beautifully decorated. The procession was led by the Cross followed by the girls, boys, ladies going two by two and the Convent girls carrying banners in the center, and the statue of St. Anne in the middle followed by the clergy, the singers and the congregation. The statue was carried by four leading and prominent members of the Indian community and four from the Chinese community. The statue was preceded by flower boys who reverently scattered flowers before the statue of St. Anne at short intervals. The procession slowly and solemnly wended its way back to the Church.
> All the charity fair stalls, were opened for business at 2.00 pm on Saturday and the stalls during the night with the numerous

lights on, presented a picturesque scene. All the charity stalls, which were erected on the Church site, were well patronized and did roaring business including the Railway Booking Office.

The Parish priest, Reverend Father Rene Laurent, thanks one and all for the kind assistance rendered to make the feast a success and the press for the publicity they gave in their valuable columns from time to time. The Bukit Mertajam police is to be congratulated for the able manner in which they conducted the traffic. [15]

Sacred Place and Special Time

Pilgrims and visitors arriving for the first time at the Roman Catholic shrine in Bukit Mertajam are usually struck by the view of an elevated gleaming white-washed building backgrounded by a forested hill. It appears that, for many, it is not only the modestly sized, neo-Gothic architecture of the church that is of major significance. Appreciative remarks also focus on the shrine's "beauty" nestled in the midst of a "peaceful" naturalistic landscape rather than the building structure *per se*. In the social construction of the religious landscape of the shrine, the hill is an integral component of

FIG 4
The modest-sized neo-Gothic church has a constant trickle of pilgrims during the Novena period but swells considerably on the eve of the feast day. Source: Author, 1998

the phenomenological subject. Rising up to about 1,000 feet the hill is significant, moreover, beyond the immediate locality. The topography of the region accentuates its prominence as up to 90 percent of the district of Seberang Perai is flat terrain with the western portions close to the coastline swampy and waterlogged. Its clear visibility for miles around—including from Georgetown on Penang Island—has made it an obvious natural landmark as evidenced in various contemporary ethnographic and geographical accounts.[16]

Local residents know the hill as Bukit Mertajam (literally, "the hill of mertajam"). The term is of Malay origin and makes reference to a particular species of a fruiting tree which once grew in abundance on its hill slopes, but now has been severely decimated because its prized wood had been sought for both commercial and domestic consumption. By comparison, the first Teochew Chinese pioneering farmers to arrive in the locality had been struck by the hill's resemblance to a mountain range in their homeland, and had mimetically named their fledgling settlement, Dwa Swa Ga—"At the foot of the Great Mountain".[17] This settlement formed the nucleus of a flourishing market and administrative town that evolved under British colonial rule. Although Bukit Mertajam was eventually adopted by the governing authorities as the official place name of this town, in daily conversations the Teochew version continues to be widely used amongst the Chinese locals and even by those further afield.

The church is sited about a mile away from the center of Bukit Mertajam town, within an expansive compound covering some 20 acres. In the distant past, around the time when the first Roman Catholic missionary chapel outpost was erected, much of the grounds were under thick and marshy jungle vegetation.[18] Decades later, the land was cleared and drained to make way for a coconut plantation. Today, most of the wizened coconut trees to one side of the grounds have been felled creating a grassy patch about half the expanse of a standard soccer pitch. Despite prohibitory signs, neighboring residents have appropriated this green space in the early mornings and evenings for daily recreational activities (like jogging, calisthenics, and soccer). The absence of any similar facilities in the town and the lax enforcement by the shrine authorities are the main motivating reasons for their bold actions.[19]

Also scattered all around the church compound are a few granite rock outcrops, remnants of a much larger army of similar rock formations that was quarried for many decades if not centuries.[20] On the hill slope backing the church most of these outcrops have remained intact. Much more recent Catholic artefacts have joined them in the shape of "The Stations of the Cross," a *grotto*,[21] and a few statues at the "top"[22] of the hill behind the shrine. Together, they create a suggestive religious topography. Many centuries ago (*circa* fifth century CE), these rock formations attracted the attention of Hindu-Buddhist merchant-travellers.[23] Traces of their sojourn are tersely inscribed in an outcrop sited at a corner of the shrine premises.[24] Presently, a roadside sign erected

FIG 5
In the early 2000s, the museum authorities built this shelter over a rock bearing an inscription dating from around the fifth century CE. Source: Author, 2002

by the Penang State museum publicizes the presence of the inscribed rock ("Batu Bersurat"). Despite its obvious antiquity there is little indication that it is the focus of much public curiosity let alone religious veneration. For pilgrims and visitors alike, the sacred focus of the shrine lies elsewhere—in the sanctuary within the church building, and at the "top" of the hill where elevated dyadic white, slightly larger-than-life-size marble statues of St. Anne and the pubescent Virgin Mary are found.

Few Roman Catholic churches in the country possess this intriguing mix of human-made structures nesting within a picturesque landscape. Town churches are embedded within cityscapes dominated by the built environment while rural churches, by comparison, are generally modest structures serving agriculturally based communities. In my conversations with both Catholic and non-Catholic pilgrims alike, phrases equivalent to words such as "peaceful" and "quiet" were used to describe the ambience of the shrine. Indeed, the effect on them was evaluated as therapeutically contagious—they felt a "peace of mind" and "rested" from the vicissitudes and

FIG 6
A close-up of the inscribed rock. The inscription has been translated (by Babu Rajendralal Mittra) as: "I acknowledge the enemies of the contented king Ramaunibha and the wicked are ever afflicted." Source: Author, 1998

FIG 7
Another inscribed rock bearing Hindu astrological symbols in the church compound of unknown date. Source: Author, 1998

cares of daily work and living. In some cases, newcomers were particularly visually struck by the "Stations of the Cross" amidst the rock outcrops strewn over the hill slopes behind the church building.[25] These artefacts heighten the aura of the shrine situated in the remote "wilderness," away from human habitation. Especially for seasoned and elderly pilgrims, the memoryscape of the shrine nestling in the "wilderness" was more pronounced with temporal reference points to fall back on. The modern residential estate that presently envelops the shrine only started springing up in stages around thirty years ago, gradually diminishing the thick vegetation that previously gave the locality a bucolic ambience. The shrine now lies within the suburban sprawl of the fast-expanding town.

It would be spurious to suggest that the shrine's "spiritual magnetism" is reducible to these environmental factors alone. Nonetheless, the shrine's natural environmental ambience is not a mere footnote to the shrine's spiritual aura and attraction if one accepts Mircea Eliade's famous depiction of sacred places. Certain natural features such as mountains, forests or rivers, lend themselves to sacred readings of the physical landscape; in Eliade's terms, an *axis mundi* between the profane and sacred worlds. The natural environment is thus not a mute backdrop but constitutes an integral phenomenological dimension of the pilgrim's religious experiences. Without much prompting, pilgrims across the ethnic and religious spectrum were able to appreciate the hierophantic qualities of the site embedded in the symbolically rich elements of mountain, stones, vegetation, and water.[26]

At the same time, these elements are read in culturally and religiously specific ways. For instance, quite a number of non-Catholic Chinese pilgrims that I spoke to chose to underscore the *feng shui* (literally, "wind and water") of the shrine. Both the efficacies (*ling*) of the deity who resides within and the auspicious effects on pilgrims and visitors were attributed to the fortuitous siting of the building.[27] By being present at the site, pilgrims desired to avail themselves of a contagion effect on them and on their children. However, when pressed to explain in detail how the shrine might be constituted according to the principles of *feng shui*, these pilgrims answered in a vague and generalized way. The "serenity" and "natural" ambience of the locality were frequently noted. The most graphic description offered to me likened the church entrance to "a dragon's mouth drinking in good luck and money blowing from the opposite direction." It would seem that the typical Chinese pilgrim or visitor was uncertain about the specifics of *feng shui*; nevertheless, this does not mean that he/she was unable to grasp the shrine's overall geomantic significance.[28] Hindu pilgrims have equivalent appreciation of sacred places due to the antiquity and vitality of pilgrimage practices in Hinduism. Pilgrimage is classically a *tirtha-yatra*, a journey (*yatra*) to a holy place, literally understood as a "ford" or "crossing place" (*tirtha*)[29] between heaven and earth where celestial deities are believed to be pervasively present and accessible, an ideal place for pilgrims to present their existential cares and afflictions for alleviation.

These varied readings of a sacred place do not alone account for the presence of massive crowds during the particular occasion of the feast of St. Anne. Notions of the moral character of time have to be considered as well. Although these different categories of pilgrims essentially differ in their respective details, their combined effect is the conjunction of sacred calendars. Unlike Roman Catholic and Protestant public worship, Chinese religionist and Hindu public worship is not governed by a weekly ritual calendar. Furthermore it is less synchronised and collectively organized than its Christian counterpart. Devotees visit temples as individuals to pray and ask for boons when the need arises. Nevertheless, there are also seasons for the observance of special events. Indeed, both the Chinese lunar and Hindu calendars can be viewed as a series of specially charged sacred moments or "tempocosms. The "birthdays" or similar anniversaries of deities are deemed to be especially auspicious and festive times during which requests for boons are viewed as more likely to be favorably considered by the presiding deity than at any other period.[30] For those who are unable to be physically present at the shrine during the feast of St. Anne, there are two possible vicarious routes. One can ask a pilgrim friend or relative to present one's petitions to St. Anne at the shrine on one's behalf. Alternatively, one can write a letter personally addressed to St. Anne and mail it to the shrine authorities. Letters to St. Anne are burnt unopened in public on the eve of the feast day as a sign of divine readership.

Grammars of Devotion

As in all other Roman Catholic feasts, there is a varying period of ritual preparation before the actual feast day. In the case of the feast of St. Anne, it is preceded by the *novenas*—nine days of preparatory evening Masses held in the "New Church."[31] During this period, a constant stream of pilgrims—predominantly ethnic Chinese—visit the shrine throughout the day and late into the night. On the feast day, the ethnoscape and atmosphere change dramatically as pilgrims of South Indian ancestry become more conspicuous in terms of numbers. Festive activity also thickens with the setting up of hundreds of makeshift stalls offering a diverse range of wares along the public main road leading to the shrine. Outside this religiously charged period, the shrine is strikingly quiet and resembles a picturesque park. Sunday Mass is held only once a month (in English) at the shrine as the bigger "New Church" nearer to the town center is the preferred focus of congregational activity. Daily, from early morning to sunset, the doors of the shrine are unlocked and left opened by the resident caretaker. As the sanctuary is left largely unattended, those seeking solace and the help of St. Anne are able to do so freely without any human intermediaries, and their prayers are directly addressed to the saint. At nightfall, the caretaker locks up the church and the building's facade is lit with powerful searchlights.

During a typical day, it is usual to witness a tiny, inconstant trickle of visitors arriving at the shrine. There are also long lulls during the hot, languid afternoons. With some notable exceptions, the spectrum of visitors is visibly wide, spanning different age groups and social classes. Persons of Chinese, Indian, Eurasian, and, occasionally, Thai, Filipino, and Indonesian ancestries are the most common visitors. By contrast, Malay Muslims are conspicuously absent from the shrine.[32] While many choose to come alone to seek divine solace and intervention, the dominant practice, especially in evidence during the feast day, is that pilgrims are accompanied by their friends, spouses, or family members. They travel to Bukit Mertajam with the specific intention of making their requests known to St. Anne.

As intimated earlier, although many arrivals to the shrine are Catholics, there are also non-Catholics who are present. A simple way to differentiate between the two groups is to observe their bodily gestures and postures, which are strikingly dissimilar. Catholics generally have standardized bodily practices of approaching the sacred. Here, at the shrine, devotional gestures routinely made at weekly Mass in their own respective churches are reproduced. For instance, when entering and leaving a place of worship Catholics characteristically dip their fingers into "blessed water" placed in receptacles at all doorways and lightly inscribe the mark of a Christian cross on their torso.[33] Symbolically, this gesture signals the acknowledgment of the presence of the divine and an entry into a sacred space. Among Indian Catholics, this demarcation is further underscored by the removal of footwear. In many rural parishes this practice is still adhered

FIG 8
An open-air shrine bearing the dyadic statues of St. Anne and her daughter Mary at the top of a hillock behind the church. Source: Author, 1998

to, while in ethnically mixed and urban congregations it has lapsed over time. Attention to the cleanliness of the sanctuary is analogous to maintaining the ritual purity of sacred spaces and is a religious etiquette which resembles practices of Buddhist and Hindu devotees as well as Muslims in Malaysia.[34]

At the altar area, Catholics usually light single, white candles as votive offerings. Standing or kneeling in front of the saint, they quietly utter prayers clasping the candles in their hands before placing them on a metal rack. Sometimes, additional prayers and petitions are said in the pews. Here, once again, there are visible features which allow one to distinguish between Catholics and non-Catholics. As Catholics enter and leave the pews, they genuflect towards the altar—bending one knee and bowing their heads in one fluid continuous motion. In the pews, pilgrims choose to either kneel or sit and the Hail Marys are softly recited with the aid of rosary beads. Some additionally rely on printed devotional reading materials to further guide their spiritual exercises.

Non-Catholics also have an array of recognizable devotional gestures at the shrine. Devotees of Chinese religions, for instance, light a bundle of candles and move them quickly up and down three or more times—a ritual action known as *pai-pai*—in the same manner in which joss sticks are used in Daoist and Buddhist temples. When candles are not used, clasped hands make this gesture. To emphasize their inferior status vis-à-vis St. Anne, some may also choose to *kow tow*—to bow or prostrate themselves on the floor. Hindu Indians, by comparison, generally dispense with candles, preferring to gaze intently at the

saint's countenance and then lightly touch their bowed heads with joined hands in the manner of *namaskara*, a gesture of obeisance and lowly submission. In Hindu devotional practice, the ritual act of gazing at or having a "visual exchange of glances" (*darshan*) with a deity is one of the central aspects of *puja* (worship). Ideally, it is not a passive act but an engaged visual and emotional interaction with the deity. As Diana Eck has characterized it, *darshan* is an evocation of a heightened sense of awareness where the deity gives auspicious sight to the devotee.[35]

The act of having visual interaction with divine images resembles the devotional practices of Roman Catholics as evidenced by the presence of an array of images in their churches. Whenever possible, having physical contact, however fleeting or indirect it may be, with the image further enhances this divine–human encounter. Contact may range from the image's feet being kissed reverentially to other parts of the image (with the exception of the head) being touched furtively and then transferred to the face or lips of the devotee.[36] In some of the major Roman Catholic pilgrimage shrines elsewhere in the world, these kinds of devotional gestures repeated countless times over the centuries have resulted in portions of same images being worn down smooth. At the Bukit Mertajam shrine, however, such gestures are difficult because of the obstacle of distance. At the chancel, the smaller-than-life-size full statues of St. Anne and the pubescent Virgin Mary are perched up high on a pedestal.[37] They are depicted simply robed in the contemporary garments of the sculptor's period and without the embellishments of jewellery, crowns, and haloes. St. Anne's protective gaze is downwards towards her child standing by her side, and is thus away from the pilgrims. The altar area is cordoned off from the rest of the sanctuary by a low railing. Even with spotlights trained onto the statues, a distance of between 10 and 15 feet forms a formidable visual chasm between the statues and the pilgrims.

In addition to white candles, flowers are also commonly brought as gifts or prestations for the saint. Bouquets or Indian-style garlands (*malai*, in Tamil) of flowers are the usual gifts left on a rack placed at the edge of the altar area. In return, pilgrims take away with them various tokens from the shrine. Invariably, this includes small packets of salt mixed with black pepper corns anonymously left on a side table. Newcomers noticing this often mimic the actions of more seasoned pilgrims. At home, the salt is added to their daily food and consumed. Often packets are also taken on behalf of those who could not make the journey to Bukit Mertajam or as special gifts for relatives and close friends. In a similar vein, flowers are another favorite item sought by pilgrims as souvenirs. Pilgrims remove flowers from bouquets brought by preceding visitors, and place them on their own domestic altars.

In this ritual action of gifting the saint, a circulation of artefacts and an imagined sharing of edible substances (commensality) are thus set in motion. Within a range

FIG 9
Collecting the prized "St. Anne's water" so that it can be taken home for family and relatives. Source: Author, 2001

of meanings imputed by the pilgrims according to their respective individual contexts there is an unintended shared practice criss-crossing the primary religious allegiances of the different pilgrims. Gifts of salt and flowers initially brought by a Catholic pilgrim are invariably redistributed—albeit anonymously—to other Catholic pilgrims as well as to non-Catholics present without regard to their ethnic, social, and economic backgrounds.

Pilgrims also collect bottles of water from a short, free-standing wall bearing a row of taps adjacent to the shrine building. On the wall, a sign reads "St. Anne's water" in three languages.[38] Constructed a few years ago, the wall superseded a sheltered well dug in the mid 1970s. In the past, water had to be drawn up by hand and dispensed manually, a task made immensely difficult and laborious by the presence of large crowds of pilgrims during the annual celebrations. With the intervention of modern pump technology, the wall of taps, partly financed by a group of well-wishers, now allows pilgrims to service themselves without the mediation of attendants.[39] At these taps, pilgrims typically wet their faces, sprinkle drops over their heads, or drink handfuls of water. Additionally, pilgrims who are familiar with the place or the practice collect "St. Anne's water" in an assortment of containers that they have brought along with them. However, for the benefit of the uninitiated the parish youth group is usually tasked with the sale of empty bottles to pilgrims during the annual feast celebrations. Recently, the plastic rectangular medicinal bottles being sold were replaced with plastic bottles sculpted in the likeness of St. Anne together with the child Virgin Mary.

Pilgrims explained to me that they have a variety of uses for "St. Anne's water." It can be drunk, applied to afflicted body parts, added to their bathing water, and used to bless homes and newly purchased artefacts through sprinkling. All these actions underscore a belief in the water's potent and polyvalent properties. The pilgrims believe that water to be curative, purificatory, and apotropaic, transformed simply because it is sited on sacred and auspicious ground. Thus, in comparison with the sacred souvenirs of flowers and salt discussed above, "St. Anne's water" has a much more extensive range of usages and is therefore, arguably, more valued by pilgrims. Especially for those coming from distant places, several bottles may be collected not only for themselves but also for relatives and friends alike.

Votive Offerings and the Morality of Sacred Exchange
Inside the sanctuary, after pilgrims have articulated their prayers and petitions, cash is deposited into an old metal alms box placed at the altar railing and in full view of the saint. The specific amount is determined according to the individual's estimation of what is sufficient and appropriate. Hence, the nature of the dyadic contract between pilgrim and saint is kept intimately private.[40] While money is by far the most common form of votive offering at the shrine of St. Anne, there are also other equivalent forms. For instance,

FIG 10
Cooking vegetarian food which will be distributed freely. Source: Author, 1998

from time to time, pilgrims have been known to deposit valuables like silver and gold jewellery (necklaces, bracelets, rings, and so forth) into the alms box. A less common practice is the donation of household perishables like cooking oil, sacks of uncooked rice, biscuits and other foodstuffs. Elderly parishioners and veteran pilgrims also recounted to me that in the not-too-distant past, some pilgrims, particularly South Indians working in plantations, preferred to bring their prized natural produce like coconuts, bananas and live cockerels as offerings to be presented to the saint. But, over the years, ecclesiastical authorities have discouraged these items as inappropriate and anachronistic, and cash has become the dominant votive offering and hegemonic medium of sacred exchange.[41]

A local practice that seems likely to suffer the same fate is the offering of free cooked vegetarian meals to pilgrims. During my fieldwork in 1998, the shrine authorities decided to withdraw permission—ostensibly for security and health reasons—to a group of about fifteen volunteers who annually pooled their labor and resources to cook a meal sufficient for an estimated 8,000 to 9,000 pilgrims. Cooking was usually conducted on one corner of the spacious church grounds, near to the ancient inscribed rock. The origins of this practice could be traced back some thirty years to a man nicknamed Somo who worked at the ship docks in Penang. For reasons since long forgotten, he decided to provide cooked food free of charge to a small number of pilgrims. Somo was known to have single-handedly labored for years—gathering firewood,

borrowing cooking pots, soliciting foodstuff and donations to buy various ingredients, and so forth—in order to prepare his simple meals. Gradually, volunteers similarly intent on providing this kind of service to pilgrims joined Somo. The diversity of the religious make-up of the pool of volunteers is reflected in part by the succession of leaders who have coordinated the annual feat. When Somo, a Hindu Indian, passed away, the leadership fell to Bachan Singh, a Punjabi Sikh. Subsequently, the responsibility passed on to a Chinese Catholic.

While this particular case is exceptional in terms of its organizational scale, the sentiment behind providing free nourishment to pilgrims at the shrine is not unique. Indeed, during the feast day, the distribution of smaller and more manageable quantities of food items like bread buns and cartons of drink by benefactors is commonplace. Because these items are sometimes said to be "blessed by St. Anne," and thus possess transvalued properties, they are eagerly sought after by pilgrims. This practice resembles the Hindu ritual practice of consuming edible items that have first been offered to deities. Called *prasad* or *prasadam* ("sanctified" or

FIG 11
For years this Hindu man has been performing the menial task of removing candle wrappers for other pilgrims in thanksgiving to St. Anne, whom he believed saved his life.
Source: Author, 1999

FIG 12
Pilgrims performing the devotional labour of *madipitchay*. Source: Author, 1998

"consecrated food leavings"), these sacred exchanges also resonate with those of popular versions of Confucianist and Taoist religions.[42] Moreover, interpreted in terms of Buddhist ritual practices, the gesture of donating services and food resonates with the cultural logic of merit making—improving the donor's karmic position during an auspicious occasion through the idiom of material generosity.

Another kind of devotional offering that is salient at the shrine is the performance of arduous vows and penitential labor. One of the recurring and striking sights during the feast day is that of long, meandering rows of pilgrims mimicking the supplicant posture of beggars seeking alms. Despite the close resemblances, these penitents can be readily distinguished from the scores of "street people" who are also attracted to the shrine.[43] The latter—comprising an assortment of men, women, and children—are usually shabbily dressed, and choose to squat or sit on the ground, emphasizing their lowly economic and social position vis-à-vis their potential benefactors. By contrast, well-groomed penitents stand rooted in their respective places for the duration of their pious act. They refrain from speaking and their gaze is directed downwards to the ground in a posture of humility. A few quietly recite the Hail Mary with the help of a rosary.

This particular form of devotional labor is known amongst South Indians as *madipitchay* (literally in Tamil, "alms from the waist"), a term which alludes to the recognizable posture of the penitent. Women in *saris* and men in *vestis* should have both their hands extended out at waist level, holding the ends of their garments to form a pouch. For pilgrims who wear Western-type clothing, a white handkerchief placed over upturned palms acts as the equivalent replacement.[44] When and for how long the pilgrim performs *madipitchay* are matters of individual assessment and negotiation but generally—as with other expressions of religious piety—these details are commensurate with the perceived nature of the request or favor granted. Penitents are keenly aware of the

FIG 15
Some of the numerous votive objects deposited in the donation boxes by pilgrims.
Source: Author, 1998

Catholic informants, it was impressed upon me that the practice of depositing plaques is prevalent only among Indian Catholics, especially those from the rural parishes. Moreover, many claimed that it is not Roman Catholic in origin but borrowed from Hindu devotional practices.[48]

In reality, this practice is widespread throughout Roman Catholic shrines in Europe, particularly in the southern regions (Nolan and Nolan 1989, 71ff.). Moreover, it dates back to the pre-Christian era. Replicas of afflicted body parts are common *ex-votos* although they are not the only forms. Moreover, the materials used for these replicas are culturally specific. In Switzerland, wooden models were once popular while in Spain and Italy metal continues to be the favored medium. Although less durable than metal, wax body parts are most commonly found in Iberia. Portugese pilgrims are known to carry wax votives in processions and leave them at shrines. When the collections grow overly large, these votive items are removed by shrine officials and resold to a new set of pilgrims. At the Marian shrine in Fatima (Portugal), pilgrims are known to bring life-size wax images of small children as well as candles measuring the length and width of the devotee's body, a practice which was widespread throughout Europe during the Middle Ages. Gifts to shrines have also included crutches, bandages, braces, engraved marble plaques, votive paintings, photographs, and braids of hair. In Irish holy wells, the list of paraphernalia extends to objects like pins, needles, tobacco tins, toys, costume jewellery, and other personal articles.

The (Grand)Mother Saint

In the preceding paragraphs, I have partially depicted various features of the myriad ritual practices as I encountered

them with the intention of ethnographically attending to the multicultural elements that are manifested at the shrine. However, the practices witnessed are not particular to this place but extend to other Roman Catholic shrines (dedicated to both male and female saints) that I visited in the region. Arguably, they are differentiated in terms of degree rather than in kind. Additionally, as intimated earlier, the specific histories of the localities are not unrelated to the social construction of the respective shrines. By and large, however, pilgrims appear to be unanimous in viewing the shrine at Bukit Mertajam as particularly potent and efficacious, and the saint is deemed as more accessible and responsive than most.

Hindu pilgrims usually refer to St. Anne as Annamal. Many consider her to be one of numerous and powerful manifestations of Amman or Devi, a benevolent mother goddess imbued with immense *shakti* ("creative power"). Mother goddesses are integral to both philosophical and popular forms of Hinduism, and goddess worship has long been a significant and pervasive aspect of the Hindu religious tradition (for example, see Kinsley 1987). It is her beneficent motherly attributes that allow St. Anne to be directly approachable for ailing devotees. By accepting her *prasadam* in the form of salt, flowers, and water at the shrine, her devotees act out a familiar Hindu idiom of expressing their subordination to her in return for her protective and curative powers. Not all Hindu pilgrims whom I spoke to, however, are clear or particularly concerned about her specific identity and status in the Christian economy of salvation. Many pilgrims indeed confuse or conflate her with her daughter, the Virgin Mary, who is a more central figure in the Roman Catholic pantheon of saints.

By comparison, belief in "mother goddesses" in popular Chinese religion has a dissimilar genealogy from Hinduism, and is nuanced differently due to the pervasiveness of shamanist beliefs and practices prior to the imposition of patriarchal Confucianism.[49] Nevertheless, with the entry and localization of Buddhism in China, the feminine figure of Guan Imm (in Hokkien dialect) or Kuan Yin (in Cantonese dialect) has been the most well-known and recognizable goddess in the Chinese religious landscape since at least the eighth century CE. Most commonly visually depicted as the "White-Clad Goddess of Mercy" and sometimes carrying or accompanied by a boy child, this icon has followed the movements of the diasporic Chinese community around the world.[50] Kuan Yin is popularly depicted as the protector of all life, the embodiment of compassion, and one who hears the cries of all those who call out to her. These are qualities that are believed to resonate with those of St. Anne, also known as Sern Wu Ann (in Mandarin, "Mother Ann") among Chinese pilgrims.[51]

St. Anne's indiscriminating accessibility to all raises an intriguing paradox for many Roman Catholics. When I asked Catholic pilgrims to account for her popularity for a wide spectrum of religious devotees, the homely imagery of familial relatedness was usually resorted to and abstract theological

FIG 16
Close-up of dyadic statues in the open-air shrine near to the site of the original chapel.
Source: Author, 1998

conundrums sidestepped. In part, the pilgrims' understanding is shaped by the comparative lacunae of available literature on the saint. Information is thus gleaned from a diverse range of sources—from terse devotional pamphlets, miniature holy pictures and statues, church sermons, and, perhaps most important of all, personal testimonies circulated by a legion of acquaintances, friends, and relatives.

At the shrine, this homely imagery of familial relatedness is visually condensed and communicated in the form of dyadic statues of St. Anne hovering over Mary found both inside the shrine and at the "top" of the hill. St. Anne's protective gaze is on her child while Mary's features convey a sense of carefree abandon as she looks out toward the front.[52] Indeed, many Catholic pilgrims whom I spoke to identify themselves as "St. Anne's children." In particular, her accessibility is understood in terms of a kinship relationship underscored by her unique historical relationship to two paradigmatic figures in Roman Catholicism. She is the mother of Mary and the grandmother of Jesus Christ. In Christian religious language, Jesus is synonymous with the "Son of God" who obediently and sacrificially follows the will of his spiritual Father in heaven, even to the point of death for a greater salvific purpose. Additionally, in Roman Catholic dogma, Jesus' mother, the Virgin Mary, plays a significant role in this drama. Without her compliant cooperation in giving birth to and nurturing the child Jesus until adulthood, this salvationary scheme would have been compromised. Hagiographies of the Virgin then commonly portray her not only as an archetypical mother but also as a model daughter. Conceived miraculously in St. Anne's old age and infertility, and imbibing much of her strong devotion to God from her own mother, she is held up to epitomize the Catholic ideal for womanhood. She is the "New Eve," reversing and cancelling the ill effects of the first Eve in the book of Genesis. While it was Eve's disobedience and susceptibility to evil that introduced suffering into the world, Mary's obedience and steadfastness by contrast bring redemption.[53] Following a similar analogy, Jesus is imputed to be the filial son and grandson *par excellence* of his earthly multigenerational family. As such, he would be predisposed to give more weight to the counsel of his mother and maternal grandmother than to the intercessions of other saints. Moreover, if so moved, St. Anne can additionally influence her daughter to look more favorably on the devotee's plight. Petitions and pleas for intervention from St. Anne are thus regarded to be especially efficacious because of these doubly persuasive possibilities.[54]

Conclusion
Anthropologist Niels Mulder has summarily characterized religious attitudes in South East Asia as pragmatically "future-oriented." Rather than looking backwards in time to his or her misdeeds and infractions, the typical religious devotee is more inclined to anticipate a life free from danger and misfortune. Morality and religious practice thus primarily revolve around the axes of individual and familial potency,

and the tapping of sacred powers to act as a bulwark against uncertainties. In this essay, I have suggested that power, thus apprehended, is believed by many to manifest itself tangibly in both the "place" and the "saint" enshrined at Bukit Mertajam. Rather than conflate the two categories, I have suggested a qualitative, dialectical distinction between them. The shrine's picturesque natural landscape lends itself to various culturally and religiously specific phenomenological appropriations. Indeed, even among non-religious visitors, it is a place perceived to be visually and experientially intriguing. The woman saint to whom the shrine is dedicated is the other crucial consideration in accounting for the drawing power of the place. The vast and diverse crowds present during her annual feast visibly attest to her presence, believed to be particularly tangible at Bukit Mertajam. Indeed, her reputation and influence extend beyond these physical, localized boundaries through the growing repository of oral testimonies of answered prayers and miraculous interventions.

I have also summarily described the grammars of devotion and sacred exchanges witnessed at the shrine. In terms of the practical emphases of "popular religion," they typify a religious pluralism "from below," and index the kinds of reverence and intimacy that pilgrims of different religious categories feel in relation to the saint. For many, these religious experiences are a familiarity borne of a preexisting everyday religiosity, a daily routine of conversations and exchanges with their respective apprehensions of the divine. Questions about what specifically constitutes the source and authority of the saint's power and accessibility lead to varied and nuanced answers. Among Roman Catholics, her illustrious genealogical connections are generally known and appreciated (albeit also theologically contested by those more inclined to reformist and textually based religious sensibilities), and frequently resorted to in accounting for her particular efficacy. For many non-Roman Catholics, by comparison, her specific position in the Christian economy of salvation is neither necessarily central nor even relevant to their concerns. She is read, experienced, and invested with subjectivities (or "misrecognized," to borrow Pierre Bourdieu's term) largely through their own religious and cultural *habitus* or standpoints. Their meanings are emergent and relational rather than fixed.

Nevertheless, this plasticity notwithstanding, I wish to suggest that the central imagery of St. Anne as an idealized (grand)mother is particularly catholic (in the Latin sense of "universal"). Briefly stated, it is a metaphorical category that destabilizes all other categories. While this central imagery seemingly draws its meaningfulness, at first glance, from a "gendered analytical domain," I have indicated that gender-related religious symbols and tropes can also extend beyond the imagery's referents and the hegemonic hold of language. At the same time, they can equally be used to substantialize hierarchical social relations and imbue them with a sense of temporality and concreteness. Historically, this was evidenced in metropolitan Catholic Europe when St. Anne's popularity was related to changes in the dominant patterns of

relationships in the early medieval period before her daughter, the Virgin Mary, institutionally usurped her. Like her daughter, St. Anne has a spiritual magnetism that lies pre-eminently in her perceived relational powers. St. Anne—and her equivalent personas—exudes fertility, longevity, filial connectedness, dependability, stability, and accessibility. Her discrimination against "her children" is deemed non-existent as she disregards human-constructed categories of gender, status, ethnicity, and even religion itself. For much of Malaysian society, where familial networks and linkages are still comparatively vibrant and euphemized as a crucial building block for a range of human endeavors—not least of which is the patriarchal project of nation-building—St. Anne and what she embodies present a fascinating counterpoint.

Acknowledgments

This paper is based on fieldwork research conducted in 1997–8 (over eight months) and was supported by the Evans Fellowship awarded by the Department of Social Anthropology, University of Cambridge. A Junior Fellowship with Wolfson College, University of Cambridge, made possible further research work at the University Library, a short visit to the pilgrimage shrine at St. Anne d'Auray (France), and a pleasant writing stint between October 1998 and July 1999. My debts to these institutions are gladly acknowledged. Additionally, I am grateful for the cooperation of the shrine custodians of the Church of St. Anne, Bukit Mertajam, and of the library administrators of College-General Seminary, Penang.

For valuable feedback on earlier versions of this paper, I would like to thank Janet Carsten, Francis Loh Kok Wah, Khoo Salma Nasution, Khoo Gaik Cheng, and the two anonymous reviewers of *Material Religion*. I enjoyed the generous hospitality of many people during fieldwork in Bukit Mertajam and Penang. In particular, I would like to mention the families of Jenny Ting, Mr. and Mrs. Phun Seng Cheng, and Mr. and Mrs. Robert Surin. For companionship and assistance, I am also grateful to Anna Har, Abdur–Razzaq Lubis, Lily Beh, Goh Beng Lan, Hai Long, Maura, Ottome Hutthesing, Salma, and Tan Sooi Beng. Last, I would like to remember all the pilgrims and informants at Bukit Mertajam who kindly shared with me their thoughts, insights, and experiences.

notes and references

[1] Extracted from a prayer card sold by street vendors at the pilgrimage shrine.

[2] In 1481, Pope Sixtus IV instituted July 26 of the Roman calendar as St. Anne's feast day (the Eastern

Church celebrated the feast of St. Anne on July 25). In 1548, Pope Gregory XIII declared her feast day to be a universal event.

[3] St. Anne's story is contained in the apocryphal *Protoevangelium of James*, written around 150 CE. Penned in Greek by a writer probably from Syria or Egypt, the *Protoevangelium* enjoyed wide circulation and exerted a great influence during the early Christian era.

[4] For instance, see Clayton 1990, Kselman 1983 and Warner 1976 for interesting historical studies of Marian devotion. For anthropological accounts of Marian devotion in different ethnographic contexts, see Dubisch 1995, Eade and Sallnow 1991, and Turner and Turner 1978. Some scholars have suggested that in late-medieval Europe, St. Anne was the most "fashionable saint" (for example, see Ashley and Sheingorn 1990; Brandenbarg 1987). An array of attributes stemming from her powerful symbol as a mediator contributed towards her cultic attraction for a large and diverse following. It is argued that the figure of St. Anne, essentially operating as a sign with shifting signifiers, did not allow any one particular narrative to dominate. Because her image was able to function as "a metaphor whose referent may vary depending on who uses it, in what context, and who receives it" (Ashley and Sheingorn 1990, 52), her cult was able to function symbolically to articulate the dilemmas and mediate the contradictions of the culture. Thus, as a woman saint who had experienced infertility until her old age, she became a popular intercessor for married women desiring offspring. Mothers who had sick or injured children also turned to her for divine healing. During the time of plagues, her name was invoked for talismanic protection. Gradually, she took over many of the mediating tasks usually assigned to other saints. As a thrice-married woman, St. Anne also epitomized contemporary ambivalence about the value of an active life and the changing roles of women. As a matriarch of a multigenerational holy family (known as the "Holy Kinship"), she became useful in authorizing dynastic claims amongst rulers whose power was contested or in the genealogical preoccupations of the bourgeoisie. Only after the deliberations of the Council of Trent (1545–63 CE) when the doctrine of the "Immaculate Conception" was promoted does the evidence suggest that iconographic representations of St. Anne became less popular. They were progressively replaced by a proliferation of artistic and religious works focusing on the Virgin Mary.

[5] Actual numbers are, of course, difficult to ascertain from year to year. In 1999, the shrine authorities anticipated a crowd size of 350,000 ("350,000 expected for St. Anne's do," *Star*, July 22, 1999). In 2001, a figure of 100,000 was quoted ("100,000 to converge on Penang," *Star*, July 27, 2001).

[6] This phrase is James Preston's (1992).

[7] In conventional Roman Catholic theology, a qualitative distinction is made between the "veneration" (Greek, *dulia*) of saints and "worship" (Greek, *latriea*). The latter is characterized as an attitude of allegiance and submission reserved exclusively for God while the former should ideally be a mixture of respect mingled with reverential awe for saints. Saints are persons who have substituted their own attitudes and ideas for those of Christ, and have achieved supernatural excellence. They are declared by the Roman Catholic Church to be in heaven acting as intercessors for those still on earth. The veneration of saints can take many forms—celebrating their feast days, imitating their virtues, soliciting intercessions, telling their life stories, and making pilgrimages to shrines dedicated to their remembrance (Glazier and Hellwig 1994, 897). In terms of the relationship between saints and the living, the Vatican II Council has modified the model of supplicant and benefactor towards that of communion and solidarity, thus rendering saints as fellow disciples of Christ.

[8] For example, see Eire 1986 for an account of this particular historical moment.

[9] For a succinct critique of the Turners' thesis, see Morris 1987, 252–63. Refer to Coleman and Elsner 1995 for a further discussion of the debate.

[10] The 1991 national census reported that out of a total population of 17 million, Christians made up 8 percent (1.36 million) of the religious ethnoscape. The Roman Catholic Church's own records reveal that it had a membership of 670,000 individuals within its fold in 1996 (Chew 2000, 25f). The national census figures for other religious adherents are as follows: 57.6 percent Muslims, 19.1 percent Buddhists, 6.3 percent Confucianist/Taoist/other traditional Chinese religions, 6.6 percent Hindus, 1.4 percent Tribal/folk religion, 0.5 percent Others, and 1.5 percent professing no religion.

[11] A broader discussion of the interplay between the dynamics of religious, ethnic, and political domains in Malaysia is beyond the scope of this essay. However, see Ackerman and Lee 1988 and 1997 for useful discussions of the links between Islamic revivalism, modernization, and the religious innovations of non-Islamic religions. Also, refer to Chew 2000 and Williams 1976 for historical overviews of the Roman Catholic Church in Malaysia. For other Christian denominations, refer to Hunt et al. (eds) 1992.

[12] Although the lineage of this major branch (Nestorian Church) of Christianity is of some antiquity, there is extant literary evidence which suggests that it was preceded by the "Church of the East," more popularly known among Western writers as "Nestorians." Small communities of these Christian traders were believed to be set up in coastal Kedah, northern Peninsular Malaysia, as early as the seventh century CE. Once boasting of a vast missionary network extending across Asia into China, the Nestorian Church was annihilated by persecution and assimilation (see England 1996 for details).

[13] Cited in *Malayan Catholic News*, June 24, 1973, p. 6. The letter was dated February 23, 1860.

[14] See *Seminarie des Missions Etrangeres. Lettre Commune 1892*, pp. 208f.

[15] See *Malaya Catholic Leader*, August 12, 1939.

[16] On a broader geographical scale, the hill is one of numerous branches connected to the spinal main range spanning almost the entire length of Peninsular Malaysia.

[17] Cognates of the Teochew's version have stuck on for other Chinese dialects as well. As elsewhere in Malaysia, the use of Teochew (and other Chinese dialects) place names is not only confined to natural features but also to an array of places where there are sizeable local Chinese populations. Malay place names have been phonetically appropriated where the Chinese numbers are small (for example, see Cowgill 1924, Newell 1964). For useful background studies of rural Chinese in the locality of Bukit Mertajam, see Low 1836, Newell 1962, and Tan 1981. Also, refer to Nonini 1998 for an interesting discussion of the politics of public space in a comparable Chinese market town in Malaysia.

[18] This can be deduced from James Low's (1848) account of his expedition to the inscribed rock in the mid nineteenth century. (See Evans 1930 for an account of a similar visit about a century later.) The Pali inscription reads, "I acknowledge the enemies of the contented King Ramaunibha and the wicked are ever afflicted" (Low 1848: 71).

[19] Since the end of 1999, this account of the "ethnographic present" of the shrine is no longer valid. The shrine authorities have embarked on a large church building project on the former coconut grove.

[20] At the time of fieldwork, quarrying was still being conducted on the opposite side of the hill.

[21] A *grotto* (Italian, "cavern") is a human-made structure that

resembles a cave or a natural recess. Usually associated with religious sites, the *grotto* at Lourdes (France) where the Virgin Mary is believed to have manifested herself in the nineteenth century is the most well known among Roman Catholics.

[22] The "top" is actually a small plateau on the hill slope that was chosen to be the site of the first chapel erected in 1846.

[23] For a useful account of the influence of Hindu-Buddhist kingdoms in the region, see Kanchan 1990.

[24] A few elderly parishioners whom I interviewed recollected that as teenagers on an outing they had encountered similar inscriptions on rock outcrops further up on the hill.

[25] These kinds of comments were especially forthcoming from Singaporean pilgrims who live in a comparatively urbanized and extensively built environment.

[26] For instance, in both Hindu and Taoist religious folklore, mountains are considered as the abodes of celestial deities and immortals.

[27] Thus far, I have been unable to ascertain whether the French missionary priest who designed the church selectively appropriated *feng shui* principles during its construction.

[28] The classical Chinese moral universe is animated and maintained by the workings of the impersonal forces of *ying* and *yang*. These forces, originate from the *Tao*, understood as the ultimate metaphysical truth behind or within appearances. While *yang* is denoted as the male, bright, positive force, *ying* represents the obverse relational aspects—female, dark, and negative. A vital dimension to the *ying–yang* polarity is that these forces are complementary opposites and are not mutually antagonistic. Anthropologist Steven Sangren (1987, 141ff.) argues that the cultural logic of *ying* and *yang* is operative in accounting for the primacy of the concept of *ling* (efficacy). In his scheme, supernatural entities (particularly female deities) are perceived as powerful and efficacious only in contexts where they mediate other entities that stand for order (*yang*) and disorder (*ying*). In other words, *ling* is an attribute of the construction of order out of disorder or of the dissolution of order into disorder.

[29] See Diana Eck 1981b for an elaboration of the "locative" strand of Hindu piety.

[30] Thus, in 1988 when Kuan Yin's birthday according to the Chinese lunar calendrical reckoning coincided with the 100th anniversary of the Church of St. Anne, record crowd numbers were reported. Similarly, during the 108th anniversary of the Church, bigger than usual crowd numbers were present at the shrine as the last digit signified an especially auspicious occasion.

[31] The "New Church," situated closer to the town center, was built in the late 1950s during the height of the Communist insurgency as the locality around the shrine was declared an insecure "black area."

[32] In contemporary Malaysia, Malays are constitutionally coupled to the Islamic faith.

[33] Clergy following prescribed liturgical prayers are the only recognized individuals who can produce "blessed water."

[34] Among Roman Catholics, this difference in devotional gesture was generally explained, stereotypically, in terms of the "more religious" nature of Indian Catholics in comparison with other ethnic groups.

[35] The act of *darshan* is not only confined to deities but can also include holy men, saints and dignitaries.

[36] I witnessed these practices at the feast of St. Jude in Rawang (Selangor state) and at the feast of St. Antony in Nibong Tebal (Penang state) in 1998. Pilgrims are known to remove pieces of images as personal mementoes.

[37] These statues are made of terracotta and are reputedly as old as the church. During the annual feast, a separate processional image is used. In late 2000, these

statues were replaced with new and larger porcelain statues as the previous ones had been vandalized.

[38] This sign is significant. Shrine authorities explained to me that it serves to distinguish the water from "holy water" or "blessed water" which can only be water ritually blessed by priests and bishops following prescribed liturgical prayers. In Roman Catholic Europe, "St. Anne's water" has been used as a remedy for a range of physical ailments including fevers, headaches, chest and stomach pains, and eye problems (Jockle 1995, 35).

[39] The benefactors' names are listed on a stone slab erected in front of the water pump.

[40] The variety of devotional sacrifices and labor that can be offered in honor to St. Anne is the outcome of both the individual's circumstances and negotiations with the saint. Examples include fasting, sexual abstinence, helping to keep the shrine clean, giving hospitality to strangers, lighting votive candles for other pilgrims, and so on.

[41] This does not mean that the use of agricultural produce has been done away with in patronal feasts elsewhere. In the southern state of Malacca, for instance, one particular celebration has been dubbed the "sugar cane feast." During Dutch rule in the sixteenth century, a village chapel was secretly built within a sugar cane plantation as Catholic public worship was outlawed. This event has been subsequently commemorated with the use of donated sugar cane stems for decorations. After the procession of the saint, these stalks are cut and freely distributed ("A sweet devotion to Mother Mary," September 10, 1995).

[42] In popular Hinduism, although food is believed to capture most effectively the sanctity of a shrine, its powerful effects are transitory. Cloth is believed to have more retentive properties by comparison. For a discussion of the symbolism of cloth in Indian society, see Christopher Bayly 1986.

[43] A number of pilgrims and shrine custodians whom I spoke to doubted the authenticity of these beggars. They are believed to be part of an organized syndicate that systematically travels from one public event to another to solicit money.

[44] The "street people," by contrast, beg using plastic cups or their open palms as receptacles.

[45] For this insight, see William Christian Jr. 1972.

[46] See "Madipitchay: Alms for penance and worship," *Catholic Herald*, August 27, 1995.

[47] The *Malayan Catholic News* of 1952 made mention of these votive images in the Bukit Mertajam feast although their use certainly predates the mid twentieth century and is geographically widespread in the Roman Catholic world.

[48] A Chinese Catholic local parishioner jokingly explained to me "the Chinese only know how to give money," thereby underscoring the stereotypical view that the Chinese Catholics are pragmatic in comparison with the "more religious" Indian Catholics.

[49] Riane Elser has characterized ancient Chinese mythology as neither matriarchal nor patriarchal but "glyanic," that is, a cosmos where male and female entities are perceived to be equal (cited in Palmer and Ramsay 1995, 9).

[50] Kuan Yin is a Chinese version of a Boddhisattva called Avalokitesvara in the Mahayana tradition of Buddhism. Her multifarious iconography is complex and cannot be dealt with here (see Palmer and Ramsay 1995 for a useful introduction). According to Palmer and Ramsay (1995, 24), the current popular iconographic image of the "White-Clad Kuan Yin" was appropriated by Chinese artists and porcelain-makers when they encountered late Renaissance statues of the Madonna brought by Spanish and Portugese Jesuits to China in the late sixteenth century.

[51] Steven Sangren (1983) argues that deities like Kuan Yin stand in a particular relationship to

worshippers, that is, as mothers to children. However, the symbolic connection is relational rather than categorical. Just as human mothers often act as mediators, intercessors, and allies in domestic groups, these deities are idealized embodiments not of womanhood in general but of motherhood. They are perceived to be totally responsive to the needs of their supplicants.

[52] The iconography of St. Anne in Europe is complex and dynamic, indexing changes in societal perceptions of marriage, motherhood, and religious politics. See Ashley and Sheingorn 1990 for details.

[53] In recent decades, this dominant religious imagery of the Virgin Mary has been put to question by feminist theologians both in the "First World" and the "Third World" (for example, see Maurice Hamington 1995 for a useful summary of the debate). In particular, feminist critiques of Asian Christianity and of the religious and social status of women in the region can be gleaned from *In God's Image*, the journal of the Asian Women Resource Center.

[54] This line of reasoning is also apparent in popular hagiographies of the saint. For example, see Keyes 1955 and Lefebvre 1959.

Primary Literature

Centenary celebration souvenir programme of St. Anne's Church, Bukit Mertajam, 1888–1988.

Catholic Herald

Malaya Catholic Leader

Malayan Catholic News

The Star

Secondary Literature

Ackerman, S. and R. Lee. 1988. *Heaven in Transition. Non-Muslim Religious Innovation and Ethnic Identity in Malaysia*. Honolulu: University of Hawaii Press.

—— 1997. *Sacred Tensions. Modernity and Religious Transformation in Malaysia*. Columbia: University of South Carolina Press.

Ashley, K. and P. Sheingorn, eds. 1990. *Interpreting Cultural Symbols. Saint Anne in Late Medieval Society.* Athens: University of Georgia Press.

Bayly, C.A. 1986. The origins of swadeshi (home industry): Cloth and Indian society. In *The Social Life of Things. Commodities in Cultural Perspective*, ed. A. Appadurai. Cambridge: Cambridge University Press, pp. 285–321.

Brandenbarg, T. 1987. St. Anne and her family: The veneration of St. Anne in connection with concepts of marriage and family in the early modern period. In *Saints and She-Devils: Images of Women in the Fifteenth and Sixteenth Centuries*, ed. L. Dresen-Coenders. London: Rubicon Press, pp. 101–26.

Bynum, C.W., S. Harrell and P. Richman, eds. 1986. *Gender and Religion. On the Complexity of Symbols*. Boston: Beacon Press.

Chew, M. 2000. *The Journey of the Catholic Church in Malaysia, 1511–1996*. Kuala Lumpur: Catholic Research Center.

Christian Jr., W. 1972. *Person and God in a Spanish Valley*. Princeton: Princeton University Press.

Clayton, M. 1990. *The Cult of the Virgin Mary in Anglo-Saxon England*. Cambridge: Cambridge University Press.

Coleman, S. and J. Elsner. 1995. *Pilgrimage Past and Present in the World Religions*. London: British Museum Press.

Cowhill, J.V. 1924. Chinese place-names in Johore. *Journal of the Malaysian Branch of the Royal Asiatic Society* 2 (3): 221–51.

Dubisch, J. 1995. *In a Different Place. Pilgrimage, Gender, and Politics of a Greek Island Shrine*. Princeton: Princeton University Press.

Eade, J. and M. Sallnow, eds. 1991. Introduction. *Contesting the Sacred. The Anthropology of Christian Pilgrimage*. London: Routledge, pp. 1–26.

Eck, D. 1981a. *Darsan. Seeing the Divine Image in India*, Chambersburg, Penn.: Anima.

—— 1981b. India's Tirthas: "Crossings" in sacred geography. *History of Religions* 20 (4): 323–44.

Eire, C.M.N. 1986. *War Against the Idols. The Reformation of Worship from Erasmus to Calvin*. Cambridge: Cambridge University Press.

Eliade, M. 1957. *The Sacred and the Profane. The Nature of Religion*. New York: Harvest Book.

England, J.C. 1996. *The Hidden History of Christianity in Asia. The Churches of the East Before the Year 1500*. Delhi and Hong Kong: ISPCK and Christian Conference of Asia.

Evans, I.V.N. 1930. Ancient inscriptions at Cherok Tokun, Province Wellesley. *Journal of the Federated Malay States Museum* 15 (11): 35–6.

Glazier, M. and M. Hellwig. 1994. *The Modern Catholic Encyclopedia*. Collegeville: The Liturgical Press.

Hamington, M. 1995. *Hail Mary? The Struggle for Ultimate Womanhood in Catholicism*. London: Routledge.

Hunt, R., K.H. Lee and J. Roxborogh, eds. 1992. *Christianity in Malaysia. A Denominational History*. Petaling Jaya: Pelanduk Publications.

Jockel, C. 1995. St. Anne, *Encyclopedia of Saints*. London: Alpine Fine Arts Collection, pp. 35–6.

Kanchan, R.K. 1990. *Hindu Kingdoms of Southeast Asia*. New Delhi: Cosmo Publications.

Keyes, F.P. 1955. *St. Anne. Grandmother of our Saviour*. New York: Hawthorn Books.

Kinsley, D. 1987. *Hindu Goddesses. Visions of the Divine Feminine in the Hindu Religious Tradition*. New Delhi: Motilal Banarsidass.

Kselman, T. 1983. *Miracles and Prophecies in Nineteenth-Century France*. New Brunswick: Rutgers University Press.

Lee, F.G. 1963. *The Catholic Church in Malaya*. Singapore: Malaya Publishing House.

Lefebvre, E. 1959. *Ste. Anne de Beaupre*. Quebec: Sainte Anne de Beaupre.

Low, J. 1836. *A Dissertation on the Soil and Agriculture of the British Settlement of Penang or the Prince of Wales Island in the Straits of Malacca, Including Province Wellesley on the Malayan Peninsula*, Singapore. Reprinted in 1972 as *The British Settlement of Penang*. Oxford: Oxford University Press.

—— 1848. An account of several inscriptions found in Province Wellesley on the Peninsula of Malacca. *Journal of the Asiatic Society of Bengal* 17 (2): 62–6.

Morris, B. 1987. *Anthropological Studies of Religion. An introductory Text*. Cambridge: Cambridge University Press.

Mulder, N. 1996. *Inside Southeast Asia. Religion, Everyday Life, Cultural Change*. Amsterdam: The Pepin Press.

Newell, W.H. 1962. *Treacherous River. A Study of Rural Chinese in North Malaya*, Kuala Lumpur: University of Malaya Press.

—— 1964. Chinese place names in Province Wellesley. *Journal of Tropical Geography*. 58–61.

Nolan, M.L. and S. Nolan. 1989. *Christian Pilgrimage in Modern Western Europe*. Chapel Hill: University of North Carolina Press.

Nonini, D.M. 1998. "Chinese society," coffee-shop talk, possessing gods: The politics of public space among diasporic Chinese in Malaysia. *positions: east asia cultures critique* 6 (2): 439–73.

Palmer, M. and J. Ramsay. 1995. *Kuan Yin. Myths and Prophecies of the Chinese Goddess of Compassion*. San Francisco: Thorsons.

Preston, J. 1992. Spiritual magnetism: An organising principle for the study of pilgrimage. In *Sacred Journeys: The Anthropology of Pilgrimage*, ed.

A. Morinis. Westport: Greenwood Press, pp. 31–46.

Ronan, M.V. 1927. *St Anne. Her Cult and her Shrines*. London: Sands & Co.

Sangren, P.S. 1983. Female gender in Chinese religious symbols: Kuan Yin, Ma Tsu, and the "Eternal Mother". *Signs* 9 (11): 4–25.

—— 1987. *History and Magical Power in a Chinese Community*. Stanford: Stanford University Press.

Tan Kim Hong. 1981. Chinese sugar planting and social mobility in nineteenth-century Province Wellesley. *Malaysia-in-History* 24: 24–38.

Turner, V. and E. Turner. 1978. *Image and Culture in Christian Pilgrimage*. New York: Columbia University Press.

Warner, M. 1976. *Alone of All Her Sex. The Myth and Cult of the Virgin Mary*. London: Weidenfield and Nicholson.

Williams, K.M. 1976. The Church in West Malaysia and Singapore. A study of the Catholic church in West Malaysia and Singapore regarding her situation as an indigenous church. Unpublished PhD thesis, University of Leuven.

opening up the ritual casket: patterns of concealment and disclosure in early and medieval chinese religion
julius n. tsai

texas christian university

Ritual caskets—potent containers of precious stone or metal housing divinely granted treasures and esoteric texts—appear with some frequency in the literature of early medieval Daoism. These caskets reveal a rich complex of mythic narratives and ritual practices in Chinese religion as a whole. This article focuses on three aspects of religious practice involving a range of ritual caskets from the ancient to the early medieval period, including: (1) the vessels' function in the acquisition of the Heavenly Mandate *tianming* for imperial rulership as well as for immortality; (2) their mediating role in disclosing the revelation of sacred texts, especially from the Latter Han and into the narratives of early Daoism; and (3) their use in ritualizing expiation in early medieval Daoism through the depositing of "substitute bodies" into hidden caches and the advancing of liturgical petitions to otherworldly offices. On the most fundamental level, the ritual casket is a container that both *conceals* as well as *reveals*. We may thus see the hollow of the casket as a generative emptiness into which have been inserted a multiplicity of applications and interpretations over time, illustrating an esoteric dimension lying at the heart of the Daoist tradition.

Julius Tsai is Assistant Professor of East Asian Religions at Texas Christian University. His research explores the history of early medieval Daoism, including such dimensions as the relationship between imperial religion and Daoism, as well as narrative and ritual practices deployed in the formation of emergent religious communities and lineages.

In past decades the study of Chinese religion has been invigorated by the remarkable pace of archaeological discoveries and a heightened awareness of methodological perspectives that focus not only on abstract formulations of doctrine but on concrete dimensions of practice. For its part, the present article focuses on a particular class of ritual objects that I have termed "ritual caskets"[1] — religiously potent containers, often of stone, jade, or precious metal, used to house oaths, prayers, petitions, divinely granted treasures, and esoteric texts — as a way of gaining insight into the formation of early medieval Daoist worldviews. In what follows, I would like to highlight three religious contexts in which the ritual casket proved not only particularly "good to think"[2] from the perspective of narrative practice, but also "good to enact" from the perspective of ritual practice: 1) in the acquisition of the all-important "mandate" (*ming*) in early China, by which term I include both of its intertwined sense of celestial mandate for imperial rulership as well as for an individual allotted lifespan; 2) in disclosing revelation, as seen when examining the uses of images of the ritual casket from the Latter Han weft texts and into early medieval Daoism; and 3) in ritualizing expiation in early medieval Daoism, that is to say, in effecting the purging of one's name from the registers of death and the advancing of one's name onto the registers of life through the depositing of ritual objects and petitions into hidden caches.

For the most part, these ritual objects have been dealt with indirectly in the textual sources available to us, and have not been focused on explicitly by scholars writing on Chinese religion. However, these objects are indeed worthy of consideration for what they can reveal in the broader study of Daoism and Chinese religion. In particular, the ritual casket draws needed attention to a religious dynamic of concealment and disclosure, a dynamic that serves to locate early medieval Daoism — with its preoccupation with the secure channeling of sacred power through esoteric lineages of textual and ritual transmission — in its broader context in Chinese religious practice. I illustrate this point throughout the essay and discuss its implications in the conclusion.

More generally, I speak of "ritual caskets" in the plural to emphasize a category of ritual objects that share family resemblances, sets of substantially but not completely overlapping traits, rather than being reducible to one single, exhaustively delineated and defined essence.[3] In the evocative words of the *Daode jing*: "By kneading clay one forms a vessel, but it is by means of what is not there that the vessel has its use" (*Laozi jiaoshi* 11.44). It is precisely through "what is not there" in that potent space that the caskets mediate the porous boundaries between materials (objects used in ritual practice), motions (sequences of ritual performances), and metaphors (narrative devices) in Chinese religions. Furthermore, while material objects have sometimes been viewed as mere carriers of abstract beliefs and meanings, the latter assumed to be of primary importance, exploring ritual caskets helps us to make the shift towards understanding

religion "through, not in spite of, material culture" to overcome a "dualistic metaphysics of reality" (Nyitray 2003, i). Indeed, the very concreteness of the ritual caskets in turn embodies a complex field of iconographic, ritual, and historical contexts that illuminates our understanding of the Chinese religious imagination.

Acquiring the Mandate

The Zhou conquest in the eleventh century BCE was accompanied by an attempt to articulate a moral rather than hereditary basis for dynastic legitimacy, that basis being *ming* (mandate) or *Tianming* (Heavenly Mandate).[4] Obtaining and holding on to *ming* became a critical feature throughout subsequent imperial rhetoric as well as ritual. However, when looking at the acquisition of *ming* as mediated by the use of ritual caskets, we move beyond seeing the concept from a predominantly ethical vantage point—as it was often portrayed in traditional Confucian discourse, and as it has come to be seen in much contemporary scholarship—to gaining a richer sense of *ming*'s magico-religious dimension. Three examples from early China are offered below.

A first example of a ritual casket involves vessels used for containing the covenants (*meng*) that renewed the bonds between local lords and the Son of Heaven. The use of such vessels as authenticating receptacles for binding oaths may be seen within the broader context of covenant-making in early China, in which the blood of sacrificial animals was used to smear the lips and draw up covenants in the presence of human and divine witnesses. These covenant texts were then either buried in the earth, or sealed away in caskets that were then placed in pits, mountains, rivers, or ancestral shrines.[5]

More specifically, the ritual classic *Yili* (Protocols and Rites), traceable to the Han period (206 BCE–220 CE) but likely containing earlier material, speaks of a receptacle known as a *fangming* (cube of divine luminescence), described as follows:

"The *fangming* is made of wood. It is green for the east, red for the south, black for the north, reddish-black above, and yellow below. It is decorated with six jades" (*Yili zhushu*, "Jinli," 27.1092c–93a). In the commentaries, Zheng Xuan (127–200 CE) remarks that the *fangming* "manifests" (*xiang*) the spirits above and below and in the four directions (mountain, river, and territorial gods whose presences were invoked), for "when the king and feudal lords assemble to effect covenants, the luminous gods oversee those covenants." Kong Yingda identifies the function of the *fangming* as follows: "During oaths, they would set up the *fangming* on the altar, and this was to contain [the texts of] their speeches and proclamations" (*Yili zhushu*, "Jinli," 27.1092b–3a). While it may well be that the *fangming* existed only as a retrospectively projected and idealized ritual object, it is clear that at least by the Han period the use of caskets to contain covenants and oaths was well recognized. For example, when the Han founder Liu Bang (r. 206–195 BCE) ascended the throne, he "split tallies with his officials to effect oaths (*poufu zuoshi*), recording them in red on iron contracts

(*danshu tieqi*), storing them in a metal casket in a stone chamber (*jingui shishi*) in the ancestral hall (*Hanshu*, "Gaodi ji," 1b.81). The short narrative account succinctly captures significant elements that we shall find recurring in subsequent accounts, notably the ritual context of binding oaths, the use of written documents sealed away in caskets, and the secreting of those objects in secure caches.

A second and better-known portrayal of ritual caskets is found in the historical classic *The Book of Documents* (*Shangshu*).[6] The chapter entitled "The Metal-bound casket" ("Jinteng") relates the story of the Duke of Zhou (Figure 1) and his supplication on behalf of the gravely ill King Wu (an episode dateable to the eleventh century BCE). Here is an excerpt from the text describing the ritual:

He then took the business upon himself, and made three altars of earth, on the same cleared space; and having made another altar on the south, facing the north, he there took his own position. He positioned the *bi* and grasped the *gui*,[7] addressing the [ancestral] kings Tai, Ji, and Wen. The grand historian by his order wrote on tablets his prayer to the following effect: "A.B., your chief descendant, is suffering from a severe and dangerous sickness; if you three kings have in heaven the charge of watching over him, Heaven's great son, let me Dan be a substitute for his person [*yi yue Dan dai mo zhi shen*] … Oh! do not let that precious Heaven-conferred mandate fall to the ground [*wu zhui tian zhi jiang baoming*], and all our former kings will also have a perpetual reliance and resort. I will now seek for your orders from the great tortoise.[8] If you grant what I request, I will take the *bi* and *gui*, and return and wait for the issue. If you do not grant it, I will put them by." The duke then divined with the three tortoises, and all were favorable. He took a key, opened and looked at the oracular responses which were also favorable. He said, "According to the form of the prognostic, the king will take no injury. I, who am but a child, have got his mandate renewed [*xinming*] by the three kings, by whom a long futurity has been consulted for. I have to wait the issue. They can provide for our one man." Having said this, he returned, and placed the tablets in the metal-bound casket; and next day the king got better. (translation adapted from Legge 1994, 352–6; *Shangshu zhengyi*, "Jinteng," 13.195c–197a)

FIG 1
Duke of Zhou, Ink rubbing from Yuansheng Temple, Qufu. *Jinshi suo* ("Shisuo" 4.56)

On the broadest level, it should be noted that the *ming*, or mandate, of the king to rule is inextricably bound up with his *ming*, or allotted lifespan. Indeed, the Duke of Zhou pleads for the life of the king so as not to allow the "precious Heaven-conferred mandate" to "fall to the ground." As for the two kinds of ritual caskets employed in this narrative, the first is the "metal-bound casket," the term referring to the metal cables that were used to bind up the casket and symbolically indicating the "binding" nature of its contents. It serves not only as a petitionary but also as a sacrificial vehicle ("Let me, Dan, be a substitute for his person") from the human to the divine realm. To speculate further, the prayer tablets may be seen not only as recording the text of an earnest prayer but as proposing a self-sacrifice on the part of the Duke of Zhou. Indeed, according to a sympathetic logic in which a person's

words in ritually spoken or written form might partake of some aspect of their presence, the tablets placed in the metal-bound casket could be seen as having been transformed by the ritual operations into a surrogate for the offered-up person of the Duke himself.[9]

The second receptacle, containing the oracular responses, serves as a revelatory vehicle from the divine to the human realm. Most significant here is the oscillation between concealment and disclosure. The way of Heaven is unknown before the augury is made, revealed through the opening up of the box of oracular responses, and then sealed away again in anticipation of future consultation. As the *Rites of Zhou* (*Zhouli*), a text whose contents likely predate the Han period, relates: "In all cases of divining, when the task is concluded, the diviner then binds [the divinatory record along with] the sacrificial cloths (*xibi*) in order to verify the divinatory charge. At the end of the year, it shall be reckoned whether the divination hit the mark or not" (*Zhouli zhushu*, "Zhanren," 24.805b). In the case of the Duke of Zhou, his prayer and divination on behalf of the king are kept largely secret at the time they are made. When he is subsequently slandered, however, the metal-bound casket is opened up, the Duke's honorable intentions are made known, and he is exonerated (*Shangshu zhengyi*, "Jinteng," 13.197a–c).[10]

A third context in which ritual caskets figured prominently was the Feng and Shan sacrifices on Mount Tai (Taishan in modern-day Shandong). These were weighty imperial rites that emerged out of the traditions of the masters of esoterica (*fangshi*) from the Warring States period (ca. 475–221 CE) and into the Qin (221–207 BCE) and Han (206 BCE–220 CE) periods.[11] In many respects the rites came to function as a kind of Chinese "sword in the stone," the ultimate symbol of a ruler's possession of the Heavenly Mandate. Indeed, the rites could only rightfully be performed by a ruler who had unified the realm, brought peace to the world, and enjoyed the appearance of auspicious omens to confirm possession of the Mandate.[12] In the Feng and Shan sacrifices of the Qin and Han, the essential ritual act was the sealing away of jade tablets into a stone casket, which was then buried within an altar mound. While there are no extant archaeological remnants of the Qin and Han sacrifices, the jade tablets from rites performed during the reigns of Tang Xuanzong (712–56) and Song Zhenzong (997–1022) are preserved in the National Palace Museum in Taipei. The jade tablets from Tang Xuanzong's sacrifice (Figure 2), as well as jade coverings recovered at the site at Mount Tai, of either Tang or Song provenance (Figure 3), may serve to illustrate at least those later versions of the rites and the objects that were sealed away.[13]

Emperor Wu of the Han's performance of the rites in the spring of 110 BCE as recorded in the "Treatise on the Feng and Shan Sacrifices" (*Fengshan shu*) in Sima Qian's (145–86 BCE) *Records of the Grand Historian* (*Shiji*) is well known to have involved both a public performance at the eastern foot of Mount Tai and an esoteric performance on

FIG 2
Jade tablets from Tang Xuanzong's Shan sacrifice on Mount Tai of 725. By permission of the National Palace Museum, Taipei, Taiwan

FIG 3
Jade covering for ritual casket, Tang or Song provenance. By permission of the National Palace Museum, Taipei, Taiwan

the mountaintop a day later (*Shiji*, "Fengshan shu," 28.1398), further compounding the "overdetermined mystery" lying at the center of the rites (Lewis 1999b, 54).

Of great interest for our purposes is a lesser-cited passage from the second-century CE *Comprehensive Meaning of Popular Customs* (*Fengsu tongyi*) dealing with popular traditions concerning Emperor Wu of the Han's (141–87 BCE) esoteric performance of those rites. The passage reveals an unexpectedly rich reading of the nature of the *ming*, the mandate, that Emperor Wu might have been seeking:

> Popular lore has it that atop Mount Daizong [Mount Tai] was a golden box containing jade tablets (*jinqie yuce*). By means of these one would be able to know whether the length of one's

years would be long or short. Emperor Wu peeked at the tablets and saw that he would be able to live another "eighteen [*shiba*] years." He then [manipulated the tablets and] read them as saying that he would have "eighty [*bashi*] years" more. Thereafter the days of life he enjoyed were indeed long. (*Fengsu tongyi*, "Zhengshi," 2.1079a)

When read synoptically with accounts of the sacrifices in the standard histories, such as the "Treatise on the Feng and Shan Sacrifices," a strikingly bivalent understanding of *ming* emerges. On the one hand, traditional views of the Feng and Shan sacrifices note their direct connection to *ming*, understood as the divinely bestowed mandate to govern; this relates to the quest for a long-lived dynastic house. On the other hand, the passage here stresses another understanding of *ming*, as an individual's allotted lifespan, as seen in a term such as *shengming* (lit. life mandate); this relates to the quest for an immortal self. In that latter context, the emperor's manipulation of the divinatory tablets speaks eloquently to the continual human hope that, through the skillful hermeneutics of divination and ritual, the ordained cosmic processes that shape human life can be overridden (Smith 1982, 50). In this doubled reading of the jade tablets, the tablets recording the span of Emperor Wu's life and reign could be interpreted as a surrogate not only for the body of Emperor Wu, but for the body politic of the Chinese empire as a whole.

It is this bivalent understanding of *ming* that bridges imperial practice in the Han period and developments in Chinese religion in the early medieval period. Indeed, in subsequent Daoist practice, which Seidel has characterized as a "recreation, on a higher spiritual level, of the lost cosmic order and splendor of the Han imperium" (1984, 173), the quest for immortality was intertwined with the quest for lasting power through the assumption of high office in the celestial empire.

Concealing to Reveal: Revelation in Early and Medieval China

In early and medieval China, ritual caskets were frequently depicted as vehicles of divine revelation. In such cases, the interplay between concealment and disclosure was central to the caskets' symbolism and religious function. Furthermore, their contents were frequently understood in a particular way: as heavenly secrets sealed up in a benighted age in anticipation of a future worthy. This section examines the transformation of such themes from classical sources into the revealed texts of early medieval Daoism.

Already in the Warring States period (475–221 BCE) we find traditions concerning the arrival of enlightened rulers and sages at critical historical junctures. Confucius, guardian of the cultural patrimony of the Zhou and in later apotheoses viewed as an "uncrowned king" (*suwang*) and supernatural figure (Dull 1966, 516–27), was said to have been spurred on by the capture of a portentous phoenix in the fourteenth year of Duke Ai of Lu (481 BCE) to "compile the *Spring and*

Autumn Annals (*Chunqiu*) in order to await a latter-day sage (*yisi housheng*)" (*Chunqiu Gongyang zhuan zhushu*, "Aigong" 14, 28.2352b–53b). For his part, Mencius spoke of 500-year intervals that would mark the rise of epoch-shaping rulers and sages (*Mengzi zhushu*, "Jinxin" 14b.2780b; "Gonsun chou zhangju xia," 4b.2699c). Sima Qian, progenitor of Chinese historians, labored as a kind of "second Confucius," following in a long line of ill-fated worthies who, when thwarted, turned to "recounting past affairs, thinking of those to come (*si laizhe*)" (*Shiji*, "Taishi gong zixu," 130.3300; *Hanshu*, "Sima Qian zhuan," 62.2735; Durrant 1995, 1–27; Lewis 1999a, 308–17).

Significantly, the language that early historians used to describe their texts spoke of "books archived in chambers of stone and caskets of metal" (*shishi jingui zhi shu*) (*Shiji*, "Taishi gong zixu," 130.3296). Sima Qian's monumental opus, the *Records of the Grand Historian*, was to be "secreted in the mountains of renown (*zang zhi mingshan*) [associated by the commentators with imperial archives] and with an auxiliary copy in the capitol, to await sages and lords of a latter age (*houshi shengren junzi*)" (*Shiji*, "Taishi gong zixu," 130.3320). The *History of the Jin Dynasty* (*Jinshu*), compiled in 644 and covering the period 265–419, includes a biography of Ge Hong (283–343), the author of the *Master Who Embraces Simplicity* (*Baopu zi*), a work divided into exoteric and esoteric sections that shared the religious milieu of early Daoist lineages in the south. Ge Hong was said to have harbored certain aspirations for his work: "Even though the texts [the *Inner* and *Outer Chapters* of the *Master Who Embraces Simplicity*] were not necessarily worthy of inclusion in the renowned mountains [imperial archives], he nonetheless desired to bind them up in metal caskets in order to show the way for those [to come who would be] in the know" (*Jinshu*, "Ge Hong," 72.1912). The association of imperial archives with the "mountains of renown" is noteworthy. These caches, along with those provided by the ritual caskets themselves, may be seen as part of a complex of both natural and humanly constructed spaces serving as hidden places for the timely concealment and disclosure of inspired texts.

In the Latter Han period prognostication and weft texts (*chenwei*), ritual caskets figured prominently in the revelation of the *River Chart* (*Hetu*) and *Luo Script* (*Luoshu*), cosmic charts disclosed to rulers granted the Heavenly Mandate (Figure 4).[14] Regarding the accession rites of the sage king Shun at the rivers we read:

> Shun, along with the Three Dukes and the feudal lords, came to divine at (*linguan*)[15] [the Yellow and the Luo Rivers]. A chart was found in a yellow casket, resembling a coffer (*tu yi huangyü wei xia ru gui*). The dimensions of the casket were three feet in length, 8 feet in breadth, and one inch in thickness. All around it were openings, with white jade panels [fitted within the openings], golden cords binding the casket, and paste sealing up both ends, imprinted with the following characters: "Talismanic Seal of the Celestial Yellow Emperor (Tian huang di fuxi)." The words were three inches in height and width, imprinted to a depth of

four inches, and written in avian-script (*niaowen*)...¹⁶ The silk contained within was dark-colored and could be unfurled; the roll was 32 feet long and nine inches wide. On it were written the terrestrial divisions (*dixing zhi zhi*) of the 72 emperors of antiquity, as well as the ranks of the stellar bureaus (*tianwen guanwei zhi cha*). (*Chunqiu yundou shu*, 156–1)¹⁷

The description of the ritual casket follows a by-now familiar iconographic idiom, strikingly resonant with the descriptions of stone caskets used to seal up the emperor's petition in the Feng and Shan sacrifices down to the details of the panels, the cords, and the imperial seal. Here, what heaven reveals is higher knowledge of the configurations of the universe. As Seidel has noted, the casket here and in the context of imperial sacrifices functions in a general way as a medium for communication between human and divine. Such revelations may be seen within the larger context of the motif of the revelation of treasure objects as symbols of power such as the *River Chart* and the *Luo Script*, material tokens of the Heavenly Mandate.

We have seen how the ritual casket could be seen as a repository for both treasures and texts. In the transition from the Han to the Six Dynasties, Seidel sees a shift in emphasis on imperial treasures and tokens themselves, towards an emphasis on texts *about* and associated with such treasures, and finally towards an emphasis on the texts themselves becoming objects bespeaking divine approval (1983, 300–1). Indeed, in the Han period, the wider cultural force of the idea of "finding" such precious texts extended to the "recovery" of classical texts from inside a wall within the home of Confucius in 168 BCE (part of the ferocious textual debates of the age between adherents of the "New Texts" and the "Old Texts" of the classics) (Gu 1995, 66–72; Tjan 1949, 1:95–145); as well as the purported appearance of the aforementioned *chenwei* texts, used to provide supernatural legitimacy to Latter Han claimants to the throne (Dull 1966, 152–252).

Given the richness of such associations, it is not surprising to see representations of ritual caskets in narratives concerning the revelatory dispensations of early medieval Daoism, beginning around the fourth century CE. Here I would like to raise the case of Yu the Great, the flood-quelling sage king, to illustrate how broader mythical narratives of the sage kings were transformed for use in the origin myths of Daoist dispensations.

Early and medieval narratives concerning Yu often portray him as receiving a jade tablet (sometimes identified with the *River Chart* itself) revealing the configurations of the land and the waters. He receives his revelation along the Yellow River, the Eastern Sea, or deep within the mountain grotto of Longmen, where he was said to have drilled through the rock to allow the water to flow through.¹⁸ A number of narrative traditions have Yu receiving revealed texts from jade and metal caskets in the grotto-chambers of Mount Guiji (Zhejiang) and nearby Mount Wanwei (Wanwei shan).¹⁹ The following is an account preserved in the *Taiping yulan* (compiled in

FIG 4
River Chart and Luo Script. Zeng Chunhai, *Zhuzi yixue tanwei* (Taipei: Furen daxue, 1983, 187)

the tenth century), that elaborates on the theme of heavenly secrets in precious caskets:

> Yu asked Feng Hou [legendary minister to the Yellow Emperor]: "I have heard that the Yellow Emperor had a chart [foretelling] victory or defeat (*fusheng zhi tu*), detailing the ways of the Six Jia (*liujia*) and Yin and Yang. Where is it now?" Feng Hou replied, "The Yellow Emperor hid the chart beneath Mount Guiji. The pit it rests within is ten thousand feet deep, 1,000 feet wide, and weighed down with a boulder. The chart is thus difficult to obtain." Yu went north to see the Six Masters, to ask them where the seas issued from. He then cleared out the mouth of the Yangzi River and played *jue* music on Mount Guiji.[20] A dragon king appeared, and the jade casket (*yügui*) floated up. Yu then opened it and looked at it, and in it was the *Scripture of All Under Heaven* (*Tianxia jing*) in 12 fascicles. Before Yu could get hold of it, four of its fascicles flew up to heaven, and Yu could not obtain them. Four of its fascicles returned to the pool and Yu was unable to recover them. Yu received the middle four fascicles, opened them up and read them. (*Taiping yulan*, "Huangwang 5," 82.382b–383a)[21]

Most interesting about the above passage is the congruence observed between the imagery of the casket depicted here with the imagery of the caskets we have seen thus far. Here, its revelatory dimension is highlighted. That the jade casket contains a revelation pertaining to the cosmic planes of heaven, earth, and water might be surmised from the three-fold division of the scripture. The lesson seems to be that the revelatory contents of the caskets described in such narratives were not to be lightly possessed, a lesson learned by the hapless King of Wu, whose illegitimate stealing of divine texts resulted in the eventual collapse of his kingdom (Bokenkamp 1986).

Let me now turn to the *Preface to the Five Talismans of Lingbao* (*Taishang lingbao wufu xu*), a text that was known by the fourth century and that forms one of the earliest scriptures of Lingbao Daoism. The centerpiece of that scripture was the Five Talismans of Lingbao (Figure 5), said to have been revealed in ancient times to Yu after his world-ordering exertions. In the *Preface*, Yu secretes one copy of the revealed talismans "atop a mysterious terrace (*xuantai*), in the hollow of a solid rock (*jianshi zhi han*), hidden away in a grotto on Mount Miao (*Miaoshan zhi xiu*)," to subsequently appear every ten thousand years (*Taishang lingbao wufu xu*, 1.6b). Another copy he entrusts to a grotto within the waters of Lake Tauhu, "sealed in a golden-flowered box (*jinying zhi han*) imprinted with the seal of the Mystic Metropolis (*xuandu zhi zhang*)" to await the passage of cosmic intervals and the coming of a latter-day sage (*Taishang lingbao wufu xu*, 1.6b–7a).[22]

Worth noting is that composer of the *Preface* not only rewrites the traditional narrative of Yu as found in the *Records of the Grand Historian* (*Shiji*, "Wudi benji," 1.50–51) but also replaces prior traditions of Yu's receipt of imperial treasures such as the *River Chart* and *Luo Script* with the Five

FIG 5
The Five Lingbao Talismans. *Taishang lingbao wufu xu* (HY 388), 3.9b–11b

Talismans of Lingbao. In this new narrative, the Five Talismans serve no longer simply to guarantee *kingly* succession from emperor to emperor, but *scriptural* transmission from master to disciple in a Daoist lineage of transmission (Tsai 2004, 230–46).

Another early set of texts that eventually made its way into the Daoist canon was the pair of the *Scripts of the Three August Sovereigns* (*Sanhuang wen*) and *Charts of the Authentic Forms of the Five Sacred Mountains* (*Wuyue zhenxing tu*).[23] Like the *River Chart* and *Luo Script* before them, these texts comprised a complementary, talismanic pair. While the *River Chart* and *Luo Script* were primarily located at the rivers, the *Scripts of the Three August Sovereigns* and the *Charts of the Authentic Forms of the Five Sacred Mountains* were to be found secreted in mountain hollows. The following passage from *The Master Who Embraces Simplicity* describes the hiding place and ritual context for receiving these texts:

> They may be received once every forty years, and to transmit them one smears blood on one's mouth and makes an oath, using pledge goods to bind the oath. All of the mountains of renown and the Five Sacred Mountains contain these texts. They are, however, hidden in stone chambers in deep, dark places (*shishi youyin zhi di*). Those who are destined to receive the Dao should enter into the mountains and with utmost sincerity meditate upon them. Then, the mountain gods will of their own accord open up the mountain and let one see them. This is like the case of Bo Zhongli,[24] who received the texts in the mountains. By himself, he set up an altar and the cloth pledges, copied out the texts, and went on his way. (*Baopuzi neipian jiaoshi*, "Xialan," 19.336)

As I have mentioned previously, we may see a general functional resemblance (if not an explicit association) between the secretion of texts in ritual caskets and the secretion of texts in mountain chambers. Mountains were considered a threshold to the sacred, and their grottoes were an opening into the inside-out worlds to be found within. In the Qing dynasty painting *Outing to Zhanggong Cave* (Figure 6), a figure stands before the mouth of a cave that is illuminated by the celestial lights that blaze in that firmament within. This particular cave, located at Mount Yufeng (Yufengshan) in Jiangsu, was said to be the site of a stay by the first Celestial Master Zhang Daoling, and was designated as a "blessed land" (*fudi*) within Daoist sacred geography.[25]

FIG 6
Outing to Zhanggong Cave. By Daoji (Shitao) (1642–1707). Handscroll, ink and color on paper. By permission of the Metropolitan Museum of Art

These worlds within the mountains were repositories of magical flora and minerals, places for encounters with wild beasts, demons, immortals, and divinities, and were seen as an ideal place for the hiding and revealing of sacred scriptures.[26] The talismans known as the *Authentic Forms of the Five Sacred Mountains* (the diagram for the Sacred Mountain of the East is given in Figure 7), for their part, were not only revealed in mountainous hiding places, but themselves served as talismanic maps in the context of meditative visualization and esoteric access to the mountains. In the illustration, for example, one finds notes regarding points of entry, locations of medicinal plants, sources of springs, and locations of the exploits of august past figures (*Dongxuan lingbao wuyue guben zhenxing tu*, 17b–18a).

Kamitsuka has studied the motif of scriptures being hidden away in chambers of stone as taken up into early medieval Daoism. As with the mountain charts already mentioned, these writings were often portrayed in talismanic form, like the "avian-script" mentioned in the previously quoted weft text account of the ritual casket granted to Shun, intimating their status as a cosmic *Ur*-script coincident with the beginning of the universe itself (1999, 385–98). Such script, like the hexagrams of the *Yijing*, surpassed the limitations of human language in directly embodying the deepest structures of reality and necessitated the development of specialized, often esoteric exegesis.

It is worth noting, furthermore, that narratives concerning the texts already discussed here (the *Preface to the Five Lingbao Talismans*, *Scriptures of the Three August Sovereigns*, and the *Charts of the Authentic Forms of the Five Sacred Mountains*) did not just serve to furnish origin myths for the scriptures in question, but also served to ground regularized rituals of transmission. While Daoist rites of transmission may not have explicitly made use of ritual caskets as depicted in such mythic narratives, it may be argued that the symbolic actions performed in such narratives sketched out liturgical contexts in which transmission rites could proceed. The passage above, for example, provides the ritual parameters within which the transmission of these texts were to take place, including the span of time between transmissions, prescriptions for the covenantal oath, and enumeration of pledge goods. We may turn to early sources such as the third fascicle of the *Preface to the Five Lingbao*

FIG 7
Diagram of the Authentic Form of the Sacred Mountain of the East. *Taishang lingbao wuyue guben zhenxing tu* (HY 441), 17b–18a

Talismans (*Taishang lingbao wufu xu*, 3.3a–7b) for explicit and fuller ritual instructions.²⁷

Literary images found in early medieval Daoist texts, furthermore, frequently involved the notion that a text that had been released in the world was one among multiple copies or rescensions that issued from celestial archives, as seen in the following passage from an early Shangqing text:

> The slips in gold and tablets in jade (*jinjian yuzha*) issue from the palaces of the Numinous Capital of the Superlative Lord of the Dao (Taishang lingdu), with carved jade for the tablets, bound gold (*jiejin*) for the slips. The writing is in vermilion script (*zhuwen*), and purple cords (*zisheng*) are used for the binding [of the documents]. (*Dongzhen shangqing qingyao zishu jingen zhongjing*, 2.2b)²⁸

The imperial resonance of the above imagery is unmistakable, from the allusion to copies of imperial histories secreted in metropolitan as well as mountainous archives, to the affinities with the petitionary tablets bound up and buried under the altar in the Feng and Shan sacrifices on Mount Tai. Such was the richness of the ritual and iconographic modes that the composers of early Daoist scriptures would have understood and drawn inspiration from.

Ritual Patterns in Early Medieval Daoism

I now want to turn from explicit references to ritual caskets in the textual sources to the more challenging task of locating broad patterns of similarity, or family resemblances, between associated ritual patterns and those found in early medieval Daoism. In terms of the latter, I focus on the ritual sealing away of objects or texts as part of the Daoist priest's role as a functionary vested with the knowledge and authority to lead human communities through the often tortuous structures of an elaborate cosmic bureaucracy. While bureaucratic mechanisms may be detected in Chinese religion from ancient times,²⁹ we may see the rise of early Daoist movements as a religious response to the collapsing Han dynasty, seeking

to preserve a vision of cosmic order. That religious response may readily be seen in the transformation of the model of an imperial bureaucracy into a Daoist "paperwork empire" (Strickmann 2000, 5).

Early medieval Daoist texts speak of at least two possible responses for an individual living within the machinations of that all-pervasive bureaucracy: to evade it or to work within its systems. A passage from an early Shangqing text may serve as an illustration of these options, which would seem to mirror the literati's often-conflicting impulses between rustic retreat and service to the state.[30] The passage is as follows:

> All those who wish to roam and sport among the Five Marchmounts, to circulate around the Eight Extremities, to not be restricted by the labors of being an immortal official, to not be harried by tiresome details of regulations, and who do not yet wish to ascend to heaven may choose not to ingest the five types of pills [detailed in the text], but simply regularly take perhaps seven or three pills at a time in order to hold fast their *hun* souls and secure their *po* souls.[31] Then they can soar through the 74 directions, roam the Five Sacred Mountains, and enjoy lifespans that match those of the Three Luminescences [sun, moon, and stars]. Everyone else may follow the prescriptions given by these five methods. If you take the five kinds of pills, you will become an overseer of the Five Sacred Mountains. You will be placed in positions of responsibility and cannot simply do as you please in the world. (*Dongzhen taishang zidu yanguang shen yuanbian jing*, 27a–b)[32]

While ancient texts such as the *Zhuangzi* might have portrayed the acquisition of power as constituting a kind of antinomian freedom from structures of authority, what we detect in the above textual passage is a vision of power inextricably linked with the attainment of high office in otherworldly bureaus. The above passage is particularly interesting in that it illustrates the tensions and choices that might have confronted individual adepts in the context of the development of the elaborate celestial bureaucracies that were imagined and accessed through the rites of early medieval Daoism.

In terms of evading the otherworldly bureaucracies, an early Daoist text of the Taiqing (Grand Purity) tradition—an early alchemical corpus—details a practice that belongs to the genre of "corpse-deliverance" (*shijie*) practices (Cedzich 2001; Campany 2002, 47–60). These exploited the mechanisms of the otherworldly bureaucracy through subterfuge. Through the ritual sealing away of a surrogate corpse, one attempted to fool the offices of the dead into thinking that one had in fact passed away, thereby prematurely triggering the removal of one's names from the registers of death:

> If you seek a method to increase your years and extend your life span, you should send a memorial to the August Sovereign of Humanity, including your clan and personal name, date, and your exact address—province, commandery, district, township, village, post station affiliation, and earth god community. At your grandfather's burial, you place this memorial in the tomb. Its

prayer says: "All that is born has to die. Our life spans should agree with [your] registers. My name was not yet recorded on the register of the Great Storehouse of Darkness [the netherworld]. Now I find myself already in Haoli [another name for the realm of death], wandering through darkness without end!" You continue wailing [there] for the appropriate while, then you return home. Beyond that, you should change your clan and adult name, as those must not be the same as before [if you want to succeed]. Having done so, you will not die even in a thousand or ten thousand years. For the records have already been corrected, and your death entry has been permanently erased. (translated in Cedzich 2001, 36; *Taiqing jinye shenqi jing* 2.1a–1b)[33]

The particular bond between son and grandson, particularly in terms of their ritual substitutability, may at least in part be traced back to ancient times, when a grandson would stand in as a bodily receptacle, a "corpse" (*shi*), for the spirit of a deceased grandfather in ancestral sacrifices (Cedzich 2001, 39n141; *Yili zhushu*, "Tesheng kuishi li," 44–50.1178–1220; *Liji zhushu*, "Jitong," 49.1602–1609). Indeed, some form of a logic of ritual substitution is clear to see in the above passage, and furthermore brings to mind earlier cases that we have examined, such as the narrative of the Duke of Zhou's sealing away of the prayer offering himself up on behalf of the king, or of Emperor Wu of the Han's changing around of the numbers given in the divinatory tablets recording his expected lifespan. While the former action would seem to be morally unimpeachable and the latter tricksterish at best, both made use of secret substitutions (or offers of substitution) to achieve their desired effect. In this case, the bureaucratic mechanisms of the otherworld are surreptitiously manipulated to evade death.

In terms of how to deal with the moral ambiguity inherent in the exercise of the methods of corpse-deliverance, Cedzich remarks on early attempts to resolve the gulf between two divergent strands of tradition, methods of evasion that frequently drew from roots in *fangshi* techniques of individual practice and other types of methods that drew from the ethical concerns and bureaucratic structures of the Celestial Masters (2001, 45–58). In terms of the latter, one of the most characteristic practices of the early Celestial Masters movement was the presentation of bureaucratic petitions confessing the devotee's misdeeds to the Three Bureaus (*sanguan*) of Heaven, Earth, and Water, divine offices said to contain the registers of life and death. These petitions were then placed on mountaintops, buried in the earth, and sunk into water, respectively (*Sanguo zhi* 8.264).[34] The bureaucratic petitioning of otherworldly offices has persisted as a basic feature of Celestial Masters practice to this day (Schipper 1974), and presents another broad area for comparison with ritual actions associated with ritual caskets involving the sealing away of bureaucratic communications to the divinities.

Here, I would like to discuss the practice known as the "casting of petitionary tablets" (*toujian*), which figured prominently in the communal rites of early Daoism.[35] An early Shangqing text details expiatory rites that prepared

an adept for transmission of sacred scriptures (*Dongzhen shangqing qingyao* 2.3a–3b), a rite that may be seen as a bureaucratic adaptation of the corpse-deliverance methods in that it "substitutes golden tablets and jade slips [on which are inscribed one's particulars] for an actual surrogate corpse" (Cedzich 2001, 51). Likewise, early Lingbao sources detail the practice that came to be known as the "casting of dragons and tablets" (*tou longjian*), which made their way into rites of textual transmission and ordination.[36] The *Wondrous Scripture of Jade Instructions To The Scripts Written In Red* (*Taishang dongxuan lingbao chishu yujue miaojing*)[37] instructs the adept to submit one's petition as follows:

> Write out the text given above in red script on silver-colored wooden tablets. Use green paper to wrap these tablets, and tie the whole thing up with green cord. Use golden dragons to bear the tablets [to the respective offices] (*jinlong fujian*). (*Taishang dongxuan lingbao chishu yujue miaojing* 1.5a)

The method of casting petitionary tablets in this text called on the offices of water, the mountains and the earth. The petitions were to be accordingly cast into water, buried at the mountains or in the courtyard of one's home, accompanied by the golden dragons that served as messengers (1.5a–7b).

The casting of tablets, whether for evasionary or expiatory purposes, was placed squarely within an imperial, bureaucratic worldview that religious Daoism both inherited as well as transformed. The connections between the Daoist and imperial ritual patterns were neither coincidental nor cosmetic in nature, but manifestations of a deeply shared religious worldview. Just as Daoist petitionary rites in their sealing away of documents evoked the ritual iconography and symbolic actions of earlier imperial rites such as Feng and Shan sacrifices, they would also anticipate the subsequent imperial practice of "casting the dragons and petitionary tablets" (*tou longjian*) for the protection of the state and mediated by Daoist priests (Chavannes 1919). Illustrated (Figures 8 and 9) are the jade tablet and golden dragon from Ming dynasty imperial rites performed at Mount Wudang (Wudang shan) in 1399.[38]

Some of the flavor of those ritual patterns may be seen in aspects of contemporary ritual. Illustrated are rectangular document enclosures (*fanghan*) used in a Daoist Offering (*jiao*) ritual held in northern Taipei (Figure 10). Petitions to the otherworldly offices, sealed away in their enclosures, are symbolically "carried" by representations wrought in paper of an official horse and rider, a messenger to the other world (Figure 11). As the officiating priest visualizes ascent to the celestial courts, the *fanghan*, horse and rider are burned, the sacrificial flames consummating their translation from the human to the divine realm.[39]

Reflections on Religious Secrecy

Each of the ritual moments we have examined, while diverse in context, nonetheless relates to the others through the

FIG 8
Golden dragon used in the imperial rite of "casting tablets and dragons" on Mount Wudang in 1399. Photo in Wang Guangde, *Xianshan Wudang* (Beijing: Zongjiao wenwu chuban she, 1999), 28

iconography, symbolic actions, and dynamics of concealment and disclosure that the ritual caskets enabled. The Duke of Zhou's metal-bound casket was secretly sealed and then later revealed. No witnesses survived to relate the esoteric contents of what Emperor Wu sealed away in his Feng sacrifice on Mount Tai, though what happened on the mountaintop was later imaginatively reconstructed and interpreted. Powerful texts, of both human and divine origin, were sealed up in caskets and mountain grottoes to await their own appointed *apocalypsis*, or uncovering. Daoist transmission rites provided a sanctioned revealing of that which, to use the language of the texts, was not to be "leaked out" (*xielou*), and created lineages reinforced through esoteric rituals. Indeed, one of the salient characteristics of early medieval Daoism was its very status as an esoteric transmission.

More broadly, secrecy (and in the following respects secrecy has much indeed to do with sacredness) has been characterized as "what human beings care most to protect and to probe: the exalted, the dangerous, the shameful; the sources of power and creation; the fragile and the intimate" (Bok 1982, xvii).[40] Simmel reflects on the distinctive human capacity to keep secrets and provides useful perspectives in thinking about the role of secrecy in religions. Human interaction, by his view, is enabled by constantly shifting and finely calibrated admixtures of knowledge, truth, and

FIG 9
Jade tablet used in the imperial rite of "casting tablets and dragons" on Mount Wudang in 1399. Photo in Wang Guangde, *Xianshan Wudang* (Beijing: Zongjiao wenwu chuban she, 1999), 28

jinjian yüzha 金簡玉札
jinlong fujian 金龍負簡
jinqie yuce 金篋玉策
Jinshu 晉書
Jinteng 金藤
jinying zhi han 金英之函
jue 角
Kong Yingda 孔穎達
Taihu (Lake Taihu) 太湖
Lingbao 靈寶
linguan 臨觀
Liu Bang 劉邦
liujia 六甲
Longmen 龍門
Luoshu 洛書
meng 盟
Miaoshan zhi xiu 苗山之岫
ming 命
niaowen 鳥文
poufu zuoshi 剖符作誓
Qi Huan gong (Duke Huan of Qi) 齊桓公
qie 篋
Qin 秦
sanguan 三官
Sanhuang wen 三皇文
Shan 禪
Shandong 山東
Shang 商
Shangqing 上清
Shangshu 尚書
Shen Yue 沈約
shengming 生命
shi (chamber) 室
shi (corpse) 尸
shiba 十八
Shiji 史記
shijie 尸解
shishi jingui zhi shu 石室金匱之書
shishi youyin zhi di 石室幽隱之地
Shitao 石濤
Shiyi ji 拾遺記
Shizi 尸子
Shuowen jiezi 說文解字
Shun 舜
si laizhe 思來者
Sima Qian 司馬遷
Song Zhenzong 宋真宗
suwang 素王
Taiping yulan 太平御覽
Taiqing 太清

Taishan 泰山
Taishang lingbao wufu xu 太上靈寶五符序
Taishang lingdu 太上靈都
Tang Xuanzong 唐玄宗
Tao Hongjing 陶弘景
Tian huang di fuxi 天黃帝符璽
Tianming 天命
tianwen guanwei zhi cha 天文官位之差
Tianxia jing 天下經
tou longjian 投龍簡
toujian 投簡
tu yi huangyu wei xia ru gui 圖以黃玉為匣如櫃
Wanwei shan 宛委山
wei 緯
wu zhui tian zhi jiang baoming 無墜天之降寶命
Wu 吳
Wudang shan 武當山
Wuyue zhenxing tu 五嶽真形圖
xia 匣
xiang 象
xibi 繫幣
xielou 泄漏
Xin 新
xinming 新命
Xu Shen 許慎
xuandu zhi zhang 玄都之章
xuantai 玄臺
yi yue Dan dai mo zhi shen 以日且代某之身
Yijing 易經
Yili 儀禮
yisi housheng 以俟後聖
yu 羽
Yufengshan 盂峰山
yugui 玉匱
zang zhi mingshan 藏之名山
zhai 齋
zhanghan 章函
Zhejiang 浙江
Zheng Xuan 鄭玄
zheng 徵
Zhou gong (Duke of Zhou) 周公
Zhou 周
Zhouli 周禮
Zhuangzi 莊子
Zhushu jinian 竹書記年
zhuwen 朱文
zi 字
zisheng 紫繩

notes and references

[1] I use the term "ritual caskets" as a general term for a number of interrelated Chinese terms. The texts I have consulted refer in many instances to the word *gui*, which I have translated here as "casket," but also include words such as *xia* (case), *du* (cabinet), *han* (sheath), and *qie* (chest). Also included in a more extended sense are architectural/natural features such as chambers (*shi*) and natural features such as grottoes (*dong*).

[2] I borrow here Levi-Strauss's memorable formulation (1963, 54).

[3] The term "family resemblance" was most notably discussed

by Wittgenstein, who wrote in a discussion of language games: "I am saying that these phenomena have no one thing in common which makes us use the same word for all—but that they are *related* to one another in many different ways." In this view of things, "similarities crop up and disappear" in "a complicated network of similarites overlapping and criss-crossing" (Wittgenstein 1958, 31–32).

[4] Early references to *ming* may be found in the classics, for which see *Shangshu zhengyi*, "Dagao," 13.197c–200b; Wechsler (1985, 10–20) provides a succinct tracing of the evolution of discourse on *tianming* and imperial legitimacy through the Tang dynasty.

[5] See the comments of Kong Yingda (574–648) in *Liji zhengyi*, "Quli xia," 5.1266b; *Chunqiu Zuozhuan zhengyi*, "Yingong" 1, 2.1714a; translated in Weld 1990, 157; see also *Mengzi zhushu jiejing*, "Gaozi zhangju xia," 12b.2759c. On covenants see also Chen 1966, Dobson 1968, and Lewis 1990, 43–50, 67–80.

[6] On issues relating to the dating of this text see Shoughnessy (1993, 376–89).

[7] The *bi*, a flat, round piece of jade with a hole in its middle, and the *gui*, a jade scepter, were symbols of imperial authority.

[8] On early divinatory methods utilizing tortoise shells see Keightley (1978a, 1997).

[9] On similarity and contagion as principles of magical thought see Frazer (1940, 11–48). We may also think through this idea from the perspective of the "virtue" (*de*) displayed by the Duke of Zhou throughout this episode. Nivison, in a study of ritual inscriptions on oracle bones and bronze vessels (1996, 17–30), has remarked on *de* as a collection of virtues possessing a moral force that is generated through acts of self-sacrifice that in turn evoke approval from the divinities.

[10] See also Shaughnessy's treatment of this episode (1997, 118–25).

[11] Studies of the rites include Lewis (1999b), Kimura (1943), Fukunaga (1954 and 1955), and Wechsler (1985, 170–94). On the *fangshi* see Ngo (1976), DeWoskin (1983), Harper (1999), and Cedzich (2001, 5–6n12).

[12] These ideals concerning the rites may be seen in the dialogue between Duke Huan of Qi (r. 685–643 BCE) and his minister Guan Zhong (d. 645 BCE) that serves as a *locus classicus* for the rites (*Shiji*, "Fengshan shu," 28.1361–2).

[13] On the *feng* and *shan* rites in the Tang, see *Jiu Tangshu* 23.881–907 ("Liyi"); for the Song see *Songshi* 57.2527–2534 ("Fengshan"). On the objects pictured see Deng (1992) and Na (1992).

[14] The *chenwei* came to prominence in the Latter Han period, their use having been prominent under the reign of Wang Mang of the short-lived Xin Dynasty (9–25 CE). Using a metaphor from weaving, the Confucian classics were considered the *jing* (warp or lengthwise strands) while the apocryphal *chenwei* were considered the *wei* (weft or crosswise strands) in the overall textual fabric. These texts often dealt with supernatural myths of origins of the sage kings and of Confucius, with political prophecy, and with the revelation of heavenly talismans and tokens taken to justify various claims to imperial rule and dynastic succession. Many of these texts revolved around the cosmic diagrams of the *River Chart* and the *Luo Script*, which were tied to the Eight Trigrams of the *Book of Changes* (*Yijing*) and the *Great Plan* (Hongfan) of the *Book of Documents* (*Shangshu*), respectively. On these charts see Gu Jiegang (1934), Saso (1978), Seidel (1983, 297–302), and Kaltenmark (1982).

[15] Following Jin Zhuo in his reading of *guan* in his comments found in the astronomical treatise of the *History of the Han Dynasty* (*Hanshu*), for which see *Hanshu*, Treatise 6, "Tianwen zhi," 1277. The weft texts tend to associate certain ritual actions with the rulers' visits to the rivers. One such

notable action is that of "dropping the jade" (*chenbi*), a ritual action that may be seen as a divinatory action seeking a favorable divine response. Granet describes the sinking of the jade as a ritual act of *dévoument* (self-sacrifice) that results in divine response in the revealing of talismans and charts from creatures rising from the waters (1959: 466–82).

[16] Xu Shen (c. 55–c. 149 CE), in his preface to *Shuowen jiezi* (*Explaining Scripts and Elucidating Characters*), relates the myth of Cangjie deriving written language from the tracks of birds and beasts (Yuan Ke and Zhou Ming 1985, 30). It is likely that the reference to "avian-script" alludes to that tale in order to emphasize the primordial status of the writing revealed in the ritual casket.

[17] Seidel translates a portion of this passage (1983, 316–17). For variant fragments see also *Hetu luyun fa*, 99–100, *Luoshu luyun qi*, 188, *Longyu hetu*, 90, *Hetu*, 137 and *Chunqiu yundou shu*, 156–7. Similar narratives may be found in the *Shangshu zhonghou qiwo*, 108, and the commentary of Shen Yue (441–513) to the *Bamboo Annals* (*Zhushu jinian*) (Legge 1994, 2.113). For apocryphal narratives of the rite of the sinking of jade (*chenbi*) as a rite of succession, see *Xiaojing gouming jue*, 67, *Shangshu zhonghou*, 82, and *Hetu zhenji gou*, 109, 113.

[18] See for example *Shizi*, "Juanxia," 438b; and *Shiyi ji*, "Xia Yu," 2.1240a; and passages collected in the *Dunjia kaishan tu* in Yuan Ke and Zhou Ming 1985, 247.

[19] See for example *Longrui guan yuxue yangming dongtian tujing* (HY 604), 1a–2b; and *Yishi* 11.

[20] The notes on a traditional five-tone scale were *gong*, *shang*, *jue*, *zheng*, and *yu*. *Zhouli zhushu*, "Chunguan zong bo," 23.795b.

[21] The source cited is the *Military Methods of the Dark Maiden Granted to the Yellow Emperor* (*Huangdi xuannü bingfa*).

[22] On this passage see Bokenkamp (1986).

[23] On the Sanhuang tradition see Chen (1963, 71–78), on the *Wuyue zhenxing tu* see Chavannes (1919, 415–24), Inoue (1926), Schipper (1967), Kominami (1984), and Li (1996).

[24] Style-name (*zi*) of Bo He, whose texts form an important part of those texts in the possession of Ge Hong. See Campany (2002, 133–7).

[25] Munakata (1991, 128–9).

[26] On the magico-religious dimensions of the mountains see the 4th ("Jindan"), 11th ("Xianyao") and 17th ("Dengshe") chapters of the *Master Who Embraces Simplicity*, in *Baopuzi neipian jiaoshi,* 4.70–109; 11.198–223; 17.299–322. A translation of these passages, to be used cautiously, may be found in Ware (1985). An account of a grotto-heaven may be seen in the 11th fascicle of Tao Hongjing's (456–536) *Zheng'ao* (Declarations of the Perfected, HY 1010). On mountain grottoes and the development of the Daoist system of grotto heavens (*dongtian*) and blessed lands (*fudi*), see Miura (1983), Stein (1990, 49–113), Verellen (1995), and Li (1996).

[27] See also the *Taishang dongxuan lingbao chishu yujue miaojing* (HY 352), 2.20a–28b; and the *Taishang dongxuan lingbao shoudu yi* (HY 528), 1a–3b.

[28] For a further enumeration of various heavenly archives see *Shangqing housheng daojun lieji* (HY 442), 9b–11b.

[29] Scholars have remarked upon the pervasiveness of a bureaucratic metaphor in early China, from observations on the structure of Shang ancestral sacrifices (Keightley 1978b) to conceptions of a bureaucracy of the dead beneath Mount Tai in the Warring States (Seidel 1987; Harper 1994).

[30] On this dynamic in early and medieval China, see Vervoorn (1995) and Berkowitz (2000).

[31] The ten souls of the body. On the wayward tendencies of the *hun* and *po*, respectively the *yang* and *yin* souls of the body, see Bokenkamp, *Early Daoist Scriptures*, 286–88.

[32] On this text see also Robinet (1984, vol. 2, 111–18).

[33] See *Baopuzi neipian jiaoshi* 19.337 for an account of a similar method of evasion.

[34] The landscape into which these ritual objects were to be sealed away was resonant with symbolic and ritual significance, the mountains and waters in particular comprising a binary set. As mentioned in the *Huainan zi*, and early Han text: "The mountains are known as accumulators of virtue, while the rivers are known as the accumulators of punishment. The heights are known as places of life, while the depths are known as places of death" (*Huainanzi jishi*, "Dixing pian," 4.337).

[35] The sixth-century compedium *Wushang biyao* (HY 1130) contains a section on the casting of petitionary tablets and slips involving the use of gold dragons, for which see 41.7a–8b and Lagerwey's annotated treatment (1981, 137–8).

[36] Schipper and Verellen (2004: 255). See *Dongxuan lingbao changye zhi fu jiuyou yugui mingzhen ke* (HY 400), 37b–38a; *Taishang dongxuan lingbao zhongjian wen* (HY 410), 1a–7a; and *Taishang lingbao shoudu yi* (HY 528), 50b–52a.

[37] This a text that systematizes the earliest extant Offerings (*jiao*) of transmission for the Lingbao scriptures, and builds upon the more rudimentary ritual instructions given in *Baopuzi neipian jiaoshi* 17.303 and *Taishang lingbao wufu xu* (HY 388), 3.3a–7b. These rites form part of the basis for the early medieval development of Daoist communal Fasts (*zhai*) and Offerings (*jiao*).

[38] Wang (1999, 28).

[39] A Song ritual compendium, the *Wushang huanglu dazhai licheng yi* (HY 508, 1.17a), provides a section on similar document enclosures, called *zhanghan* (petition enclosures). See also fascicles 3–14 of this text for examples of the use of *fanghan* during the Yellow Register Fasts.

[40] For further studies on secrecy in religious traditions, see Kippenberg and Stroumsa (1995) as well as Bolle (1987).

[41] A rich resource for comparative work lies in the scholarship on ritual caskets in the ancient Near East, with the Jewish Ark of Covenant serving as an important specimen. Intriguingly, use of such objects included their functioning as war palladia, divinatory sites, oath-making archives at the feet of the gods, and divine dwelling places with the divine manifestation housed within represented as iconic as well as aniconic stone betyls. See Morgenstern (1928 and 1941), Sarna (1986, 208–9), and Jeffers (1996, 197–229).

Abbreviated Titles

BZQS *Baizi quanshu* (Complete Works of the Hundred Masters). 1998. Hangzhou: Zhejiang guji chuban she.

HY Harvard-Yenjing Index to the Daoist Canon. *Daozang zimu yinde* (Combined Indices to the Authors and Titles of Books in Two Collections of Taoist Literature). [1966] 1988. Edited by Weng Dujian. 1935. Beijing: Yenjing University Library. Reprint, Taipei: Xinwenfeng chuban gongsi.

SSJZS *Shisanjing zhushu* (Commentaries and Sub-commentaries to the Thirteen Classics). [1980] 1996. Edited by Ruan Yuan (1764–1849). Reprint, Beijing: Zhonghua shujü.

IS *Isho shūsei* (Compendium of apocrypha). 1972. 6 vols. Edited by Yasui Kōzan and Nakamura Shōhachi. Tokyo: Meitoku shuppansha.

Works Cited

Baihu tong (Comprehensive Discussions in the White Tiger Hall). By Ban Gu (32–92 CE). See *Baihu tong shuzheng*. 1997. Beijing: Zhonghua shujü.

Baopuzi neipian (Master Who Embraces Simplicity). By Ge Hong (283–343 CE). See *Baopuzi neipian jiaoshi*. 1996. Beijing: Zhonghua shujü.

Berkowitz, Alan J. 2000. *Patterns of Disengagement: The Practice*

and Portrayal of Reclusion in Early Medieval China. Stanford, CA: Stanford University Press.

Bok, Sisela. 1982. Secrets: On the Ethics of Concealment and Revelation. New York: Pantheon Books.

Bokenkamp, Stephen R. 1983. Sources of the Ling-Pao Scriptures. In Tantric and Taoist Studies, ed. Michel Strickmann. Brussels: Institut Belge des Hautes Études Chinoises.

——. 1986. "The Peach Flower Font and the Grotto Passage." Journal of the American Oriental Society 106(1): 65–77.

——. trans. 1996. Record of the Feng and Shan Sacrifices. In Religions of China in Practice, ed. Donald Lopez. Princeton, NJ: Princeton University Press.

——. Early Daoist Scriptures: 268–88, 322–6.

Bolle, Kees, ed. 1987. Secrecy in Religions. Leiden: Brill.

Campany, Robert. 2002. To Live as Long as Heaven and Earth: A Translation of Ge Hong's Traditions of Divine Transcendents. Berkeley, CA: University of California Press.

Cedzich, Ursula-Angelika. 2001. Corpse Deliverance, Substitute Bodies, Name Change, and Feigned Death: Aspects of Metamorphosis and Immortality in Early Medieval China. Journal of Chinese Religions 29: 1–68.

Chavannes, Edouard. 1919. Le jet des dragons (The [Rite of] Tossing the Dragons). Mémoires concernant l'Asie orientale 3: 51–220.

——. Le T'ai Chan: Essay de Monographie d'un Culte Chinois. Paris: Ernest Leroux.

Chen Guofu. 1963. Daozang yuanliu kao (Investigation into the Sources of the Daoist Canon). Beijing: Zhonghua shujü.

Chen Mengjia. 1966. "Dongzhou mengshi yu chutu zaishu" (Covenant Texts of the Eastern Zhou and Excavations of Ritually Buried Documents). Kaogu 5: 271–79.

Chunqiu Gongyang zhuan zhengyi (Rectified Meaning of the Gongyang Commentary to the Spring and Autumn Annals). SSJZS edition.

Chunqiu yundou shu. IS edition.

Chunqiu Zuozhuan zhengyi (Rectified Meaning of the Zuo Commentary to the Spring and Autumn Annals). SSJZS edition.

Deng Shupin. 1992. Tang Song yuce ji qi xiangguan wenti (Jade Tablets of the Tang and Song and Related Issues). Gugong wenwu 106:12–25.

DeWoskin, Kenneth J. 1983. Doctors, Diviners and Magicians of Ancient China: Biographies of Fang-shih. New York: Columbia University Press.

Dobson, William. 1968. Some Legal Instruments of Ancient China: The Ming and the Meng. In Wen-lin: Studies in the Chinese Humanities, ed. C. Tse-tsung. Madison, WI: University of Wisconsin Press: 269–82.

Dongxuan lingbao changye zhifu jiuyui yugui mingzhen ke (Grotto Mystery Codes of the Luminous Perfected in the Jade Coffer of the Nine Shades, Found in the Long Night Bureau). HY 1400.

Dongxuan lingbao wuyue guben zhenxing tu (Ancient Edition of the Charts of the Authentic Forms of the Five Sacred Mountains). HY 441.

Dongzhen shangqing qingyao zishu jingen zhongjing (The Imperial Lord of Qingyao's Collected Shangqing Scriptures of Cavern Perfection on the Golden Root Written in Purple). HY 1304.

Dongzhen taishang zidu yanguang shen yuanbian jing (Scripture on the Divine Primordium Transformations of the Radiance of the Purple Orders). HY 1321.

Dull, Jack. 1966. A Historical Introduction to the Apocryphal (Ch'an-wei) Texts of the Han Dynasty. Seattle, WA: University of Washington.

Durrant, Stephen. W. 1995. The Cloudy Mirror. Tension and Conflict in the Writings of Sima Qian.

Albany, NY: State University of New York Press.

Fengsu tongyi (Comprehensive Meanings of Popular Customs). By Ying Shao (ca. 140–204). *BZQS* edition.

Frazer. 1940. *The Golden Bough: A Study in Magic and Religion*. New York: Macmillan.

Fukunaga Mitsushi. 1954. Hōzensetsu no keisi (I) (Formation of the Treatise on the Feng and Shan Sacrifices). *Tōhō shōkyō* 6: 28–57.

———. 1955. Hōzensetsu no keisi (II). *Tōhō shūkyō* 7: 45–63.

Granet, Marcel. 1959. *Danses et légendes de la Chine ancienne* (Dances and Legends in Ancient China). 1926. Paris, Flix Alcan. Reprint, Paris: Presses Universitaires de France, 1959.

Gu Jiegang. 1934. Hetu yu Luoshu (The *River Chart* and the *Luo Script*). *Gushi bian* 7: 219–33. Shanghai: Shanghai guji chuban she.

———. *Qin Han Fangshi yu rusheng* (Masters of Esoterica and Erudites of the Qin and Han). 1995. Taipei: Liren shujü.

Hanshu (History of the Former Han Dynasty). 1962–75. By Ban Gu (32–92 CE). Beijing: Zhonghua shuju.

Harper, Donald. 1994. Resurrection in Warring States Popular Religion. *Taoist Resources* 5(2): 13–29.

———. 1999. Warring States Natural Philosophy and Occult Thought. *The Cambridge History of Ancient China: From the Origins of Civilization to 221 B.C.* Cambridge: Cambridge University Press.

Hetu. IS edition.

Hetu Luyun fa. IS edition.

Hetu zhenji gou. IS edition.

Hou Hanshu (History of the Latter Han). 1973. By Fan Ye (398–445). Beijing: Zhonghua shuju.

Huainan zi. 1998. By Liu An (ca. 179–122 BCE). See *Huainan zi jishi*. Beijing: Zhonghua shuju.

Hubei sheng bowu guan (Hubei Provincial Museum). 1991. *Wudang Shan* (Mount Wudang). Beijing: Hubei sheng bowu guan.

Hucker, Charles. 1966. *Official Titles in Imperial China*. Stanford, CA: Stanford University.

Inoue Ichii. 1926. Gogaku shinkeizu ni tsuite (Regarding the Charts of the Authentic Forms of the Five Sacred Mountains). In *Naitō Hakase kanreki shukuga shina gakuronsō*. Tokyo, pp. 43–91.

Jeffers, Ann. 1996. *Magic and Divination in Ancient Palestine and Syria*. Leiden: Brill.

Jinshi suo (Research on Bronze and Stone Epigraphy). 1968. By Feng Yunpeng and Feng Yunyuan (Qing dynasty). *Guoxue jiben congshu sibai zhong* edition. Taipei: Shangwu.

Jinshu (History of the Jin Dynasty). 1974. By Fang Xuanling (578–648). Beijing: Zhonghua shuju.

Jiu Tangshu (Old History of the Tang). 1975. By Liu Xu (887–946). Beijing: Zhonghua shuju.

Kaltenmark, Max. 1982. "Quelques remarques sur le *T'ai-chang Ling-pao wou-fu siu*" (Some Remarks on the *Taishang lingbao wufu xu*). *Zinbun* 18: 1–10.

Kamitsuka Yoshiko. 1999. *Rikuchō dōkyō shisō no kenkyū* (Research on Six Dynasties Daoism). Tokyo:, Sōbunsha.

Keightley, David N. 1978a. *Sources of Shang History: The Oracle Bone Inscriptions of Bronze Age China*. Berkeley, CA: University of California Press.

———. 1978b. The Religious Commitment: Shang Theology and the Genesis of Chinese Political Culture. *History of Religions* 17.

———. 1997. Shang Oracle-bone Inscriptions. In *New Sources of Early Chinese History: An Introduction to the Reading of Inscriptions and Manuscripts,* ed. Edward L. Shaughnessy. Berkeley, CA: Society for the Study of Early China; Institute of East Asian Studies, University of California.

Kimura Eiichi. 1943. Hōzen shisō no seiritsu (The Establishment of Ideas Concerning the Feng and

Shan Sacrifices). *Shinagaku* 11(2): 179–217.

Kippenberg, Hans and Guy Stroumsa. 1995. *Secrecy and Concealment: Studies in the History of Mediterranean and Near Eastern Religions*. Leiden: Brill.

Kobayashi Masayoshi. 1990. *Rikuchō dōkyōshi kenkyū* (Research into the History of Six Dynasties Daoism). Tokyo: Sōbunsha.

Kominami Ichirō. 1984. *Chūgoku no shinwa to monogatari: ko shōsetsu no tenkai* (Chinese Myths and Narratives: The Development of Early *xiaoshuo*). Tokyo: Iwanami shoten.

Lagerwey, John. 1981. *Wu-shang pi-yao: somme taoïste du VIe siècle* (The *Wushang biyao:* A Daoist Compendium of the 6th Century). Paris: École Française d'Extrême-Orient.

Laozi jiaoshi (Collated Commentaries to the *Laozi*) 1984. Beijing: Zhonghua shuju.

Legge, James. 1994 (1879). *The Shoo King, or The Book of Historical Documents*. Vol. 3, *The Chinese Classics, with a Translation, Critical and Exegetical Notes, Prolegomena, and Copious Indexes*. Taipei: SMC Publishing.

Lévi-Strauss, C. 1963. *Totemism*. Trans. Rodney Needham. Boston, CT: Beacon Press.

Lewis, Mark Edward. 1990. *Sanctioned Violence in Early China*. Albany, NY: State University of New York Press.

——. 1999a. *Writing and Authority in Early China*. Albany, NY: State University of New York Press.

——. 1999b. The *feng* and *shan* Sacrifices of Emperor Wu of the Han. In *State and Court Ritual in China*, ed. Joseph P. McDermott. Cambridge: Cambridge University Press, pp. 50–80.

Li Fengmao. 1996. Liuchao daojiao dongtian shuo yu youli xianjing xiaoshuo (Six Dynasties Daoist *xiaoshuo* Regarding the Grotto-heavens and Blessed Lands and the Traversal of Lands of the Immortals). *Xiaoshuo xiqu yanjiu* 1: 3–52.

Liji zhengyi (Rectified Meaning of the Book of Rites). SSJZS edition.

Longrui guan yuxue yangming dongtian tujing (Chart and Scripture on the Longrui Temple, Site of the Cavern of Yu and the Yangming Grotto-Heaven). Compiled by Li Zong'e (Song Dynasty). HY 604.

Longyu Hetu. IS edition.

Luoshu luyun qi. IS edition.

Mengzi zhushu (Commentaries and Sub-commentaries to the *Mencius*). SSJZS edition.

Miura Kunio. 1983. Dōten fukuchi shōkō (A Small Study of Grotto-heavens and Blessed realms). *Tōhō shūkyō* 51: 2–11.

Moore, Wilbert and Melvin Tumin. 1949. Some Social Functions of Ignorance. *American Sociological Review* 14: 785–95.

Morgenstern, Julian. 1928. The Book of the Covenant (1). *Hebrew Union College Annual* 5: 1–151.

——. 1954 [1941]. *The Ark, the Ephod and the Tent of Meeting*. Cincinnati, OH: Hebrew Union College Press.

Munakata, Kiyohiko. 1991. *Sacred Mountains in Chinese Art*. Urbana-Champaign, IL: Krannert Art Museum; University of Illinois Press.

Na Zhiliang. 1992. Tang Xuanzong, Song Zhenzong de shan diqi yuce (Jade Tablets Used in the *shan* Sacrifices to Earth Spirits of Tang Xuanzong and Song Zhenzong). *Gugong wenwu* 106: 6–11.

Ngo, Van Xuyet. 1976. *Divination, magic et politique dans la Chine ancienne*. Paris: Presses universitaires de France.

Nivison, David. 1996. *The Ways of Confucianism: Investigations in Chinese Philosophy*. Chicago and LaSalle, IL: Open Court.

Nyitray, Vivian-Lee. 2003. Teaching About Material Culture in Religious Studies. *Spotlight on Teaching* 18(3): ii, xi.

Robinet, Isabelle. 1984. *La révélation du Shangqing dans l'histoire du taoïsme*. 2 vols. Paris, École Française d'Extrême-Orient.

———. 1993. *Taoist Meditation: The Mao-Shan Tradition of Great Purity.* Albany, NY: State University of New York Press.

Sanguo zhi (Treatise on the Three Kingdoms). 1971. Comp. Chen Shou (233–97). Beijing: Zhonghua shuju.

Sarna, N. 1986. *Exploring Exodus.* New York: Schacken Books.

Saso, M. 1978. What is the Ho-t'u? *History of Religions* 17(3, 4): 399–416.

Schipper, Kristofer. 1965. *L'Empereur Wou des Han dans la légende Taoiste: Han Wou-ti nei-tchouan* (Emperor Wu of the Han in Taoist Legend: The Inner Biography of Emperor Wu of the Han). Paris: École Française d'Extrême-Orient.

———. 1967. Gogaku-shingyōzu no shinkō (Religious Beliefs Relating to the Charts of the Authentic Forms of the Five Marchmounts). *Études taoïstes* (Tokyo) 2: 114–162.

———. 1974. The Written Memorial in Taoist Ceremonies. In *Religion and Ritual in Chinese Society.* Ed. Arthur Wolf. Stanford, CA: Stanford University Press, pp. 309–24.

———. 1993. *The Taoist Body.* Berkeley, CA: University of California Press.

——— and Franciscus Verellen. 2004. *The Taoist Canon: A Historical Companion to the Daozang.* 3 vols. Chicago, IL: University of Chicago Press.

Seidel, Anna. 1983. Imperial Treasures and Taoist Sacraments: Taoist Roots in the Apocrypha. *Tantric and Taoist Studies*, ed. Michel Strickmann. Brussels: Institute Belge des hautes études chinoises. II, pp. 291–371.

———. 1984. "Taoist Messianism." *Numen* XXXI: 2.

———. 1987. Traces of Han Religion in Funeral Texts Found in Tombs. In *Dōkyō to Shūkyō bunka*, ed. Akizuki Kan'ei. Tokyo: Hirakawa shuppansha.

Shangqing housheng daojun lieji (Shangqing Biography of the Lord of the Dao of the Latter Generation). HY 442.

Shangshu jingu wen zhushu (Commentaries and Sub-commentaries to the Old and New Text *Shangshu*). 1998. Beijing: Zhonghua shuju.

Shangshu zhengyi or *Shujing* (Book of Documents). SSJZS edition.

Shangshu zhonghou. IS edition.

Shaughnessy, Edward L. *Shang shu* (Shu ching). *Early Chinese Texts: A Bibliographic Guide*, ed. Michael Loewe. Society for the Study of Early China; Institute of East Asian Studies, University of California, Berkeley.

———. 1997. *Before Confucius: Studies in the Creation of the Chinese Classics.* Albany, NY: State University of New York Press.

Shiji (Records of the Historian). 1982. By Sima Tan (c. 180–110 BCE) and Sima Qian (145–86 BCE). Beijing: Zhonghua shuju.

Shiyi ji (Gleaning of Remnant Accounts). By Xiao Qi (sixth c. CE). BZQS edition.

Shizi. By Shi Jiao (c. 390–c. 330 BCE) BZQS edition.

Simmel, Georg. 1950. The Secret and the Secret Society. *The Sociology of Georg Simmel.* New York: Free Press, pp. 307–76.

Smith, Jonathan Z. 1982. *Imagining Religion*. Chicago: University of Chicago Press.

Songshi (History of the Song Dynasty). 1997. By Tuotuo (Toghto) (1313–1355). Beijing: Zhonghua shuju.

Stein, Rolf. 1990. *The World in Miniature: Container Gardens and Dwellings in Far Eastern Religions*. Stanford, CA: Stanford University Press.

Strickmann, Michel. 2002. *Chinese Magical Medicine*. Stanford, CA: Stanford University Press.

Taiping yulan (Imperial Encyclopedia of the Taiping Era). 1963. Compiled by Li Fang (925–996). Beijing: Zhonghua shujü.

Taiqing jinye shenqi jing (Taiqing Scripture on the Golden Elixir and Numinous Cinnabar). HY 881.

Taishang dongxuan lingbao chishu yujue miaojing (Wondrous Scripture of Jade Instructions to the Scripts Written in Red). HY 352.

Taishang dongxuan lingbao shoudu yi (Lingbao Transmission Rites). HY 528.

Taishang dongxuan lingbao zhongjian wen (Tablets of the Numinous Treasure). HY 410.

Taishang jiuchi banfu wudi neizhen jing (Scripture of the Nine Mottled Tallies in Red and the Inner Perfection of the Five Emperors). HY 1318.

Taishang lingbao wufu xu (Preface to the Five Tallies of Lingbao). HY 388.

Tjan, Tjoe Som. 1949. *Po Hu T'ung: The Comprehensive Discussions in the White Tiger Hall*. 2 vols. Leiden: Brill.

Tsai, Julius. 2004. In the Steps of Emperors and Immortals: Ritual Tours to the Mountains in Early Daoism. PhD dissertation, Stanford University.

Verellen, Franciscus. 1995. The Beyond Within: Grotto-Heavens (Dongtian) in Taoist Ritual and Cosmology. *Cahiers d'Extrême-Asie* 8: 265–90.

Vervoorn, Aat. 1995. *Men of the Cliffs and Caves: The Development of the Chinese Eremitic Tradition to the End of the Han Dynasty*. Hong Kong: Chinese University Press.

Wang Guangde, ed. 1999. *Xianshan Wudang* (Wudang, Mountain of the Transcendents). Beijing: Zongjiao wenhua chuban she.

Ware, James. 1985 [1966]. *Alchemy, Medicine and Religion in the China of A.D. 320: The Nei P'ien of Ko Hung (Pao-p'u tzu)*. New York: Dover Publications.

Wechsler, Howard. 1985. *Offerings of Jade and Silk*. New Haven, CT: Yale University Press.

Weld, Susan. 1990. The Covenant Texts from Houma and Wenxian. *New Sources of Early Chinese History: An Introduction to the Reading of Inscriptions and Manuscripts*, ed. Edward L. Shaughnessy. Berkeley, CA: Society for the Study of Early China; Institute of East Asian Studies, pp. 125–60.

Wittgenstein, Ludwig. 1958. *Philosophical Investigations*. Third Edition. Translated by G.E.M. Anscombe. New York: Macmillan Publishing.

Wushang biyao (Supreme Secret Essentials). HY 1130.

Wushang huanglu dazhai licheng yi (Supreme Rites for the Establishment of the Yellow Register Fast). HY 508.

Xiaojing gouming jue. IS edition.

Yamada Toshiaki. 1989. Longevity Techniques and the Compilation of the *Lingbao wufuxu*. *Taoist Meditation and Longevity Techniques*, ed. Livia Kohn and Sakade Yoshinobu. Ann Arbor, IL: Center for Chinese Studies.

Yili zhushu (Commentary and Subcommentary to the *Protocols and Rites*), SSJZS edition.

Yishi (Arrayed History). 1969. By Ma Su (1621–1673). *Biji congbian* edition. Taipei: Guangwen shujü.

Yuan Ke and Zhou Ming. 1985. *Zhongguo gudai shenhua ziliao cuibian* (Collected Fragments from Ancient Chinese Myths). Chengdu: Sichuan sheng shehui kexue yuan chuban she.

Yunji qiqian (Seven Slips from a Cloud-Satchel). Compiled by Zhang Junfang (11th century). HY 1026.

Zeng Chunhai. 1983. Zhuzi Yixue tanwei (Investigation into Zhu Xi's studies in the *Yijing*). Taipei: Furen daxue chuban she.

Zhouli zhushu. SSZJS edition.

Zhushu jinian (Bamboo Annals). CC edition.

the formation of early buddhist visual culture
klemens karlsson

jönköping university and stockholm university

The absence of anthropomorphic images of the Buddha in early Buddhist visual culture can be characterized as a *de facto* aniconism. It was not due to any prohibition, or to religious or philosophical doctrine; nor was it a reaction against iconic worshiping. Instead, the absence of images of the Buddha was due to the fact that early Buddhist visual symbols belonged to a shared sacred Indian culture. In this sacred culture, one tended to depict auspicious symbols, mythological creatures and local deities. The Buddhists used auspicious symbols to protect themselves, but also to popularize and strengthen the Buddhist movement. The Buddhist movement was in need of local support. Eventually, this early Buddhist visual culture was transformed into a conscious Buddhist visual culture with distinct Buddhist visual symbols.

Buddhist visual symbols are not timeless works of art but, rather, part of a social and cultural context. As successive generations interpret these visual symbols over time, the meaning may change. However, auspicious symbols, such as wheels, trees and lotus-flowers, often depicted in early Buddhist sacred sites, were interpreted by later generations as distinctly Buddhist visual signs. This development is difficult to grasp, because a great number of different people were involved in the manufacture and use of early Buddhist visual culture.

This paper stresses different categories of people and the roles they played in the creation of Buddhist visual culture. The creation of Buddhist visual culture was an intricate social drama involving large numbers of people. The "iconographic authority" was an expert team consisting of monastic monks or nuns, donors and artisans. This paper also stresses that early visual culture gave shape to the life story of the Buddha and was important for the origin of the first Buddha images.

Klemens Karlsson (Ph.D., Uppsala University, Sweden) completed his doctoral dissertation on early Buddhist visual art in 2000. He is currently teaching Religious Studies at Jönköping University and teaching the History of Art in India and Southeast Asia at Stockholm University. He is also librarian at Jönköping University.

Prologue

When Westerners visited early Buddhist sites such as Sāñcī, Bodhgāya and Amarāvatī in the nineteenth century they were astonished not to find any images of the Buddha. The stone railings (*vedikā*) that enclosed Buddhist *stūpas* were crowded with signs and symbols, such as wheels, sacred trees, lotus flowers, animals and mythological creatures, but the Buddha was nowhere to be seen. In the mid-nineteenth century, however, James Fergusson and Alexander Cunningham suggested that some of these signs/symbols might actually represent the Buddha. Fergusson suggested that "if the first person of the Trial [the Buddha] was represented on the monuments at all, it must have been by some emblems" (Fergusson 1971, 106). However, it was Alfred Foucher who later expressed the theory of aniconism in Buddhist art in plain terms, saying that the ancient stone-carvers were "representing the life of Buddha without Buddha" (Foucher 1917, 4).

It might still seem mysterious that anthropomorphic images of the Buddha cannot be found in early Buddhist cultic sites. In the early 1990s, an animated debate about this so-called Buddhist aniconic art took place (Dehejia 1991; Huntington 1990; 1992). This debate clearly unmasks the difficulties in interpreting early Buddhist visual signs. It shows that it is possible to interpret reliefs from early Buddhist visual culture in several different ways. It also shows that it is difficult to know exactly which interpretation is the final one. There is no such thing as a fixed, predetermined or unified meaning in individual visual objects. Meaning is always context-dependent and it resides in the minds of artists, sponsors, beholders, etc.—and the beholder's view may not always correspond to the artist's intention.[1] There can also be multiple meanings in one and the same artifact. According to Vidya Dehejia, artists working at early Buddhist sites frequently seem to have intended a conflation of meanings. She maintains that most early Buddhist visual narratives display layers of meaning and that this conflation of meanings was intentional (Dehejia 1991, 45).

However, this debate was mainly about how to interpret separate artifacts. Was a throne only a throne, or was it intended to be read as a representation of the Buddha? Susan Huntington is of the opinion that the so-called aniconic signs portray worship and adoration at sacred sites, not events in the live of the Buddha (Huntington 1990; 1992). In response to this, Vidya Dehejia advocates that these signs may be interpreted in three distinct and equally valid ways. According to her, they can be read as aniconic presentations of the Buddha, but they may also represent worship at sacred sites or attributes to the Buddhist faith (Deheija 1991). It is not the aim of this paper to continue the discussion concerning specific pictures and identification of motifs. Instead, it will tackle the problem from another angle. My aim is to uncover the origin and purpose behind early Buddhist visual culture and grasp its historical development. A futher aim is to illuminate the complex connection between visual signs and written or orally told stories.

Buddhist visual culture should be treated as part of a social and historical context. It must be seen as closely connected to the structure and development of the Buddhist movement. At the same time, however, it is important to understand that visual religion is a significant part of any religious tradition and not just a phenomenon secondary to a literal tradition. Buddhist visual culture does not merely illustrate sacred texts, legends and doctrines. It is a preconceived Protestant-Christian notion to believe that written words are always the fundamental nature of a religion. Texts are indeed important in interpreting religious notions, but Buddhist scholars have preferred texts, and nothing but texts, for the understanding of Buddhism. Today's Buddhist scholars have used texts to acquire knowledge that the majority of the Buddhists living in ancient India never had. If we are at least a little interested in actual Buddhist everyday religious life, we cannot trust written sources only. Visual culture is an important part of Buddhist religion and must be treated as part of the social, historical and geographical context of both its manufacture and use.

Previous studies on so-called Buddhist aniconic art tend to disregard the passage of time. Different signs have been discussed and compared without taking into account differing historical conditions. A common way to discuss this so-called aniconic art is just to mention that the Buddha is represented as "an empty space, made meaningful by the use of symbols" (Snellgrove 1978, 23) and with no reference to historical development. Figures 7 and 8 in the otherwise excellent handbook *The Image of the Buddha* (Snellgrove 1978, 29–30) are interpreted in a similar way without taking into consideration that Figure 7 is from Amarāvatī (second century CE) and Figure 8 is from Bhārhut (early first or late second century BCE). This is still present in scholarly writings today. It is true that Susan Huntington emphasized "place and time" as key issues in her interpretation. However, time is for her the only thing that the reliefs are meant to depict. She considers specific reliefs and if they represent the time of the Buddha or an unspecific time thereafter? The historical development of the reliefs under discussion seems to be of secondary importance for her. She discusses an Amarāvatī relief from the third century CE together with reliefs from Sāñcī and Bhārhut (Huntington 1990). The same can be said about Deheija. She also lacks a real historical interest. In her keenness to show that there really are aniconic presentations of the Buddha, she uses reliefs from Bhārhut, Sāñcī, Gandhāra and Amarāvatī (Deheija 1991, 53–5) without establishing a chronological order. This pre-anthropomorphic Buddhist visual culture is nearly always regarded as a homogeneous period without any progress.

However, the fact that much of early Buddhist visual culture is lost forever makes it difficult to understand the way visual culture changed during the first centuries of Buddhist history. Despite the fragmentary state of archaeological evidence, I believe it is possible to establish at least a preliminary chronology of early Buddhist visual signs. Such

a chronology, even if it is preliminary, would provide an opportunity to understand better the origins and purpose of early Buddhist visual culture. I have elsewhere (Karlsson 1999, 86–145) made a detailed attempt to establish such a chronology. In this paper I will only point to and discuss a couple of interesting details in this chronology in purpose to illustrate the development and formation of Buddhist visual culture.

De Facto Aniconism

There have been several explanations why the Buddha is absent in early Buddhism. One explanation is that it was prohibited to make images of the Buddha. The prohibition argument was, and still is, supported by scholars. Prudence R. Meyer, for example, argues that "the Enlightened One himself is of course not seen, in accordance with the convention of the period which forbade the representation of his corporeal presence" (Meyer 1958, 282). Others assume that a doctrine prevented early Buddhists from depicting him. Peter Harvey assumes that "the profound nature of a Buddha could not be adequately conveyed by a mere human form" (Harvey 1990, 68). This is a common conception to this day. Charles Allen writes about "the earliest phase of Buddhist iconography, when it was still considered disrespectful and contrary indeed to Gautama Buddha's wishes, to show any likeness of him" (Allen 2002, 127).

Scholars have scrutinized Buddhist texts, looking for a prohibition statement or a doctrine declaring it inappropriate to depict the Buddha in human form. So far, no one has presented any conclusive evidence to support the prohibition argument. The main indication is an indirect reference found in the monastic rules of the *Sarvāstivādins*. Instead of interpreting this text as a prohibition statement, however, it should be read as sanctioning an already established tradition of making images of the Buddha.[2] The specific cultural traditions of Western scholars are likely to be the reason behind such an assumption. The scholars who proposed the prohibition argument may have been overly influenced by the history of iconoclasm in the Near East and Europe. Furthermore, scholars may have compared early Buddhist art with early Christian paintings that, from the beginning, had a specific Christian purpose. Even if a prohibition statement were to be found in Buddhist texts in the future, it might still only be an example of a rationalization and point to the fact that there were already images of the Buddha at the time when those texts were written.

To examine these explanations further, we may compare early Buddhist visual culture with the programmatic aniconism promulgated in ancient Israel. Today, there is a clear prohibition against creating images of the God in both Judaism and Islam. What is the reason behind such prohibition? Tryggve Mettinger pointed out that an important cause for a prohibition against icons in ancient Israel was the surrounding cultures in the ancient Near East (Mettinger 1995; 1997). In particular the cultures of Babylonia and Egypt

were noted for their iconic worship. Mettinger points out that iconic worship among the surrounding cultures must have contributed to a sharpening of the Israelites' awareness of the distinctiveness of their own cult.

No similar circumstances were present in early Buddhist culture. The culture in ancient India was not marked by iconic worship. The basis for the Vedic tradition was ritual sacrifice performed by a priest. Visual anthropomorphic representations of gods did not constitute an important part of the cultic practice in India at that time. Images were certainly present but the cult was generally not directed towards images. Mettinger makes a distinction between the programmatic demand for a cult without images, programmatic aniconism and a mere, unreflective absence of images, *de facto* aniconism (Mettinger 1997, 174–75, 199). This terminology may be applied when characterizing early Buddhist visual culture. It is tenuous to assume the existence of a programmatic aniconism in early Buddhism. Instead, the absence of anthropomorphic images of the Buddha in early Buddhist visual culture may be characterized as *de facto* aniconism. This absence was not due to prohibition, or to religious or philosophical doctrine. Nor was it a reaction against iconic worshiping. Instead, "it was just not the custom to make images of the Buddha," as Albert Foucher suggested in the early twentieth century (Foucher 1917, 7).

The Chronology of Early Buddhist Visual Culture

The oldest remains of a visual culture in Buddhist sites are from the third century BCE.[3] The remains consist of both Aśokan monumental columns and *stūpas*. There is, however, not much that remains of the *stūpas* from Mauryan times, and the monumental columns made at the time of Aśoka are, if not really "foreign," then an official and dynastic sponsored art with distinct foreign influences. The oldest remains under discussion are from the second century BCE, with the exception of an early crossbar from Amarāvatī, dated as far back as the third century BCE.

FIG 1
Nāga and lotus flowers. Stūpa 2, Sāñcī

The earliest surviving visual signs in Buddhist cultic sites depict lotus flowers, wheels, trees, tridents, animals and mythological creatures (Figure 1). These auspicious signs were most probably also depicted earlier on perishable materials. Small pieces in wood and the design of the railings are indications that there would have been older railings made from wood. This *de facto* aniconism was replaced by anthropomorphic images around the beginning of the first century CE.[4] There is a line of development from these early signs to narrative compositions representing the Buddha in symbolic form. This development can be exemplified with Sāñcī.[5] If we compare early decorations on the smaller Stūpa 2 (Figures 1–3) with later artistic creativity from the Great Stūpa (Stūpa 1) (Figures 4–6), it is easy to recognize this development. Stūpa 2 is a small *stūpa*, measuring only about 14 m in diameter and 8 m to the top of the dome. It is surrounded by a richly decorated stone railing (*vedikā*), 2.30 m high with four entrances. The carvings of Stūpa 2 look very archaic and have a stiff and angular style. The railing has been

FIG 2
Sacred tree. Stūpa 2, Sāñcī

FIG 3
Pillar with elephants and wheel. Stūpa 2, Sāñcī

dated to somewhere between 150 and 100 BCE. Later on in this article, I will argue that it must be closer to 150 than 100 BCE. The railing uprights are all decorated with lotus flowers, animals, mythological creatures, plants, humans and other similar signs. At the north gate, there is a sign of a sacred tree enclosed within a railing (Figure 2) and another upright at the same entrance depicts a pillar with elephants and a wheel at the top (Figure 3). These two signs, the sacred tree and the wheel, have been interpreted as representing two of the four major events in the life of the Buddha. Later on in this paper, I will reconsider this supposed connection.

The famous Great Stūpa at Sāñcī (Figure 4) is 36 m in diameter and 16 m in height. It encases a smaller *stūpa*, dating back to the time of Aśoka, which was rebuilt in the middle of the second century BCE. The railing at ground level was made at that time, but it does not have any carvings, only inscriptions of names of donors. At some point in the late first century BCE or early first century CE, four gateways (*toraṇa*)

FIG 4
Stūpa 1, Sāñcī

FIG 5
The Buddha leaving the palace. Stūpa 1, Sāñcī, east gateway

FIG 6
A monkey offering honey to the Buddha. Stūpa 1, Sāñcī

were added to the entrances.[6] These gateways display a rich and clearly Buddhist visual art. A period of 50–150 years elapsed between the signs being made on Stupa 2 and those at the gateways on Stūpa 1. Unlike Stūpa 2, the Great Stūpa at Sāñcī does show traces of an elaborate and distinctly Buddhist visual culture. In addition to all the lotus flowers, tridents, wheels, trees, *stūpas* and mythological creatures, five *jātaka* tales (stories about the Buddha's previous life) are depicted. Most conspicuously, however, there are several signs obviously pointing to events in the life of the Buddha. Figure 5 depicts the young Buddha leaving his palace. And it would be difficult to interpret Figure 6 as representing anything but the gift of honey at Vaiśali, the event during which a monkey offered honey to the Buddha. In several signs at the Great Stūpa, we can see a throne or an altar (*āsana*) and sometimes a pair of footprints (*pādas*). These signs are very different from those at Stūpa 2.

FIG 7
Sacred tree and *stūpa* on crossbar. Amarāvatī

The differences between early general signs and later, more elaborate signs representing the Buddha can also be seen further south in Andhradeśa. The Great Stūpa at Amarāvatī is the most famous Buddhist site in the modern Indian state of Andhra Pradesh. It has been established that Buddhism was introduced in the area as early as during the reign of Aśoka. Believed to date back to around the third century BCE because of the style of its Brāhmī inscription (Knox 1992, 32), a carved limestone crossbar (Figure 7) found at Amarāvatī, may belong to a *stūpa* made during the reign of Aśoka or slightly later. The crossbar depicts a *stūpa* and a sacred tree, both enclosed within a plain railing. Furthermore, a couple of signs depicting sacred trees, *stūpas* and wheels have been found on an old granite railing at Amarāvatī (Knox 1992, Figure 109). The signs are in very low relief and the style is stiff and angular. This railing originates in the second or first century BCE. Several centuries later, the Great Stūpa at Amarāvatī had developed into a place of rich artistic expression. The railing and the dome were covered with distinctly Buddhist signs representing the Buddha without depicting him in a human shape (Figure 8). It is interesting to note that this classical time in Amarāvatī, first to third century CE, was at a time when the Buddha was already represented in anthropomorphic form in both Mathurā and Gandhāra.

Thus, in both Sāñcī and Amarāvatī, there was a development from early simple signs belonging to a shared sacred Indian culture to an elaborate and distinctly Buddhist visual culture with aniconic signs pointing to the life of the

FIG 8
Empty throne with footprints in front of sacred tree. The Great Stūpa, Amarāvatī

Buddha. The same development can be found elsewhere but, since most artifacts have been lost at sites such as Bodhgayā, Sārnāth and elsewhere, this development is more difficult to establish in these places.

One special problem in establishing this development is the dating of the Bhārhut Stūpa. Michael Willis has made an attempt to compile a chronology of early Indian sculpture on stylistic grounds (Willis et al. 2000). His starting point is the "Bhārhut style." He suggests that this style, with "perpendicular cuts which emphasize flat and cubic shapes," marks the beginning of a continuous tradition of stone sculpture (Willis et al. 2000, 55). He concedes that the dating of the Bhārhut Stūpa is problematic, but holds on to the traditional dating of 150 BCE without further arguments.[7] On the basis of stylistic comparison, he proposes that the most important parallel to Bhārhut can be found on the railing of Stūpa 2 at Sāñcī. This seems quite tenuous to me. A stylistic comparison of signs on the Bhārhut Stūpa and Stūpa 2 at Sāñcī discloses a distinct divergence. The Bhārhut style is much more elaborate than the stiff and angular style of Stūpa 2 at Sāñcī. Some *yakṣas* and *yakṣiṇīs* at Bhārhut are almost made in the round (Figure 9). Quintanilla, in an otherwise

FIG 9
Yakṣiṇī Bhārhut Stūpa

excellent examination of the development of early Mathurā artifacts, considers the complicated dating of Bhārhut in a similar way. She states that it cannot be dated with precision and accepts the traditional dating to 150 BCE (Quintanilla 1999, 5). Rowland, in line with my argumentation, believes that the Bhārhut sculpture cannot be earlier than 100 BCE and that it represents a distinct improvement over the primitive carvings of Stūpa 2 at Sāñcī (Rowland 1967, 88). A similar view has been pointed out by Taddei. He believes that the *stūpa* of Bhārhut, finds its place between the two Sāñcī *stūpas* (Taddei 1996, 90).

If the motifs of the two *stūpas* are compared, the differences are even more striking. As mentioned above, Stūpa 2 at Sāñcī does not include any exclusively Buddhist subjects. Instead, the railing is decorated with lotus flowers, animals, mythological creatures, plants, human beings and other similar signs. In contrast, the Bhārhut Stūpa has many signs with distinct Buddhist features. At least forty-four *jātaka*

FIG 10
Deer *jātaka*. Bhārhut Stūpa

tales (Figure 10) can be clearly identified on the railing. There are also explanatory inscriptions on the Bhārhut *stūpa* which identifies the *jātakas*. As Bénisti (1986, 168) has suggested, the reason behind this may be that it was a new custom to depict distinct Buddhist themes. Therefore, there is every reason to place Bhārhut at a time between Stūpa 2 and the Great Stūpa at Sāñcī.

Having thus examined the physical settings of early Buddhist visual culture and its historical development, we may conclude that early Buddhist visual signs were part of a general sacred Indian culture. As time passed, this early visual culture was re-interpreted and transformed into a conscious Buddhist visual culture with distinct Buddhist visual signs.

Auspicious Signs, Local Deities and Mythological Creatures

A first step to understanding the reasons behind this transformation would be to look more closely at the underlying symbolism in a couple of frequently occurring signs. Trees, wheels, lotus flowers, fly whisks, flags, umbrellas, lamps, conches, tridents (*śrīvatsa*), the vase of plenty (*pūrṇaghata*) and swastikas are all sacred signs called *maṅgalas*. They are all considered auspicious and capable of bringing about happiness, prosperity and giving protection.[8] They are often seen on footprints of the Buddha (Figure 11). Altogether, the number of auspicious signs is more than forty, but *maṅgalas* are often referred to as the eight auspicious signs (*aṣṭamaṅgala*) due to the fact that they often occur in a group of eight. The *aṣṭamaṅgala* is a confluence of two symbolic systems; the symbolism of the number eight and individual signs with magical properties. The number eight was regarded as an especially auspicious and mystic number. According to Alex Wayman (1989, 236–7), it was connected with female symbolism and particularly with Śrī Lakṣmī. Originally, these *maṅgalas* may have been used for their individual magic properties, and not just as a group of eight. These auspicious signs have played a significant part in Buddhist visual culture.

FIG 11
Footprints of the Buddha with *maṅgalas*. Amarāvatī

In addition to these auspicious signs, a great number of local deities and different mythological creatures are depicted on the *stūpa* railings. There are *yakṣas*, *yakṣiṇīs*, *nāgas*, *makaras* and many others. *Yakṣas* and *yakṣiṇīs* are associated with fertility and prosperity. They are also important as guardians and gatekeepers and can often be found at *stūpa* gateways. *Yakṣiṇīs* are female vegetation deities, closely related to the tree-goddess (*vṛkṣadevatā*). These deities are often depicted as nude, voluptuous women adorned with necklaces, anklets and bracelets (Figure 9). *Makaras* are often represented as a creature with a crocodile head and a long tail ending like that of a fish. Creatures with the heads of elephants, horses and lions, and with fish-like tails are common motifs at Buddhist *stūpas*. All these creatures are closely connected with water and fertility. Mythological creatures are also mentioned in Buddhist texts. In particular *yakṣas* are often included in Buddhist stories and there are a number of places used for spirit worship (*yakṣacaitya*) referred to in Buddhist literature.

Mythological creatures and local deities depicted on the Buddhist *stūpas* raise several questions. Why were *stūpas* ornamented in this way? Did Buddhist monks and nuns deliberately encourage the use of these symbols? Early scholars have had a tendency to regard mythological creatures and local deities as something not belonging to a "true" Buddhism. Today, we know from several studies that a world-view with mythological creatures is involved in early

Buddhism. Robert DeCaroli (2005) has clearly demonstrated, not only from visual evidence but also from a great many early Buddhist texts, the close relationship between spirit deities and members of the monastic community. He points out that local people approach the Buddhist community when "they need help in dealing with a supernatural problem" (DeCoroli 2005, 38). DeCoroli highlights examples from the Buddhist literature how the Buddha is believed to tame and subdue malevolent *yakṣas*. However, it was not just the Buddha who had this power. Monks and nuns are also described as converting spirit deities in order to transform them into devotees and protectors of the Buddhist faith. Therefore, the local population recognized Buddhist monks and nuns as experts in dealing with mythological creatures. Rupert Gethin claims that the Buddhist movement was in need of local support: "The success of early Buddhism [...] assumes both a desire on the part of certain members of the population to give up 'normal society' or 'the household life', and sufficient good will on the part of those remaining in normal society to allow them to do so" (Gethin 1998, 85). Since the Buddhist movement was dependent upon the generosity of local people for the provision of food, clothing and dwellings, it was important for those who had given up the household life to popularize the Buddhist movement.

One of the reasons why Buddhists adopted auspicious signs must have been that these signs were meaningful, important and familiar to the majority of people in India at that time. The use of auspicious signs (*maṅgalas*), mythological creatures and local deities must have been a way to popularize and strengthen the Buddhist movement, but also a way for the Buddhists to protect themselves. Auspicious signs, *yakṣas*, *yakṣiṇīs* and other mythological creatures were an integral part of a vast Indian mythical world-view, held not just by the locals, but also by Buddhist monks and nuns themselves. Thus, the Buddhist movement tends to make use of auspicious signs, mythological creatures and local deities in order to place itself within the local population. In this way, Buddhist sites became established as sacred space for Buddhist monks, nuns and laypeople, as well as for non-Buddhist locals.

Monks, Nuns and Guilds of Artisans
Early Buddhist visual culture was linked with the people living in close connection to sacred sites. "All images are local" (Kinnard 1999, 22) and cannot be interpreted in the context of Buddhist texts alone. In a study of the Ajaṇṭā caves, Richard S. Cohen demonstrates the way Buddhists established their local legitimacy within a local *nāga* cult in the fifth century. He points out that locality is a powerful factor in analytic reconstruction of Buddhism (Cohen 1998, 361), stating that "[i]f the term 'Buddhism' is to be meaningful, it must be connected to people, to Buddhists, who lived their lives as Buddhists in places" (Cohen 1998, 362).

People living in close connection to early Buddhist sites were part of a social drama. However, we can only guess

at the details in this far-away drama. Taking a quick look at the intricate drama that takes place around the manufacture and use of early Buddhist visual culture, we will discuss the production of visual signs with respect to different categories of people who lived in the vicinity of sacred sites or who were engaged in the production of the sites. This will hopefully give some clues regarding who was responsible for the origin and development of Buddhist visual culture.

Several categories of people contributed to the construction of Buddhist sacred sites and their visual culture. Buddhist monks (*bhikṣu*), nuns (*bhikṣuṇī*) and laypeople (*upāsaka* and *upāsikā*) were, of course, important. In addition, donors, artists and artisans contributed to the origin and production of early Buddhist visual culture in different ways. There is also every reason to believe that even non-Buddhist locals played an important, albeit indirect, part in Buddhist visual culture.

Buddhist monuments must have been present in some form in most parts of the region that was the Mauryan state. By around 200 BCE, this state was succeeded by a number of regional powers—the Kharavela, the Śuṅgas, the Satavahanas, the Kshatrapas and the Indo-Greeks. Most monuments, if not all, can be found in the direct vicinity of trade routes and cities. Sāñcī, for example, was not far from Vidiśā, the western capital of the Śuṅgas. Vidiśā was an important location on the trade route linking northern India, Deccan and western India. Apart from Sāñcī, there were several Buddhist settlements, Sonari, Satdhara, Bhojpur and Andher, within a radius of 20 km from Vidiśā. This implies that the Buddhist movement was closely connected with the urban population, and not with the majority of the rural population. Buddhist communities often chose to settle on sites already functioning as sacred sites. Gregory Schopen (1996) has shown that many Buddhist monastic sites in India were built very near or even in the midst of megalithic cemeteries.

It has been common among early scholars to make a clear-cut distinction between monks and laypeople. They took for granted that monks lived outside society and laypeople inside. Today, we cannot presuppose that monks and nuns were only concerned with the final liberation and that any worldly concerns were the laypeople's alone. Instead of a two-tiered model, Reginald Ray and others have proposed a three-tiered structure. Ray (1994, 434–5) contrasts the settled monastic lifestyle with the solitary life in the forest and proposes three categories of Buddhists: forest monks, settled monastic monks and laypeople. One should also consider the words of Gregory Schopen (2004, 27) who, in the *Mūlasarvāstivāda-vinaya*,[9] found that monks were engaged in "…money transactions, sophisticated financial enterprises, the promotion of "art" and extensive fund-raising projects." He even denies that there were some monks who had cut all ties with the world. "If this monk [forest monk] ever existed, by the time of our Code he would certainly have been an exception, and by no means a popular one" (Schopen 2004, 26).

Those monks and nuns who lived close to sacred sites most likely had a very close relation to the visual culture nearby. But did these monks and nuns really care about the artistic decorations? We know from inscriptions that many monks and nuns made donations to the construction of *stūpas*. Nevertheless, it is one thing to be part of the construction of a *stūpa* and quite another to engage actively in its sculptural program. However, in the *Mūlasarvāstivāda-vinaya* there are several references to paintings and the importance of esthetically beautiful monasteries. It is obvious that the paintings were made to attract people with the purpose of generating large donations (Schopen 2004, 31–7) and we can make the conclusion that monks and nuns really were engaged in the decoration of sacred sites at that time. It is also clear from inscriptions at Sārnāth, Gandhāra, Ajaṇṭā, Mathurā and elsewere that the use of Buddhist cult images in the Kuṣān period was almost entirely a monastically initiated and supported cult (Schopen 1988/89, 240–2). Even if there is no conclusive evidence from the early time we are dealing with (second to first century BCE), it is tempting to presuppose that monks and nuns played a similar role to their later followers.

Inscriptions found at Sāñcī and elsewhere make it clear that early Buddhist monuments were created with the support of a large number of individual donations made by monks, nuns and laypeople. Approximately 700 donative inscriptions have been found at Sāñcī, most of them made by ordinary people, such as householders, housewives, merchants, bankers, weavers, etc. At least 200 of the donations were made by Buddhist monks or nuns (Marshall and Foucher 1982, vol. 1, 297–372). Most donors gave only small pieces, such as a plain crossbar. Sometimes, members of the same family or people from the same community would donate a series of successive pieces for a specific railing. Royal or political patronage had very little to do with Buddhist cultic sites in this early period. It was not until the third or fourth centuries CE that religious monuments were the result of royal patronage to any considerable extent (Dehejia 1988, 4–6).

It was considered a sacred act to build a *stūpa*. The donors received religious merit (*puṇya*) through the act of building a *stūpa*. They also received worldly prestige, as is the case to this day. In contemporary politics, it is interesting to see how the military government in Myanmar uses religious donations as a way of legitimizting themselves (Schober 1997). The importance of religious merit in the construction of sacred sites can be exemplified by a story in *Mahāvaṃsa* (Mv 30, 21–41), telling us that when King Duṭṭhagāmaṇi erected a *stūpa* he was nearly cheated. A monk, hoping to share the merit with the monarch, made a brick himself and used it in the construction of the *stūpa*. As the king was unable to remove the brick, he had to give the monk a generous payment to ensure that the entire merit of the construction was retained by the king alone. This leads us to conclude that the donor retained religious merit and worldly prestige—not the artists and artisans. Without the donors and the

conception of merit-making, the visual culture of Buddhism would doubtlessly have been less significant. However, this does not mean that the donors decided what to depict on the *stūpa*.

When, at a later stage, Buddhism was more dependent on royal patronage, the donor was probably responsible for the visual culture as well. At the time of the production of Sāñcī, however, there were hundreds of donors. It is difficult to believe that hundreds of people could have collectively designed the Great Stūpa at Sāñcī. Of all the 700 donative inscriptions, no one tells anything about art or architecture. Most of them only mention the name of the person or persons who made the donation. The design of the *stūpa* is constructed in such a way that there had to be one or a few persons, *the iconographic authority*, responsible for the artistic program.

There is no conclusive evidence whether monks and nuns actually had the authority and interest to decide what to depict in Buddhist sacred sites. There is from this early period neither inscriptions nor written texts left to indicate who have had the authority to decide and at the same time care about it. Some highly ranked monks or nuns in the monastery must have been of vital importance in the creation of sacred sites. However, there is another category of people that may also have played an active role in the construction of visual culture at Buddhist sacred sites: the guilds of artists and artisans. The building and decoration of a *stūpa* were a collaborative effort. Artists and artisans worked together organized into guild teams (*śreṇi*). As they were manual laborers, they belonged to the lowest caste; they were treated as paid workers and did not work for religious purposes. It was a way of earning their livelihood and the occupation was often hereditary. Guild teams would work in different places for different donors and for different religious movements. Vidya Dehejia has identified the same artistic hand on an eight century Śiva temple in Bhubaneśvara and in the Ratnagiri Buddhist monastery some 120 km to the north (Dehejia 1997, 14).[10]

At the head of each guild team, there must have been one or several experts in artistic craftsmanship. They were not only experts on technical constructions, but probably also on religious symbolism. The frequency of auspicious signs and mythological creatures on sites that belonged to Buddhists or other religious movements was likely due to the work of guild teams of artists and artisans. The qualification of artists and artisans depended on their skill and experience, a competence transferred orally from father to son, or from master to pupil. It can be assumed that most of them were conservative regarding their profession. However, monastic monks traveled and are likely to have picked up new ideas in this way. Nevertheless, those who were most experienced among the artists and artisans must have had some influence on what to depict at the sacred sites.

It can be assumed that the manufacturing of *stūpas* and their decoration were part of an intricate social interplay involving several people. The iconographic authority most

probably consisted of one or several highly ranked monastic monks or nuns. The head of a guild team of artists and artisans may also have contributed in the process of deciding what to depict on the *stūpa*. As has been pointed out earlier, there was a development from early signs depicting auspicious signs and mythological creatures to a conscious Buddhist visual culture with distinct Buddhist visual signs. The responsibility for this reinterpreting must have been in the hands of highly learned monks and nuns. The iconographic authority also had to take into consideration the opinion of non-Buddhist locals, as they were dependent on local support.

The Visual Life of Śākyamuni Buddha

There are many sacred sites associated with the life story of the Buddha. Pilgrimage to these sites became commonplace for a living tradition of worship. The Eight Great Pilgrimage Sites (*Aṣṭamahāprātihārya*) are all connected with events in the life of Śākyamuni Buddha and have a special place in Buddhist pilgrimage and Buddhist visual culture. Four of these events are more important than others and are emphasized in *Mps 5.8*.

> Ananda, there are four places the sight of which should arouse emotion in the faithful. Which are they? "Here the Tathagata was born" is the first. "Here the Tathagata attained supreme enlightenment" is the second. "Here the Tathagata set in motion the Wheel of Dhamma" is the third. "Here the Tathagata attained the Nibbana-element without remainder" is the fourth.
>
> (Thus Have I Heard 1987, 263)

These four events have made an enormously important impression on Buddhist visual culture and have been depicted repeatedly throughout Buddhist history. Most early scholars commonly assume that some of the signs of Stūpa 2 at Sāñcī depict these events (Marshall 1918, 138; Marshall and Foucher 1982, 1980–91; Mitra 1992, 63–4; Rowland 1967, 85). The sacred tree in Figure 2 is believed to represent the Enlightenment and the wheel in Figure 3 the First Sermon of the Buddha. The goddess standing in a lotus flower (Figure 12) has been interpreted as representing the birth of the Buddha and, finally, there is a *stūpa* that has been interpreted as representing his death. If this actually was the case, then this would be the first representations of the life of the Buddha. However, there is reason to question such an interpretation. It is obvious that these signs are connected with events in the life of the Buddha in later Buddhist art, but it is unclear why and when this connection occurs. It can be argued that later Buddhist art misled interpreters, and it is the purpose of this last part of the paper to illuminate the connection between signs and events in the life of the Buddha in early Buddhist visual culture.

The origin of the connection between visual signs and events in the life of the Buddha can be explained in at least two different ways. The first and most conventional way is to

FIG 12
Śrī Lakṣmī. Stūpa 2, Sāñcī

take as a starting point the story of the Buddha as it is told in Buddhist biographies. Thus, very early on, perhaps already at the time of the Buddha, the four most prominent sites in the life story of the Buddha become connected with specific signs that have important roles in the events told about the Buddha. Albert Foucher has proposed such an explanation. He suggests that, when the pilgrims had visited these sacred sites, they brought back home with them small souvenirs in the shape of such signs.

However, there is also an alternative and more controversial way to explain this connection. Instead of taking the story of the Buddha as a starting point, it is possible to take the visual culture and auspicious signs as starting points. Auspicious signs, such as lotus flowers, sacred trees, wheels and *stūpas*, depicted at sacred sites became a source of inspiration and gave shape to the life story of the Buddha.

To examine these two alternatives, we have to look more closely at the four major events in the life of the Buddha. The birth of the Buddha is the first event and has in visual culture foremost been associated with a lotus flower. It is told that the future Buddha took seven steps immediately when he was born. Lotus flowers grow out of his footprints. It is also told that Queen Māyā gave birth to the future Buddha in a standing position. The child was born from the right side of her body while she was holding onto the branch of a tree. Her position indicates that the story of the birth was related to tree goddesses (*vṛkṣadevatā*). There was a frequent practice to depict tree goddesses (Figure 9) on *stūpa* railings and they were depicted in a standing position holding onto the branch of a tree. The first event is also associated with a white elephant. The supernatural conception is described as the Bodhisattva entering the womb of his mother in the shape of a white elephant. This is told very briefly in *Mahāpadāna sutta* of the Pāli canon. In this early text, we are told that the Bodhisattva descended from Tuṣita heaven into his mother's womb, but the text does not mention that it is in the shape of an elephant. In the later *Nidāna-kathā*, the event is described as a dream by Queen Māyā.

The woman depicted on Stūpa 2 at Sāñcī (Figure 12) is seen within a ritual bath, standing on a lotus flower while two elephants pour water over her. It is hardly possible to interpret this sign as anything except Śrī Lakṣmī. In the later Bhārhut *stūpa*, however, there is a sign that with all probability depicts the conception. Queen Māyā is depicted in bed with an elephant above her. The connection of Queen Māyā with fertility is obvious, as her pregnancy gave birth to the future Buddha. The lotus flower is a symbol of purity and the white elephant is an auspicious symbol of sovereignty and an emblem of the universal monarch and wheel-turner king *Cakravartin*. The birth-legend of the Buddha may foremost have been inspired by visual signs and local traditions about female vegetation deities (*yakṣiṇīs*), tree-goddesses (*vṛkṣadevatā*) and particularly the goddess Śrī Lakṣmī.

The second event is about how the future Buddha obtained full Enlightenment under the Bodhi tree at

Bodhgayā. This event is therefore foremost associated with a sacred tree. It is well known that an image of the Buddha sitting in *bhūmisparśamudrā* in front of the Bodhi tree represents the Enlightenment. His right hand rests on his knee, taking the earth as witness and overcoming Mara, the Lord of death and rebirth. In the *Mahāvagga* of the Pāli *Vinaya Piṭaka*, the tree is only briefly mentioned. In the later *Lalitavistara*, the tree is much more prominent and six chapters describe the episodes connected to the Bodhi tree.

Is the sacred tree on Stūpa 2 at Sāñcī a representation of the Enlightenment? The tree is a sacred sign for Buddhists, but it is also sacred among Jains and others. The tree may have been depicted as an auspicious sign among others and not as a specific representation of the Enlightenment. However, it is obvious to connect the Enlightenment with a sacred tree, irrespective of whether or not it is a historical fact. It was surely a common practice among ascetics to sit beneath a tree practicing meditation, and parts of the story about the Enlightenment are certainly very old. Therefore, it is impossible to know exactly if the tree on Stūpa 2 really was meant to be a representation of the Enlightenment.

The third event is about the First Sermon told by the Buddha. It has foremost been associated with a wheel and is often called "Setting in Motion the Wheel of Dharma." The First Sermon is told in both *Mahāvagga* and *Saṃyutta-nikāya*, but the wheel is only briefly mentioned. In *Nidāna-kathā* and other later texts, the wheel is more highlighted. Patricia Karetzky has pointed out that the story about the First Sermon was late in evolving. She calls attention to the fact that the First Sermon is not present in the Chinese translations until the third century CE (Karetzky 1992, 156; 1995, 143).

If the wheel is a late addition to the story of the Buddha, then there is every reason to question that the wheel on Stūpa 2 (Figure 3) really represents the First Sermon. Instead, the well-known Maurya lion capital standing in Sārnāth may have served as a model. This pillar was probably made at the time of Aśoka and it was crowned by a gigantic stone wheel at the top of four highly stylized lions sitting upon an abacus. The inscription on the pillar makes no reference to the First Sermon. This wheel of Aśoka is not a Buddhist wheel. It is a wheel of the universal monarch and wheel-turner king, *Cakravartin*. The wheel and its movement symbolize the ceremonial conquests over all the lands where it goes. The metaphor of a wheel in connection with the First Sermon is therefore certainly influenced by visual signs of wheels, especially the wheel that crowns the Mauryan lion capital.

Finally, the fourth event is about the last death and complete extinction of Śākyamuni Buddha. This is the Buddha's *parinirvāṇa* and it is of course associated with a *stūpa*. However, no remains of a *stūpa* from this early time have been found. It is first from the third century BCE that we have archaeological evidence of a *stūpa* cult in Buddhism (Härtel 1991). The last days, death and cremation of the Buddha are described in detail in *Mps*. According to the text,

the remains of the Buddha should be treated as a wheel-turning monarch and deposited in a *stūpa*. His body was cremated and the relics were collected into eight equal shares and enshrined in *stūpas*.

These four major events in the life of the Buddha have repeatedly been the motives in visual art and literature throughout Buddhist history. There is, however, no way to know exactly what happened at that time and there is no clear-cut answer to the question how these narratives developed. Neither of the alternatives mentioned above can be the sole explanation, but they are a starting point for further discussion.

As already stated, the birth and the First Sermon are two events that definitely have been influenced by visual signs. The story about the birth of the Buddha has definitely been inspired by female vegetation deities (*yakṣiṇīs*), tree goddesses (*vṛkṣadevatā*) and particularly the goddess Śrī Lakṣmī. Likewise, sacred wheels and particularly the wheel erected at Sārnāth by Aśoka must have had a marked effect on the shape of the story of the First Sermon. Therefore, Stūpa 2 displays no subjects that are exclusive to the Buddhist tradition, and it definitely does not display the four great events. Thus, the signs on Stūpa 2 belong, with all probability, to a general sacred Indian visual culture, and have no or little connection to specific Buddhist themes. We can clearly notice this if we compare these signs with visual signs in early Jain sacred sites. Signs that we commonly associate with the life of the Buddha frequently occur among early Jain art.

It is impossible to know anything in detail about the life story of the historic Buddha. According to Reynolds and Hallisey (2005, 1,062), the details from the real life of the Buddha are so few and disconnected that our knowledge of the historical Buddha remains shadowy and unsatisfactory. No complete biography was made until the beginning of the Common Era. In the canonical texts there are only biographical fragments presenting particular episodes.[11] The Pāli canon was written down for the first time in the last quarter of the first century BCE in Sri Lanka. Most parts are from an older oral tradition, but it is impossible to know exactly its contents, because the canon is the result of grammatical and editorial decisions. According to Gregory Schopen (1997, 24), it is impossible to know anything definite about the actual contents of it until the commentaries from the fifth and sixth centuries CE. Accounts of the Buddha's life were definitely transmitted orally from the beginning. Gradually, they became committed to written text in the *Vinaya* and *Sutta* of the Buddhist canon. Later, in *Mahāvastu* (first century CE), *Lalitavistara* (first century CE), *Buddhacarita* (second century CE) and *Nidāna-kathā* (second or third century CE), the life story of the Buddha became much more elaborated.

Nevertheless, some events in the life of the Buddha may actually be derived from an old oral tradition that may go as far back as the time of the Buddha. At the same time,

however, visual culture may also have had effects on the telling of the life of the Buddha. Auspicious signs may have been depicted at sacred sites as far back as the time of the Buddha. Early visual culture depicting auspicious signs, mythological creatures and local deities may actually have shaped the oral, written and visual narratives about the life story of the Buddha.

Most importantly, however, the life story of the Buddha is a sacred biography, not history, nor fiction. The biographical fragments were written by religious people to emphasize the extraordinary holiness of their leader and founder. Generations of followers and devotees select and reject episodes to illustrate and project their shared ideals onto that person who was regarded as the founder of the Buddhist movement. The Buddhist movement created the Buddha almost as much as he created the Buddhist religion, and the visual culture was in fact one inspiration in that process.

Much has been written about the origin of the Buddha image, but its logic succession with the aniconic tradition at Buddhist sacred sites is almost neglected. The discussion has almost exclusively been about in which area the Buddha image originated, Gandhāra or Mathurā. Foucher put forward the view that the Buddha images originated in Gandhāra with influences from Graeco-Roman tradition. Coomaraswamy reacted to that and proposed a region further south, Mathurā. Independent of where the first images of the Buddha are believed to have originated, this has always been described as a break from earlier tradition. Krishan, in his attempt to put forward the tradition of Gandhāra as the origin, describe it as a "break from this aniconic tradition" (Krishan 1996, 29). Rowland, in contrast, neglected this tradition of nonanthropomorphic representation completely in his discussion about the origin of Buddha images (Rowland 1963, 5–8).

Instead of this view, I point to the importance of the pre-anthropomorphic tradition for the origin of the Buddha images. As we have seen, the Buddha was already there. However, this tradition was only one of several interacting reasons for the origin of the Buddha image. In the northwest of the Indian subcontinent, i.e. the region of Gandhāra, Buddha images were made in grey schist in approximately the first century CE. The dominant characteristics of Gandhāra were Hellenistic. The Buddha is described in his human nature as a man in the world. Further south, in Mathurā, totally different types of Buddha image were made at about the same time. This so-called Kapardin Buddha type was based upon models of *yakṣas* or kings. In this image, the Buddha is not portrayed as a human, but rather as a superhuman, *Mahāpuruṣa*. He is a combination of a timeless ideal Buddhist king *Cakravartin* and a Buddha (Härtel 1985).[12] The dating of the first Buddha images is controversial and has been under discussion for a long time. Today, it is almost generally accepted that these two types of Buddha images appeared within the same Kuṣāna Empire. The making of anthropomorphic images of the Buddha may seem a clearly

in conversation

an historical pilgrimage among "the last heathen"

Jane Samson

Charles Montgomery's wonderful book *The Last Heathen* (2004) has introduced many readers to a part of the world they might not know: the western Pacific islands (Figure 1). Montgomery wanted to see the sites of his grandfather's career as a missionary bishop in Melanesia and, as it turned out, he experienced a remarkable personal challenge to his views of identity and spirituality. It's that kind of place.

Certain places resonate with special spiritual significance. Some are famous: Mecca, Lourdes, Glastonbury. Others are far more personal: roadside shrines for accident victims; special walks or favorite gardens for meditation. Roadside shrines were on my mind while I was researching the death of the British missionary John Williams on Eromanga, one of the New Hebrides islands (Figure 2), in 1839 (Samson 2005). Like them, the site of Williams's death was not the final resting place of his body. The story is far more interesting than that.

On March 31, 1840 a solemn funeral took place at Apia in Samoa. The remains of LMS missionary John Williams, and of his assistant James Harris, were laid to rest with all of the ceremony that could be provided by the visiting officers and crew of HMS *Favorite*. The two missionaries had hoped to leave some Polynesian teachers at Eromanga. There had been little Western contact with the island since the

FIG 1
The Western Pacific. Map drawn by Jane Samson.

Jane Samson is Associate Professor in the Department of History and Classics at University of Alberta, Edmonton, Canada. She is completing a book about missionaries as anthropologists in the South Pacific, and is interested in many other aspects of British expansion in the region. Her work on Victorian naval activities was published as *Imperial Benevolence: Making British Authority in the Pacific Islands* (1998).

FIG 2
The New Hebrides islands (now Vanuatu) from William Gill. 1855. *Gems from the Coral Islands.* Philadelphia: Presbyterian Board of Publication, p. 138.

explorations of Captain Cook, and missionaries assumed (often with tragic results) that other Pacific islanders would be able to pick up the local language quickly and be accepted by local communities. Although initial contacts with the Eromangans seemed peaceful, trouble began after Williams and Harris began walking inland from the beach. Harris was struck down first; some islanders then pursued Williams as he ran for the water. While Captain Morgan watched helplessly from the mission ship offshore, islanders stripped the bodies and dragged them away. Unable to land safely to recover their remains, Morgan sailed for Sydney where he pleaded for a warship to help him retrieve the bodies of his friends. HMS *Favorite* was dispatched, but found that the bodies had been dismembered and dispersed. The Eromangans offered two skulls and a few bones which they claimed were those of Williams and Harris, and *Favorite* departed with them for Samoa. Only much later was it revealed that the bones were not those of the murdered missionaries. This is therefore a tale of absent bodies and present spirits.

John Williams was one of the earliest missionaries to the south Pacific: a bold adventurer who built his own ships and sailed them into uncharted waters in the name of Christ (Figure 3). In Victorian Britain he was already a hero; now he was a martyr. Other missionaries would be killed on Eromanga, but popular images of "The Martyr Isle" revolved almost entirely around Williams and the events of

FIG 3
Henry Anelay. *The Rev. John Williams on board ship with native implements, in the South Sea Islands* 1838. nla.pic-an6621835. Reproduced with the permission of the National Library of Australia.

1839. Missionaries, teachers' and converts were inspired by the story of his death; Pacific mission stations reported an upsurge in conversion. In England a martyr's cult sprang up. Thousands of prints were sold showing Williams being clubbed to death with his face raised to heaven (Figure 4). When his book was reprinted in a cheap edition, sales doubled. Tributes poured from the presses making Williams seem like a combination of St. Paul and Christopher Columbus (Sivasundaram 2004).

FIG 4
George Baxter. 1841. *The massacre of the lamented missionary, the Rev. J. Williams, and Mr. Harris*. Baxter Collection, <http://library.vicu.utoronto.ca/special/Baxter/82b.jpg.> Reproduced with the permission of the Victoria University Library (Toronto).

FIG 5
Distant View of Dillon's Bay from William Gill. 1855. *Gems from the Coral Islands.* Philadelphia: Presbyterian Board of Publication, p. 106.

DISTANT VIEW OF DILLON'S BAY.

The Victorians were proud of their place in history, and missionaries anticipated the fulfilment of scriptures concerning the conversion of the Pacific world. Biblical references to "the isles" and "the uttermost parts of the earth" were recited after Williams' death in order to emphasize that his passing was part of a story already told: martyrdom as history-in-the-making. His mission society built a new ship, the *John Williams*, and in 1852 Captain Morgan watched the sun rise over Dillon's Bay at the same spot where he had witnessed the deaths of his two friends years before (Figure 5). The distant mountains were shrouded in clouds, but the sun shone above them. Morgan "recognised something emblematical in it, and he said that it led his mind forward to the time, when 'the Sun of Righteouness shall arise with healing in His wings', to illuminate and save the inhabitants of this dark isle" (Patterson 1882, 325). For him, the island's geography displayed what was believed to be the spiritual darkness of its people: a classic case of colonial discourse. This discourse is far from straightforward, however. Morgan saw a landscape speaking not only of "othering" and cultural distance, but also of forgiveness, healing, and a shared future.

Despite Protestantism's ambivalence about relics, it is clear that the whole question of Williams's remains, and the metaphorical power of his spilled blood, became of tremendous importance to Protestant Christians. Even self-consciously modern Victorians, proud of their technological and imperial triumphs, were sensitive to the mysteries of death. Visitors to Eromanga came as pilgrims, seeking a landscape made holy by suffering and blood: a *via dolorosa*. Captain Morgan and the others had seen the body of Williams lying on the beach "where a crowd of heathen boys had so cruelly beaten it with stones, that both the stream and the shore were red with blood" (Gill n.d., 107). For later visitors, however, none of the actual blood remained, nor did any need to be sought because its presence was everywhere. References to Eromanga's "blood-soaked" shores abound in accounts of Williams' death, and such images multiplied after later missionaries were also killed. The island's geography

FIG 6
An Eromangan club from William Gill. 1855. *Gems from the Coral Islands*. Philadelphia: Presbyterian Board of Publication, p. 129.

became literally steeped in martyr sacrifice. As missionary James Paton explained: "Thus were the New Hebrides baptized with the blood of Martyrs; and Christ thereby told the whole Christian world that He claimed these Islands as His own" (Paton 1965, 75). Blood could speak.

Missionaries and other visitors liked to retrace Williams' last steps and reconstruct the story of his death. Everything from the search for Williams's remains to the investigation of reasons for his death reveals the way in which his colleagues and supporters sought a fitting narrative with which to give his death meaning. The need for this became more urgent when it was discovered that the bones brought away by HMS *Favorite*, and so solemnly buried in 1840, were not the bones of Williams at all. This invested the Eromangan landscape with a special significance because it was, in effect, a living tomb. What I call the "Williams Trail" was the result. In 1852, after watching the Eromangan sunrise, Captain Morgan and missionary George Gordon went ashore to drink together in melancholy communion from the "Williams River." Morgan recounted the story of the 1839 disaster while walking in Williams' very footsteps. Gordon sought relics, gathering "a number of pebbles as nearly as possible from the spot where Mr. Williams was killed" (Patterson 1882, 326). He wanted to touch the past and affirm the future.

Later visitors walked the Williams Trail in the company of the Eromangan men who had confessed to his murder. They even collected the club said to have been the instrument of Williams's death (Figure 6). A mission station was built near the martyrs' beach, and some of its pious visitors brought newfangled cameras, capturing the scene for those unable to visit the island itself. Unfortunately none of their photographs appear to have survived. We do have a map of the Williams Trail, however, thanks to missionary George Turner who visited the island in 1859. Turner took particular pains over the geography of Williams' death. "Every direction is associated with the tragic scenes of November, 1839," he wrote:

> At the foot of the hill on which the chapel stands is the stream in which Mr. Harris fell, and the beach where Mr. Williams ran into the sea. Down the hill, below Mr. Gordon's study window, is the spot where the oven was made in which Mr. Williams's body was cooked. Over in another direction is the place where the body of Mr. Harris was taken. (Turner 1861, 486)

Turner published a map of the area (Figure 7) with each of the martyr's landmarks labelled. He even created one of his own, planting a date palm "in a line towards the stream with the spot where Mr. Harris was struck, and in a line towards the sea with the place where Mr. Williams fell" (Turner 1861, 486).

Eromangans were not confined to bit parts in this drama. One of Turner's most intriguing observations concerned a stone pointed out to him by the Eromangans who had been involved in Williams's death and dismemberment. They showed him a large flat block of coral up the hill from the beach, telling him that they had cut up the body there, making

FIG 7
Scene of the Massacre of Williams and Harris at Dillon's Bay from George Turner. 1861. *Nineteen Years in Polynesia.* London: John Snow, p. 487.

three marks in the stone to preserve the remembrance of its size (Figure 8).

It was the islanders themselves who drew visitors' attention to this stone and performed for them there. We cannot know exactly what was in the islanders' minds as they guided visitors around the Williams Trail, and we cannot explain the exact significance of the stone with any certainty. Despite the enormous scholarly interest in the death of Captain Cook in Hawai'i, anthropologists have taken no interest in Eromangan memories of Williams or the sites of his passing. Even if they did, the views of today's islanders cannot convey comprehensive insight into the thoughts and actions of their ancestors.

There is nevertheless an important point to make here. Sometimes the same place can have different types of significance for different people; the Eromangans wanted to tell something of their own story of Williams. It is not a question of a single viewpoint being "right" or "true" at the expense of other views. People estranged by language and culture—and who more so than nineteenth-century Victorians

FIG 8
The measurement of Williams's body? From George Turner. 1861. *Nineteen Years in Polynesia.* London: John Snow, p. 490.

and isolated Pacific islanders—can still gather together around objects or sites of meaning that speak to them. Georges Dumézil and Mircea Eliade have both written about hierophany, the perception of sacredness in the material world (Bonnemaison 1994, 113). I think that the Williams stone was a *hiérophane*, a focus for both Eromangans and Europeans as they shared memories of Williams's death and the meaning of his dismemberment. From what we know of indigenous religion in the New Hebrides island group, the notion of both sharing and overcoming the power of an enemy was a commonplace one. Since the spiritual and material worlds were not regarded as distinct, the treatment of someone's body reflected the treatment of their *mana*: their power and prestige. To dismember a body, or to receive part of it and either consume or dispose of it ritually, was to interact with the spirit of the dead person, to benefit from the person's *mana*, and to disperse its power to work harm.

The concept of hierophany is a very useful way to think about spiritual spaces and places in this context. We cannot speak with certainty about the precise religious beliefs of the islanders who met and killed Williams; their languages had no written form and no Westerner knew how to speak more than a few hesitant words. Communication through and around objects was therefore of great importance (Figure 9). At Eromanga, the result was a piece of sacred geography which generations of pious visitors could invest with all of the reverence which they could no longer pay to Williams' official gravesite in Samoa. If the location of Williams' remains was uncertain, there were at least tangible signs of his body's presence in relics like the Williams stone. Through features such as "Williams River" they were creating a homeland which spoke of their mission's origins and its ancestral heroes. We need to remember that this process took place in the context of increasingly unbalanced power relations: future Eromangans who killed missionaries would be bombarded by the Royal Navy. Nevertheless, when visitors invested Eromanga's geography with sacred meaning, they did not do so alone. We must acknowledge the power of modern colonialism in the south Pacific, but we must also pay attention to how, under particular circumstances, a hierophany could take place in which both Europeans and islanders actively participated.

George Turner, our hierophanic map-maker, was never easy in his mind about the final resting place of Williams's remains. It was he who exposed the charade of the bones picked up by HMS *Favorite* in 1840 and buried so reverently in Samoa. On his visit to Eromanga in 1859, Turner found an inland grove of coconut palms where Williams's skull was said to be buried. He could not discover the exact location of the burial, but was delighted by the palm trees, knowing their prominence in the Bible and their traditional association with Holy Week and the procession of Jesus into Jerusalem. "There let the remains of the martyr rest, and still form part and parcel of that palm which waves its foliage in every breeze, emblematic of the Christian hero's triumph!", he wrote

FIG 9
The Revd. J. Williams' first interview with the Natives of Erromanga from John Campbell. 1842. *The Martyr of Erromanga.* London: John Snow, frontispiece.

(Turner 1861, 486–7). It is significant that visitors like Turner embraced their martyr in a liminal space which featured both indigenous and Christian spiritual significance. Eromanga's "blood-soaked shores," and the bones in the grove, helped to build one of the great foundation myths of Pacific Christianity. Here the pioneer missionary John Williams was killed and consumed, his remains scattered to join the island itself and to consecrate it to God. This mythology both completed and undercut the European appropriation of Eromanga: the sacred geography was traced on Eromangan landmarks and made necessary by Eromangan actions. A Williams safely buried in Samoa would not have given the same meaning to the landscape as a Williams killed and consumed by the land's inhabitants. Because Eromangans had forced Europeans to seek their martyr in the island itself, Williams became an immediate presence: "Williams 'being dead yet speaketh,' and his voice will be heard throughout these realms for ages

yet to come" wrote one commemorator (Campbell 1842, 248). Missionaries both described the south Pacific landscape and were embodied in it: the ultimate material presence.

The Bible supplied missionaries with geographical metaphors inviting hope for the future, enabling them to construct landscapes as spaces awaiting fulfilment: geographies of redemption. Although a large scholarly literature exists on missionary appropriations, conquests and colonial discourses, I find that these terms permit only a partial analysis of complex historical material. The postcolonial focus on Western power—whether textual, economic, political or cultural—marginalizes human spirituality and the role of religious belief in influencing attitudes and building bridges. Many Western academics today prefer materialist and rationalist historical analysis, but in this age of postmodern reflexivity we should question those preferences. I am not a Muslim, but I would never contend that Muslim hopes for the expansion of Islam are "really" just imperialism (or terrorism), or that Muslim spirituality is a facade for various mechanisms of social control. It makes no sense to reduce Christianity to these mechanisms either. Instead I contend that belief must be taken seriously in any analysis of Christian missionary activities or, to put it another way, that religion matters in the history of religion.

Wilderness metaphors in the Bible produced a profoundly missiological geography, encouraging the construction of desert or bushland as empty space waiting for revelation. "The wilderness and the solitary place shall be glad for them" wrote the prophet Isaiah, "and the desert shall rejoice, and blossom as the rose" (Isaiah ch. 35:1). This verse and others like it were often quoted as missionaries blended their aesthetic response to landscape with their mission calling. Although such metaphors may function as literary tropes in a colonial discourse, this is not the sum total of their significance. Missionaries did not choose them because they were functional tropes, they used them because they came from what they believed was the word of God. The metaphors are entangled with, but not limited to, a material world of power relations. To see an island as "dark" or "wild" is certainly to appropriate it, and to deny the legitimacy of the aboriginal significance of it. This has powerful implications for theories of colonization and dispossession. But the wilderness metaphor is also a statement of faith; of belief that, in time, the desert would rejoice.

I began my inquiries about the Eromanga pilgrims by thinking about roadside shrines. As I write this particular essay, I am also mindful about the funeral of a pope. I was intrigued by newspaper editorials which spoke of "mass hysteria". Was this because Rome is a Western capital, or because Christianity is perceived as a western faith? I cannot recall newspaper editorials speaking of "mass hysteria" in connection with huge funerals for beloved Muslim clerics, or the pilgrimages of millions to the River Ganges or Mecca. Only brown and black people, it seems, are taken seriously when they make room for mystery in their lives. There is

a very special communion when large numbers of people gather in significant places, or at significant times, to reach together beyond their daily existence. They become more than the sum of their parts. Can white people only be taken seriously when they gather to consume, as at a rock concert or a football match? Are white people presumed to have "advanced" beyond the need for mystery, including social communion?

Recent "post-colonial" scholarship has added little to this debate beyond reinforcing the notion that religion is somehow opposed to modernity. What appears to be religion in modern Western societies is really something else: colonialism. Missionaries devoured landscapes, as they devoured the lives and spirits of their indigenous inhabitants; far from being the means of grace, they were instead the means of destruction. John Williams, however, turned out to be the one who was devoured. As Charles Montgomery tells us in *The Last Heathen*, sacrificial death makes potent mythology in Melanesia. While he was in the Solomon Islands (to the northwest of the New Hebrides/Vanuatu), several members of an Anglican religious order, the Melanesian Brotherhood, were murdered by political insurgents. Their deaths horrified the islanders so deeply that the insurgency has stalled. The Brothers' sacrifice brought a locally meaningful peace to one of the world's least-known "failed states." As on Eromanga, blood could speak, and not only Westerners define how or when.

Landscapes were full of spiritual significance for missionaries to the Pacific. Without the perception of darkness there could be no light; without wilderness there could be no gardens. The same landscape could be, at different times, a desert or a fruitful field. These metaphors underline the importance of accepting paradox when considering the role of Christian belief in history. Missionaries needed mutually sustaining geographies of conversion and heathenism. This does not mean, however, that islanders and their homes were the passive objects of the missionary gaze. People, objects, and landscapes were embedded in a matrix of interpretation, rather than part of a linear process of colonization. Within this matrix a number of meanings could be held in tension, as they are today at the Dome of the Rock in Jerusalem, or when Muslims and Christians pray at the mosque-cathedral in Cordoba. The same creative tension once surrounded a much humbler place: the Williams stone at Eromanga. For me, such places speak less of power than of generosity. Are we listening?

references

Bonnemaison, Joël. 1994. *The Tree and the Canoe. History and Ethnogeography of Tanna*. Honolulu: University of Hawai'i Press.

Campbell, John. 1842. *The Martyr of Erromanga: or, The Philosophy of Missions, Illustrated from the Labours, Death, and Character of the Late Rev. John Williams*. London: J. Snow.

Gill, William Wyatt. n.d. *Gems from the Coral Islands*. Philadelphia: Presbyterian Board of Publication.

Montgomery, Charles. 2004. *The Last Heathen. Encounters with Ghosts and Ancestors in Melanesia*. Toronto: Douglas and McIntyre.

Paton, James. 1965. *John G. Paton: Missionary to the New Hebrides*, orig. publ. 1889. London: Banner of Truth Trust.

Patterson, George. 1882. *Missionary Life Among the Cannibals*. Toronto: James Campbell.

Samson, Jane. 2005. Landscapes of Faith: British Missionary Tourism in the South Pacific. In Gareth Griffiths and Jamie W. Scott, eds. *Mixed Messages: Materiality, Textuality, Missions*. New York: Palgrave.

Sirasunderam, Sujit. 2004. Redeeming Memory: The Martyrdoms of Captain James Cook and the Revd John Williams. In Glyndwr Williams, ed. *Captain Cook: Explorations and Reassessments*. Woodbridge, UK: Boydell Press.

Turner, George. 1861. *Nineteen Years in Polynesia: Missionary Life, Travels and Researches in the Islands of the Pacific*. London: J. Snow.

whose sacred place?
response to jane samson
Crispin Paine

By chance I've just been reading William Christian's account of the creation of another sacred place, in northern Spain in 1931. There, children saw a vision of the Virgin Mary, and within weeks newspaper photographers had decided on the *place* where she appeared (between two oak trees), local people had marked off the site with barbed wire, clergy had imposed a pattern of ritual practices, the Virgin had appeared many more times in the agreed spot, and a large cross and a stage had been erected. People came in their tens of thousands and miracles quickly followed. The following year, the focus of devotion was changed again as a stream was diverted and a chapel built over it.

The context at Basque Ezquioga was very different to that at Melanesian Eromanga, but the similarities remain striking. They include the deliberate creation of a landscape considered appropriate to the events that took place there (the martyrdom / the visions), the mixed motives of those involved, the negotiations and alliance between locals and outsiders, the imposition of a regular pattern of ritual behavior, and the building of facilities for pilgrims which also served to focus their devotion. At both Eromanga and Ezquioga a river and trees were either introduced or incorporated as significant elements in the sacred landscape. At both places pilgrims take away relics/souvenirs: pebbles at Eromanga, oak leaves and twigs at Ezquioga. At both, a sacred place was created.

Only in its most basic geology is landscape "natural"; everywhere it has been moulded to suit the needs of people. Usually those needs are mundane, but sometimes people decide they need a sacred place. When they do, they seem seldom to have any hesitation in radically altering the landscape to provide the kind of sacred place they want. Think of what Emperor Constantine did to Jerusalem, hacking away a whole hilltop in order to allow for the enormous Church of the Resurrection on the spot where (his advisers decided) Christ had been crucified and buried. Examples of equally radical intervention can be found worldwide.

Jane Samson describes two types of sacred place: that made sacred by the presence there of a relic, a body-part or possession of a holy person, and a place where an event of sacred significance took place. If we were to try to "classify" sacred places, one way of doing so might be to add to these two another four: places made sacred by formal dedication (most religious traditions have rites whereby particular places can be set apart, permanently or temporarily, and some

have received much attention from anthropologists looking at *why* this is done), places created to convey spiritual feelings (generally buildings and gardens), places credited with spiritual meaning, and places believed to have innate sacredness or "energy."

One of the oddest of these "classes" of sacred place is those places "credited with spiritual meaning." We agree, it seems, to regard some landscapes both as beautiful and (not always quite so unanimously) as possessing a spiritual quality that offers refreshment to those who approach them in the right spirit. Often these are wildernesses. The subject of a number of North American studies, the wilderness as sacred place was popularized by the poet William Wordsworth, whose love of the English Lake District led him to "cover hill and dale, farm and inn, wagonette and picnic-basket, with the fat, yellow, comfortable warmth of religiosity" as the Cumbrian poet Norman Nicholson so delightfully put it. Nicholson accuses Wordsworth of "confusing the exhilaration of mountain climbing with the fervour of religious experience." Here is an interesting parallel with the way Samson describes missionaries who "blended their aesthetic response to landscape with their mission calling." How does this mixture of "spiritual" and "beautiful" work when applied to landscape? How exactly did the Wordsworthian tradition of the wilderness or other "beautiful" landscape flow into the mainstream of sacred places? In what ways is the Western Romantic tradition different to—say—the Buddhist tradition in China and Japan, where appreciation of landscape as beautiful and appreciation of landscape as spiritual are similarly blended, and how do both relate to literature and art?

Those places credited with innate spiritual power are perhaps the most interesting category of all, for they raise forcibly the question of what a sacred place really is. These are places that are seen—by some people at least—as innately sacred, regardless of the beliefs, views, and actions of human beings. They would stay sacred even if no-one believed they were. Such innate sacred character may be the action of a god, or it may be a phenomenon of nature, but it cannot be disputed or changed.

It is this distinction between places credited with *innate* spiritual power and those that have been given spiritual power in some way by people that makes me a bit wary of using Eliade's term "hierophany."

Eliade's hierophany is an irruption of the sacred into the world—an "act of manifestation of the sacred"—an irruption that is constantly repeated in a particular place, particularly if it is recognized and demarcated by humankind. The difficulty is that any attempt to say *who* recognizes and honors the sacred place raises the issue of the relationship of observer or devotee with the place. Eliade is quite happy treating sacred places (and myths, and beliefs) *as if* they are true, or as if they are reflections of one great truth, almost as a Jungian collective unconscious. But this concern to ensure that all accounts of religion are written from the perspective of the religion itself effectively prevents him from addressing

the relationship of the believer with the place, or examining critically what it is that the believer is bringing to the place.

The Williams stone on Eromanga clearly has been recognized and demarcated by people, but has it been the site of any manifestation of the sacred, apart from within the minds and memories of local people and visitors? Eliade's hierophany seems to refer only to the sacred place that is understood to be *innately* sacred, while the Williams stone is surely "made sacred by memory." In other words, the importance of this particular sacred place lies in the memories and understandings of the people who visit it.

To my mind, the importance of *every* sacred place lies in what devotees and observers bring to it, and Eliade's attempt to respect local belief in the innate sanctity of some places went too far and is perhaps no longer helpful. We still look back over our shoulders at the great Eliade; recent scholarship in the field (surprisingly limited) has produced few Big Beasts. What we need now is much more study of *people*, how we imagine special places, how we agree to define them, why we want them, how we behave towards them. Particularly revealing are those places that attract more than one understanding. Two issues ago this journal looked at the conflict of understandings at Ayodhya; it is exceptionally appropriate and helpful now for Jane Samson to bring to our attention a place where two parties have negotiated a common understanding.

references

Christian, William A. 1990. The delimitations of sacred space and the visions of Ezquioga, 1931–1987. In *Luoghi Sacri e Spazi della Santita*, eds. Sofia Boesch Gajano and Lucetta Scaraffia Rosenberg & Sellier.

Eliade, Mircea. 1959. *The Sacred and the Profane. The Nature of Religion*. New York: Harcourt Brace.

Graber, Linda H. 1976. *Wilderness as Sacred Space*. Washington: Association of American Geographers.

Nicholson, Norman. 1955. *The Lakers: the Adventures of the First Tourists.* London: Robert Hale.

book reviews

sheela-na-gigs
unravelling an enigma

Freitag, Barbara. 2004
London and New York: Routledge

Reviewed by Juliette Wood
Cardiff University

Compelling figures of female exhibitionism known as *sheela-na-gigs* adorn both religious and fortified structures in Ireland, the British Isles and on mainland Europe. They have been interpreted as Celtic goddesses, apotropaic figures, warnings against sin, fertility fetishes, or symbols of life and death. The search for meaning in these enigmatic carvings reflects changing attitudes towards culture, and the varied explanations tell us much about the persistence of models of cultural survival, the vitality of popular culture, and our fascination with marginal images.

Barbara Freitag's intention is to open up new avenues of research and provide fresh impetus to the study of this carving. To a great extent she succeeds and this is undoubtedly the most complete and authoritative book on the subject so far. Freitag presents a balanced and fair survey of previous theories, while her chapter on the name itself, until now never satisfactorily explained, is particularly welcome. The linguistic connections with dancing and attitudes to women considerably extend the network of meanings which surround this image. Frietag describes a complex and ambiguous figure with links to folk religion, especially rites surrounding pregnancy and birth. The placement of these figures in liminal contexts, such as churchyards and fortifications, also suggest an apotropaic link with life and death.

The popularity of microhistory studies since the 1980s provides a context for interpreting previously peripheral material, and it is here that one would expect to find the theoretical focus of this study. However, Freitag opts for a more far-reaching conclusion, namely that the *sheela* is an ancient folk deity with life-giving powers associated with childbirth and the dead. This folk deity informed "a persistent struggle" between the people and the church (p. 111). She suggests that the church tolerated this pagan image until it could be phased out, an endeavor that resulted, from the seventeenth century onwards, in the disposal of many figures. The author is aware that her thesis depends on comparative material from different places and periods, and that a degree of generalization has been necessary. However, in an attempt to uncover cultural unities uncontaminated by the imposition of Christianity, the broad-brush approach of this book often fails to consider whether such de-contextualized formal similarities can really be construed as a single, coherent belief-system.

Freitag interprets instances of top-down ecclesiastical disapproval as an indication of a persistent struggle between church and rural peasantry. She synthesizes disparate examples in time and geography into a surviving cult in which the worship of a pagan deity informed the folk struggle against authority. Citing Valerie Flint's work on witchcraft, Freitag suggests that the church had great difficulty winning over the peasants and thus permitted pagan practices until it could eliminate them. Unfortunately, the existence of such clear mentalities is difficult to prove. What evidence is there that "medieval rural peasants" thought of themselves as other than Christian? In support of this, Freitag relies on that over-quoted chestnut, Pope Gregory's dictum to absorb pagan practices into Christian ones. This was said in the context of the conversion of the Anglo-Saxons, while the bulk of the *sheela* figures are much later. How would Gregory's dictum apply in twelfth-century Ireland where the power and influence of the church were quite different? It is even more problematic in the context of the post-counter-reformation church of the seventeenth and eighteenth centuries.

Nevertheless, this study raises some interesting issues. The concept of continuity as a framework for reconstructing the past was largely replaced in folklore studies with a more relativistic and context-oriented concept of culture in which changes of form, content and meaning are acknowledged. However, reconstructing continuities with earlier stages of civilization re-emerged during the late twentieth century, led by such notable scholars as Carlo Ginsberg. In this context, Freitag reassesses some of the ideas of E. O. James, Margaret Murray, and Anne Ross. This is a study which, commendably, attempts to examine the *sheela* phenomenon from below, seeking popular continuity beneath elite attitudes. Various elements were undoubtedly present in some places at some times, but it may not be possible to discern an organized (or even an identifiable) cult that attempted to maintain a cohesive identity in the face of repression by treating

cultural entities like artefacts which can be sifted out of historical contexts and then interpreted in a similar way. What is interesting here is not a lack of evidence, but the way of thinking which reflects the popular need to search for origins, even at the expense of historical notions of continuity. This study certainly challenges folklorists to question their own categories and ideologies. Freitag is undoubtedly right in stressing the long-standing nature of gender ideologies, and she does consider these gleeful grotesque disruptive and ambiguous images in a wide variety of visual and narrative media.

sacred shock
framing visual experience in byzantium

Peers, Glenn. 2004
University Park, Pennsylvania:
Penn State University Press

Reviewed by Cecily Hilsdale
University of Michigan

Glenn Peers' recent book takes its title from a Derek Walcott Poem, "Tiepolo's Hound," in which one "epiphanic detail" illuminates its epoch. This process underlies Peers' investigation of sacred framing in *Sacred Shock: Framing Visual Experience in Byzantium*. One of the most significant contributions of the work is the way in which it expands our understanding of a frame beyond a mere decorative border to a much larger, more fluid conceptual category. As unstable entities, frames—"or simply edges, margins, transitional spaces generally" (pp. 5–6)—are seen by Peers as "labile, covert, equivocating" (p. 7). Through close analysis of key moments and strategies of framing in Byzantine visual culture, his work investigates a process of assimilation in which divine presence is made manifest for the viewer. Thus, as the subtitle indicates, the book is not about frames *per se* but about how visual experience is framed in Byzantium. As such, it engages a number of recent art historical debates about viewer response, modes of vision, and absence and presence.

Interdisciplinary in scope, *Sacred Shock* combines close formal analysis of surviving objects and iconographies with interpretation of texts of diverse genre. Peers argues that Byzantine frames—broadly defined—are sites of assimilation more than demarcation that bridge immaterial and material realms and mediate the relationship between art object and viewer (medieval beholder and modern art historian). This claim unfolds in five chapters, each surrounding a particular object or select group of pieces in different media from the Early Christian to Late Byzantine periods, prefaced by an introduction and a short epilogue.

The introduction provides the reader with the intellectual tools necessary to forge the connections between the five chapters. Peers is interested in the ever shifting space between the viewer and representational core and argues that the frame mediates that relationship by acting as a "heuristic prism" (in the words of P. Sohm). The medieval frame is positioned in contrast to the modern classic frame that aims to separate, distance, and call attention to surrounded artifice, as evidenced by a Baroque frame that intervenes between viewer and object and "reveals painting's nature as representation, as absence of the real thing" (p. 2). Unlike such closed and self-contained frames, medieval frames are all about presence: "they were also where the reality of the image was declared, where its emergence and existence as a quasi-animate entity took place" (p. 6). For this reason, the Middle Ages are characterized by Peers, in the phrase that lends the introduction its title, as "The Great Age of the Frame."

Chapter 1 situates pectoral crosses within the context of devotional desires for increasing intimacy and proximity. Peers draws upon Louis Marin's "pathetic figure" of the frame in order to position viewer participation as a central theme of this chapter, one that remains constant throughout the entire book. He constructs a total visual experience that encompasses the haptic and optic realms, and explores how meaning is experientially activated through the mediation of the frame. Chapter 2 takes a page from the mid-ninth-century Chludov Psalter as a point of departure to consider the body—Christ's incarnation—and its role in iconoclastic theology and politics. Here as elsewhere the frame is not to be understood in merely a literal sense, but in Peers' expanded understanding as that which mediates object and viewer as the site of interpretation and integration. Through analysis of the relationship between center and periphery of the frontispiece miniature of

Gregory Nazianzus in Sinai 339 in Chapter 3, Peers relates the painted architectural frame to contemporary monastic experience. Far beyond a formal analysis of this one particular page, this chapter investigates twelfth-century monastic reforms, architecture, and monumental visual programs as frames for the liturgy enacted below, and also the use of the manuscript. Here we see the success of Peers' method most strongly—integrating close readings of objects, architecture, liturgy, and politics.

Indeed one of the strengths of Peers' work is its move beyond origins, iconographies, and styles towards logic and visual effect. This is perhaps most evident in Chapter 4 which explores thresholds, size, and dimensionality as framing strategies through close analysis of a vita icon of St. George in the Byzantine Museum in Athens. Peers provides a productive and compelling reading of this unique icon despite the fact that many questions must remain unanswered. Chapter 5 then turns to metal icon revetment. The discussion is divided between Annunciation imagery, where analysis centers on two early-twelfth-century icons in Ochrid, and Mandylion imagery, where the focus turns to the holy image and late-thirteenth- or early-fourteenth-century silver narrative frame in Genoa. In the discussion of all these works and related comparanda, light and environment emerge as themes: "During liturgy, these interiors became Gesamtkunstwerken, in which all the senses—sight, hearing, smell, touch, and taste—were appealed to and used" (p. 109).

The book concludes with a short epilogue, "Framing the Body," that aims to synthesize the material and restate the main claim that frames, even unselfconsciously, mediate the viewers' experience of divine presence. The Chludov Psalter's blood, the crucifix's outline, architecture around Gregory, bodies around George, and the aura of silver's surface are for Peers "epiphanic details" and "each contained the conditions for consuming that object, for providing a 'sacred shock' of presence unexpectedly contingent on our own presence" (p. 134).

Just as frames blur boundaries and act as points of assimilation, so too does Peers make the Byzantine material fully present for the reader, both powerfully evocative and elusive. The larger project of the book is not teleological and does not posit a single stable ideal viewer. The author acknowledges this he is acutely aware of his own subjectivity in the framing of the material. The result is a rigorous and theoretically informed work that will satisfy a scholarly audience invested in new analytical approaches to material culture.

At times the book's production values preclude full appreciation of the analysis. The reproduction quality falls short at some key moments—for instance, the image of the Kurbino Annunciation plays a key role in the author's text but is difficult to make out in the small black-and-white reproduction (fig. 66). Moreover, a full bibliography would have been most welcome as the present one seems too "selected" to this reviewer. Nonetheless Penn State is to be commended for publishing such an evocative work that exceeds traditional iconographic, media specific, or temporal restrictions.

reframing pilgrimage
cultures in motion

Coleman, Simon and Eade, John (eds). 2004
London: Routledge

Reviewed by Alan Morinis
The Mussar Institute

In early 2004, while visiting New York, I joined the crowds gawking at "Ground Zero" where the World Trade Center (WTC) towers had once stood. Though nothing more than a hole in the ground now remained to be seen, what went on around that unadorned excavation was a display of reverence and awe that matched any of the holy pilgrimages I have witnessed in Europe and Asia. Hushed visitors lit candles, placed notes in the chainlink fence, erected memorials to their visits, and silently circumambulated the site in an orderly, clockwise direction. I wondered whether the visitors to the WTC site were perhaps consciously calling on and applying their own experiences of religious pilgrimages to this unconventional context, or whether perhaps more typical pilgrimages as well as other rites (like visiting disaster sites) might weave their meaningful and affective practices out of strands of generic threads that are anchored deep in the human soul.

These very sorts of questions motivate the scholars whose essays are collected in this interesting and imaginative volume, which

all deal with the subject of pilgrimage, and all present original data collected in the field—though only one deals with the sort of religious journey to which we might most easily apply the term "pilgrimage." By employing the conceptual and analytical tools developed for the study of pilgrimages to rituals and behaviors in diverse social-cultural contexts that are similar (if not identical) to what we might label as more classic forms of sacred journeying, the editors who have collected these essays expand the frame that encompasses the term "pilgrimages." The central question that this book raises is indeed *the* central one: what can (and, by inference, cannot) be called a pilgrimage?

So when we accompany Viet Nam war veterans on an annual motorcycle cavalcade from California to the Viet Nam Memorial in Washington, DC, or observe people from the Scottish diaspora returning to the motherland on journeys to discover their roots, or, in the most extreme case, learn about West African traders in the Canary Islands who forego traditional pilgrimages and instead send money while experiencing their pilgrimages in their minds ("Corporeal travel has been exchanged for imaginative travel"), the very conceptual category of what is a pilgrimage is called into question. The chapters are well researched and well argued by thoughtful scholars, and the result is a deep and confirmed recognition that the ways in which people around the world journey in search of satisfaction for a wide range of needs owe more to the nature of the species, in body, emotions, spirit, and mind, than to the particular institutions through which such collective satisfactions are sought. And so it is that the authors highlight phenomena like somatic memory, social identity, shared emotional experiences, and contested meanings—phenomena that typify classic forms of sacred journeying but which are not unique to them alone, as is well illustrated here. These essays convince that a wider range of phenomena than the classic journey to a holy shrine deserves to be classified and understood within the reframed definition of pilgrimage this volume implicitly advances.

More explicit is the editors' attempt in the introductory essay to focus their broadened view of pilgrimages on the common element of movement that is evident in all but the most unconventional members of the class. The obvious risk here is that the emphasis on movement will open up the pilgrimage category so widely as to render it meaningless, as arguments could be raised to include within the frame not only the pilgrims' close cousin, the tourist, but also commuters, business travelers, migrant workers, refugees, and so on. Only one chapter comes close to succumbing to this potential danger—focusing on Turkish dervishes who visit cultural conferences and "perform" their dances for public consumption outside Turkey—while on the whole the essays collected here do not trip into that pitfall, but rather deliver a measured, well-considered and insightful challenge to our understanding of sacred journeys, successfully bringing about the reframing that the title of this book promises.

A must-read for anyone interested in this specific field (or, for that matter, anyone who wants to know what anthropologists can do in the post-modern world), *Reframing Pilgrimage* offers a valuable and intelligent rethinking of the institution of pilgrimage. It provides fresh challenges to old categories, though surely not the final word, as the editors themselves note when they describe the study of pilgrimage as "an analytical journey without end." This book, however, gives us one stimulating reason to go on.

belief in the past
the proceedings of the 2002 manchester conference on archaeology and religion

Insoll, Timothy (ed.). 2004
Oxford: BAR S1212

Reviewed by Mike Parker Pearson
University of Sheffield

This volume demonstrates that archaeologists of religion are a broad church—some theoretically minded, others more concerned with empirical detail. There are minority extremist and fundamentalist positions that contrast with more balanced and mature expositions. The editor's introductory chapter takes to task archaeologists past and present for their lack of interest in studying religion *per se*. Past generations are castigated for their simplistic formulations of prehistoric religion while contemporaries are chastised for focusing on ritual rather than religion. There is certainly a fair point to be made but Insoll perhaps

protests too much, omitting recent work which could undermine his case. In the next chapter, Andrén explains how recent research into Norse religion has reformulated it as fluid, vague, and creolized. He concludes persuasively that its hybridization has been a long-term characteristic, going back at least to the Early Bronze Age.

In the third chapter Bardsley argues for a cognitive and cultural evolutionary perspective on religious beliefs. Although he claims that this approach sidesteps antagonistic debates between biological and cultural perspectives, it seems to fall squarely within the realm of biological functionalism and cultural Darwinism. Such an approach may have value for the long-term evolution of the species over millions of years but it doesn't convince for the brief period of his case study, the Early Minoan in Crete. As a counterpoint, Ina Berg's following paper on diversity of religion in Minoan Crete is a contextually grounded study which argues that beliefs in personified deities existed side by side with animism. She concludes that palaces employed a formal priesthood whereas country people relied on healers, shamans, and witches.

Bond's chapter on the Early Neolithic "Sweet Track" across the marshes of Glastonbury is a good critique of its assumed purpose as merely a practical means of crossing from one area of dry land to another. He uses the evidence of its votive deposits, among other things, to argue that the trackway was a sacred place, although many will conclude that the practical and the religious were probably inseparable in this context. The next chapter by Clack is a theoretical exploration of neurophenomenology, attempting to relate neurology to religious experience. There follow two excellent papers on Ethiopian archaeology, history, and ethnoarchaeology: an investigation of Ethiopian monasticism and its ideological links with landscape and royal power by Finneran and Tribe, and a study by Haaland, Haaland, and Dea of the symbolic schemes mobilized in iron-smelting.

The next three chapters take us to south Asia, with James' study of competing secular and religious uses of ancient Hindu monuments, Lahiri's history of stupa restoration by Christians and Muslims as well as Buddhists, and Oestigaard's fascinating account of Nepalese royal funerals and socio-religious cosmology. The book is completed by a chapter by Turner on Middle and Late Saxon church sites in South West England, in which he makes the point that these agricultural landscapes were perceived within a Christian ideology of concentric zones from "holy city" at the core to the outer zone of evil forces.

The chronological and geographical dispersal of the book's case studies makes for an uneven read, and it will most likely appeal to specialists on a chapter by chapter basis rather than as a coherent entity. This issue of coherence is also raised in a more metaphysical sense when considering the nature of an archaeology of religion. The editor is at pains to revitalize religion as a universal category of human practice on a par with economy, say, or technology. Yet chapters by Andrén, Berg, Bond, Finneran and Tribe, and Haaland et al. reveal the interpenetration of the religious and the secular, the practical and the ritual in many different times and places. One of the pitfalls of developing an explicitly religion-focused approach is the capacity for implicit back-projection of concepts derived from today's world religions onto prehistoric practices, encouraging a potentially misguided search for coherent belief systems that were supposedly free-standing, divorced from the social, technological, economic, and practical concerns of daily life. Were Neanderthals "religious"? Can we even characterize Neolithic ancestor rituals and practices as "religious" in the same way as our world religions? In other words, is "religion" (as a self-defining sphere of human life) actually an invention of the last three or four millennia? Despite these caveats, this is a thought-provoking collection of essays which brings together some interesting case studies and useful syntheses.

a zoroastrian tapestry
art, religion and culture

Godrej, P.J. and Mistree, F. Panthakey (eds). 2002
Ahmedabad: Mapin Publishing

Reviewed by Tehmina Goskar
University of Southampton

A Zoroastrian Tapestry is an object to behold. It is neither coffee table book nor exhibition catalogue, neither religious history nor cultural anthropology. Instead, this colossal, stunningly illustrated volume is all of these and much more. Thirty-six contributors, ranging from Mary Boyce, doyenne of Zoroastrian Studies in the UK, to Shirin Simmons, Persian culinary expert and writer, have written the thirty-nine chapters. Many of these articles highlight the importance

of material culture in the lives of Zoroastrians past and present.

Despite the book's great size, there is little relating to Iranian Zoroastrians outside of the province of Yazd, or to Parsis outside Mumbai (Bombay). Readers should also note that although the book contains a fascinating insight into the Zoroastrian identities of the Yezidis and Kurds, there is no coverage of other (non-Indian/non-Iranian) communities, notably those in the Americas and continental Europe.

These omissions do not harm the book. It still successfully illustrates the richness and diversity of Zoroastrian identities and cultures over time and space, without having to be encyclopaedic. The plural here is important to note as, for too long, general books on Zoroastrian religion and history have concentrated on conservative analyses of doctrine and religious praxis, and/or the high political history of the Persian empires. Instead, this volume documents the myriad Zoroastrian traditions that, in the editors' words, are "fast disappearing."

Each chapter stands on its own, with full notes and references. The book commences with an appropriate set of articles on Zoroaster (Zarathushtra) himself. Mary Boyce begins with a survey of the origins of the Zoroastrian faith, the Avestan scriptures and traditional doctrine, and ends with a short discussion on recent reformist movements. James Russell follows this with a fascinating article on the subject of where and when Zarathushtra existed. Religious doctrine, literature, belief, and practice are dealt with in articles by Jamsheed Choksy, Hormazdyar Mirza, Firoze Kotwal and Khojeste Mistree, and Shehnaz Munshi and Sarah Stewart.

Of particular note are the contrasting contributions of Kotwal and Mistree on public and priestly orthodox Zoroastrian ceremonies, and Munshi and Stewart's excellent article on domestic rituals and observances. Kotwal and Mistree's chapter takes the reader through the Zoroastrian ideal for ritual worship and the purpose it serves in the wider universe. They discuss two of the most emblematic items of Zoroastrian material culture which are ceremonially bestowed on children between the ages of 7 and 14 at their initiation (known as *navjote* to Parsis and *sudreh-pushi* to Iranians). These are the *sudreh*, a fine muslin vest containing a symbolic pocket in the middle that will contain a person's good and bad deeds; and the *kusti*, a woven girdle formed of seventy-two strands of wool that is tied three times around the waist, over the *sudreh*. The strands represent the seventy-two chapters of the *Yasna* liturgy, one of the most fundamental of priestly rituals. Both garments work together to provide the spiritual protection that is potentized in them from the prayers chanted during the initiation rite.

On a domestic level, certain objects are key for the role they play in transmitting the spiritual heritage and knowledge from one generation to the next, and this is usually done by women. Few Zoroastrian homes will be without the *ses*, a tray of symbolic objects, usually made of silver, representing strength and purity. The *ses* is almost exclusively arranged and kept by the women of the household. Items on the tray will vary according to the occasion, but most common are a silver cone (*paro*) containing a sugar cone symbolizing the mountain of life's sweetness, a rose water sprinkler for fragrance and joy, a fish representing protection and freedom, a cup of water symbolizing purity, rice for blessings, and perhaps some coins to invoke prosperity and an egg for new beginnings. Parsis will also include a small pot of the vermillion which is moistened to make a red mark on the forehead of the person at the center of the ceremony: a round "moon" on women and a vertical streak (the sun) for men. This is a direct absorption from Hindu practice. A new set of clothes is always laid on the *ses* for the child on their initiation.

Complementary to these topics are the articles on comparative religion which compare Zoroastrian beliefs and practices with those of Hinduism, Judaism, and Christianity. The influence of Zoroastrian ideas on Islam is dealt with by A. Sh. Shahbazi who discusses their influence on the development of Shi'ite principles. Shahbazi examines how the concept of free will and taking responsibility for one's actions—fundamental to Zoroastrianism—is very much at the center of Shi'ite Islam as well. The persistence of Zoroastrian traditions is also echoed in Shi'ite material culture. In celebrations such as No Ruz (New Year), Zoroastrians, Muslims, and Jewish Iranians alike will faithfully lay out the Haft Sin table with various foods and other items representing the seven creations of God. Instead of the Avesta (Zoroastrian religious writings), Muslims use the Qu'ran to represent the wisdom of God.

Religious architecture, namely the Fire Temple and the Towers of Silence, and the functions of sacred space are discussed in two chapters by Faroukh Dastur and Firoza Punthakey Mistree, and Azmi Wadia respectively. As a material manifestation of Zoroastrian orthopraxy, the Fire Temple encompasses much that is fundamental to Zoroastrian theology. From the triadic form of the building, which assists devotees in the process of achieving physical and spiritual purity, to the orientation of

the inner sanctum where the holy fire is tended, every element serves an existential purpose to ground devotees in prayerful thought. Usually, each material aspect of the inner sanctum is handled or used only by the priest, though in many cases worshippers can at least enter to make offerings of fragrant wood to the fire. Through the brass bars which define the three "open" sides of the sanctum, worshippers can face the metal fire urn which is seen standing on a hard stone (usually basalt) plinth intended to provide a direct connection between earth and fire. A copper crown is suspended from the ceiling to protect the fire from falling dirt. On the walls are a mace with a bull's head, symbolizing priestly authority, two swords and a dagger to defend the fire against attack, and a brass bell which is rung before a ritual to drive away dead and negative energies.

Another series of chapters deals with the role and evolution of Zoroastrian culture during the era of the Persian Empire(s). These range from another contribution from Boyce who explains the Achaemenid impact on the religion, to Albert de Jong's chapter which seeks to re-evaluate cross-cultural interactions between Classical Persians and Greeks. Richard Frye and Frantz Grenet introduce readers to the lesser-known worlds of Central Asian Zoroastrians before the advent of Islam. Grenet's contribution on the early medieval Sogdian ossuaries discusses how the symbology stamped on these terracotta caskets relates directly to a Zoroastrian sphere of beliefs. A fine example is given of a seventh-century ossuary found in Samarkand which depicts the soul being judged at the "Bridge of the Separator" by Rashn, the *yazad* (divine being/angel) of justice, shown with scales. This process is central to Zoroastrian eschatology.

Discussions of Zoroastrian responses to post-conquest Iran are covered by Mary Boyce and Farhang Mehr. Kaikhushroo M. JamaspAsa follows these with a synthesis of the history of textual transmission and survival, from the centuries before the seventh-century Arab conquest right up to the publication of the seminal series *Sacred Books of the East* in the nineteenth century. A considerable proportion of the second half of the book is devoted to the history and culture of the Parsis—Zoroastrians who descended from the Persian "refugees" fleeing Arab-ruled Persia. Topics range from the eighteenth- and nineteenth-century Parsi diaspora to the role of Parsi women and men in the Indian Nationalist movement. Saryu Doshi's article on Parsi theatre is particularly remarkable, as the dramatic arts are not very often dealt with in Parsi histories nor, one imagines, does Parsi theatre feature much in mainstream theatre histories.

The final chapters deal with "popular" Zoroastrian culture, and food and feasting feature prominently. Shirin Simmons eloquently conveys the important role that food plays in Zoroastrian life, as offerings to the Divine, as hospitality towards friends, and as charity for the poor, sick, and needy. Shalini Devi Holkar and Sharada Dwivedi, and Katy Dalal discuss Parsi cuisine. Dalal's contribution on the rural cuisine in Gujarati villages is especially noteworthy as it gives a rare insight into rural Parsi society. These chapters are followed by four articles on Iranian and Parsi costume from imperial to modern times. Mistree's chapter on the traditional costumes of Yazd reminds readers of the impact the Islamic government of Iran had on even the most basic aspects of Zoroastrian lifestyles. For example, before World War II the government forced Zoroastrian men to wear only pale beige, brown, and gray in order that they could blend into the landscape and be erased from view. Ironically, the number of items of traditional Zoroastrian Iranian costume is few because of the tradition of burning the clothes of the deceased.

In sum, the high-calibre and wide-ranging content of *A Zoroastrian Tapestry* will do a great and long-term service to anyone interested in Zoroastrianism, its past and contemporary influences, and the beauty and variety of its material cultures.

muslim saints of south asia

Suvorova, Anna. 2004, 2nd edition
Routledge Curzon

Reviewed by Ron Geaves
University of Chester

To anyone interested in the historical development of classical Sufism in the Indian subcontinent from the eleventh to the fifteenth centuries, the biographies of eminent medieval *awliya* such as Mu'inuddin Chishti, Baba Farid, and Nizamuddin Awliya, the Suhrawardi founder *shaikhs*, Baha'uddin Zakariya and Jalaluddin Tabrizi, or the anthropology of the shrines and the popular religion manifested therein to the

present day, Anna Suvorova's book is both essential and gripping reading. Her ability to separate hagiography from biography is skilful, such that she is able to reveal the real men, replete with piety, extraordinary charisma, love of humanity and God but stripped away from the fantastical miracles that adorned their life histories once the cult of saints flourished in the fertile ground of the subcontinent.

The book not only explores the more sober Muslim mystics but also provides fascinating insights into the "wild growth" that was in part generated by the unique syncretism that developed as a result of the mixing of popular religion from both Islam and Hinduism, forming a distinct sub-culture, especially in the northwest and north-eastern regions of India. However, Anna Suvorova is careful not to place undue emphasis on the impact of this "wild growth" on the ruling classes, even though she acknowledges that it penetrated the court circles under the influence of a few more liberal rulers, and she is aware that the "wild growth" may have had its roots in the heartlands of Islam itself and not necessarily been due to the "corrupting" influence of Hinduism. However, I felt that she could have made more of this. She recognizes the political significance of syncretism, in that it promoted socio-political stability (p. 6), at least until the relatively recent rise of communalism.

I am not so convinced as the author that the phenomenon of the cult of saints with all of its material dimension is "far removed from Islamic ceremonies, rituals and customs" (p. 6). In taking this stance, Anna Suvorova asserts that there is a normative or orthodox Islam from which the cult of saints has deviated. This is certainly the position of a considerable body of the *ulema* and remains to this day an aspect of the many Wahhabi and Wahhabi-type movements, but I would be wary of describing them as normative. To do so privileges a particular development of Islam dominant in the Arab Middle-East, and by no means the development of the majority of Muslims who inhabit the non-Arab speaking Muslim and non-Muslim world. The situation has never been so clear-cut in its divisions, especially in the subcontinent. Reformed Naqshbandi Sufis such as Sirhindi and Shah Wali-Allah, are venerated by all the *tariqas* but remain closer in outlook to the Wahhabi strands. Their nineteenth-century successors in Deoband and its offshoots retain Sufi characteristics and train their clerics in the exorcism of *djinn*. The hairs of the Prophet's beard found in so many famous Sufi *dargahs* of the subcontinent are also brought out to be venerated by the faithful in the Delhi jami'a masjid, considered to be the most authoritative public voice of Indian Islam.

My only other criticisms may sound harsh in such an excellent work, and they both relate to language. In describing the cult of saints, adjectives and phrases such as "illegitimate offspring," indicate a lack of neutrality and positioning by the author. Other varieties of positioning can be found when the author occasionally compares any discovery of virtue or deep love of humanity among the Sufis and declares it to be Christian. For example, on p. 103, she comments that the ethical maxims of the Chishtiyya are "downright Christian in spirit." I also have problems with the assertion that the relationship between the older Shaikh Farid and his younger disciple Nizamuddin Awliya contained an element of homosexuality (p. 97). It is not to say that homosexuality could not be found among Sufis, but the language of romantic love used to describe the relationship between master and devotee can refer to a platonic relationship whose sublimity is known only to those so smitten.

For me, as much as I loved the stories of the saints and the renderings of their poetry at a personal level, my academic interest was aroused by the descriptions of the material dimension of the popular religion that occurs throughout the subcontinent at the countless shrines containing the tombs of pious Muslims elevated by common impulse to sainthood. Few visit the shrines for reasons other than the pragmatic—the curing of diseases, or the desire for fertility and success in their everyday life. Although there are commonalities of architecture, dress codes, rituals, prayers, and custodians, there is also an extraordinary range of diversity among shrines.

The author provides a fascinating insight into the close relationship between the cultic legends and the nature of the ceremonies and rituals. All ritual acts conducted at the shrine sites have their explanation in a legend that usually points back to an incident in the life of the saint. As demonstrated by Eliade, myth and ritual coexist. At times, local legends support local myths but universal legends support the behavior at the threshold of tombs such as kissing them, circumbulating the shrines, or sweeping the dust. So vivid are Anna Suvorova's descriptions of the material dimension of Muslim shrine veneration, especially in those places that I am so familiar with from my own field excursions, that on reading about them, I longed to return.

This special form of religious veneration remains vibrant in all nations of the subcontinent, in spite of the rise of communalism, religio/political orthodoxies and the creation of Muslim nations. It can unite people of different ethnic and religious communities and transcend the frontiers of newly created states. I know how

much my Sufi informants in Britain, of Pakistani origin, envy my freedom to visit Ajmer or Nizamuddin in Northern India, making me aware that the countless shrines create a topology of the subcontinent distinct from geography and national borders. Anna Suvorova makes us aware of the vitality of this vibrant tradition, and highlights that the relationship between living saint and future shrine centers continues unabated, not relegated to history but a continuous process of tradition construction embedded in the relationship between charisma, tradition, the material dimension of religion, and the individual's experiential negotiation of these.

the sacred gaze
religious visual culture in theory and practice

Morgan, David. 2005
Berkeley: University of California Press

Reviewed by Stephen Pattison
Cardiff University

In *The Sacred Gaze* David Morgan provides an important introductory text that will help readers in many disciplines to see the value of studying visual culture for the scholarly study of religion. His aim is to move understandings of religion far beyond the creeds and words that have dominated the study of scriptural religions. The book is mainly exemplified in terms of Western Christianity. However, Morgan has a considerable understanding of a number of world religious traditions. He argues that his approach might be applied far beyond the Protestantism of North America, the visual culture in which he is most expert.

Morgan understands gaze as a range of ways of seeing and a set of practices. It is "the visual network that constitutes a social act of looking" (p. 3), encompassing image, viewer, and the act of viewing.

Having established this "thick" understanding of gaze, the first part of the book is devoted to questions and definitions surrounding visuality in religion. Here, in chapter one, visual culture is discussed and defined as, "what images, acts of seeing, and attendant intellectual, emotional, and perceptual sensibilities do to build, maintain, or transform the worlds in which people live" (p. 33). The second chapter examines visual practice and the functions of images, providing a very useful sevenfold typology for the latter that includes imagining community, communicating with the divine or transcendent, and displacing rival images and ideologies. Most images simultaneously perform more than one function.

Modifying an idea from George Steiner, the third chapter innovatively analyses the covenants that viewers make with images. Morgan argues here that seeing is a negotiation of belief and assumption with the visual medium "to empower it to act on those who stand before it" (p. 75). In a sense, what we believe in and trust is what we allow ourselves to see. A very helpful typology of kinds of visual covenants is included.

The second part of the book goes on to look at images between cultures. There is a chapter on the violence of seeing that discusses idolatry and iconoclasm. This is followed by a consideration of the way in which religious images circulate between cultures in mission history, with Morgan again providing a typology of "moments" of encounter.

Part 3 of *The Sacred Gaze* considers the social life of pictures in history. Chapter 6 is a fascinating case study of nineteenth-century visual artefacts which reveal the way in which seeing gender in North American visual culture engendered and disseminated vision. Thus, the absence of the father is reflected and constructed in popular visual artefacts such as engravings in pious books and magazines. The last chapter is an equally interesting historical survey of how the US flag came to supplant the Bible as an icon of patriotism in the cult of US civil religion. Thus Morgan demonstrates that sacred gaze is not confined to overtly religious communities, but affects all groups of people, everywhere.

The Sacred Gaze has many strengths. It is interesting, stimulating, informative, and lucidly written throughout. Morgan conveys his considerable knowledge and understanding lightly to his readers. He begins to articulate and systematize many aspects of gaze and vision which, to many readers, will be unthought and disorganized phenomenological "knowns." His expositions of complex, contested concepts like gaze and visual culture are magisterial and clear.

The book is at its most intellectually challenging and innovative in the first three

chapters, especially in the typification of the functions of images and the exploration of different kinds of visual covenant with images. It is at its most interesting and gripping when Morgan deploys his considerable analytic talents and powers of interpretative expression upon specific examples of images, for example, in the discussion of the correspondence between images and words using the specific works of Magritte and religious artists in Chapter 3. It is at its most erudite and informative when Morgan is on his home territory, analyzing nineteenth-century Protestant religious images from primary sources such as books, prayer cards, and pictures.

What of the limits of the book? First, there were moments when I felt that rather than being one book in three parts, this was an assemblage of three different books—one about visual culture, theory, and religion in general, one about specific visual artefacts, and one about nineteenth-century US Protestant religious visuality. Each of these would be very worthwhile in its own right, but they are not always completely complementary. Morgan glosses the coherence of the book well, but there are necessarily unevennesses, cracks, and gaps that arise from the very different approaches and types of material that he expertly deploys.

Second, the book exists somewhat uneasily somewhere between being a student textbook and a monograph for scholars. The originality and complexity of thought together with the detail of analysis suggest the latter as a readership, while the wide exemplification and level of basic discussion in places suggest the former. I would welcome an additional book which built on the achievements of the present work, one more oriented to students and ordinary seers which helped them to work through images and artefacts more thoroughly using Morgan's analytic insights and tools as templates. I hope Morgan will address this in future; he undoubtedly has the enthusiasm and skills to produce a more "hands-on" guide to sacred gaze.

These are minor criticisms. *The Sacred Gaze* is to be thoroughly recommended to those senior students, scholars, and general readers who want better to understand religious visual and material culture. There is no doubt that Morgan succeeds in demonstrating the overall importance and interest of visual culture for understanding religion, both historically and in contemporary cultures.

an archaeology of images
iconology and cosmology in iron age and roman europe

Aldhouse-Green, Miranda. 2004
London and New York: Routledge

Reviewed by Martin Henig
Wolfson College, Oxford

Here is an erudite and wide-ranging survey of images, for the most part from northern Europe. This is a part of the ancient world where religion can only be viewed through its material remains, even in the Roman period, and so explanation of provincial paganism has to be at best very tentative.

The images discussed are very varied. While some are undoubtedly intended to receive veneration, others change their purpose over time. We find representations of sacrifices (including human sacrifices), of votaries, images used in sympathetic magic, and for apotropaic purposes, in human and animal form. None of these need surprise us. The problem with the book's approach to its subject is that it remains too earth-bound. There are plenty of images, but where is the worldview? Its most glaring fault is that it is far too rooted in fashionable modern anthropological jargon and sociological theories. With the best will in the world, no modern writer can ever be a witness to how people felt in the past. Thus, bringing in ethnographic examples of barely understood practice in other parts of the world will be irrelevant unless one believes (as I do not) that what one finds in an image has its origin in an underlying natural history. Subjects such as "gender" and "resistance" probably rank as large as they do in the book simply because they are ways in which a modern post-Colonial and multi-racial world tries to understand itself, but they surely reflect our problems rather than those of the creators of the images.

Gender is, nevertheless, an interesting issue and, to be fair, Aldhouse-Green rightly avoids the pitfall of seeing the subject as just about women, and realizes that this is a very complex area. It is, however, even more complicated than presented

here. Thus, Ferris's exposition of the Aphrodisias relief on p. 75, as an image of Claudius raping Britain (a rather curious application of Hellenistic art by local sculptors in Asia Minor to a far-away event), is mentioned by Aldhouse-Green, but not the fact that the same type of bare-breasted Amazon was employed as the Roman type of Virtus, i.e. as Roman power. The mother-goddesses, sometimes seen in triads, are clearly images of power too, and evoke for us thoughts of the Virgin, again a subject requiring thoughtful exploration.

However, the idea that, in the conditions of the Roman Empire, sculpture was produced as an act of resistance to Roman culture was always rather a simplistic one. Any assiduous church visitor will be aware that some Romanesque sculpture in village churches will be no more than a child-like parody of the great works of art at Lincoln or Autun, though few would doubt that the same deep faith informs them. To see some of the simple Cotswold carvings on inferior cuts of stone (of hooded genii, for instance) as being deliberately non- or even anti-Roman is a deduction we are not entitled to make.

Lurking in the pages of the book, and what makes it worth our perseverance, are a range of wonderful images of Gallo-Roman or Romano-British origin, which show how the educated and ruling elite of the north-west provinces captured and gave "a local habitation and a name" to ideas which classical art allowed them to communicate. Some are well known and even find a place in Graeco-Roman literature, such as Epona, the pony goddess (Figs 8.6, 8.7), whose artistic origin lies with depictions of Europa on her bull. Mercury can be an old man, a concept not totally foreign to Classical thought, although it was so to art until the carving of the splendid statue from Lezoux (Fig. 8.1). Tricephalic images had long been a feature of Classical art, on gems, for example where they served to protect against the Evil Eye (though two-faced Januses were commoner), but the imagination of those who created images like those in Figs 7.14 and 7.15 augmented an already powerful metaphor for all-seeing divine power. Often nature is viewed attractively and benignly in images of hunter-gods like those from Le Donon, Vosges (Fig. 5.6) and from Nîmes (Fig. 5.13), who protect as well as control nature. Something more could be made of this aspect of imagery, by including the Cotswold hunter-god probably equated with Apollo and perhaps later influencing a local type of Orpheus. I was especially grateful to find the bird-man from Moux (Fig. 5.17), to which not just the woodpeckers of Picus on the Thetford ring, but a scepter head in the form of Venus with a dove on each shoulder from Ludford Magna, Lincolnshire, provide parallels.

But, of course, these were images venerated by those who created and used them and, if the sympathetic observer feels a slight sense of awe standing before the Reims Cernunnos (Fig. 8.8), then it is because after all it does reflect underlying realities of the relationship of man to the divine world. Historical and poetic imagination is needed to transpose such images into our worldview, demanding a sympathy even greater than that which Rowan Williams[1] demands in our interrogation of Christian texts. The gods of the ancient world met real needs and, not surprisingly, were often later subsumed into saints.

This book is well produced and most of the illustrations are of a high standard. It would have read better if the over-copious references had been relegated to end- or footnotes. In a book which occupied a sabbatical and a great deal of other time it would have been good to have been able to write an entirely positive review. There is much here worth careful consideration. It is a pity that the author was not more disciplined, and did not concentrate on providing a full corpus of Gallo-Roman images which differ from Classical norms and then writing a sympathetic commentary on them based on her own acquired wisdom rather than those of archaeological theorists. Miranda Aldhouse-Green is the only person in Britain who could still accomplish this.

Note

[1] See Williams, Rowan. 2005. *Why Study the Past? The Quest for the Historical Church.*

the impact of buddhism on chinese material culture

Kieschnick, John. 2003
Princeton: Princeton University Press

Reviewed by Shreena Gandhi
University of Florida

The Dhammapada, the Four Noble Truths, the Eight-Fold Path, Zen Koans, the Mahavamsa—these are all textual sources that give one an insight into Buddhist teachings, beliefs, and narratives. In this book John Kieschnick challenges the belief that such textual evidence is the only or best way to study Buddhism. Kieschnick looks at the material culture of Buddhism for a broader and more nuanced comprehension of Buddhism as it is lived and practiced. Though there are Buddhist schools of thought that operate on the total rejection of the material world, Kieschnick points out that this is not a static or popular stance in Buddhist philosophy or religious practice. He writes, "Material culture is as much a part of religion as language, thought or ritual. Hence, unless we appreciate the place of material culture in Chinese Buddhist history, our picture of this history remains skewed and incomplete" (p. 23).

Kieschnick organizes his material culture study into four sections: "Sacred power," "Symbolism," "Merit," and "Accidents & incidentals." Each chapter gives detailed examples of how material culture played many roles in establishing Buddhism in China. In his chapter on sacred power, Kieschnick explains how and why images and relics became important in the lives of many Chinese after the advent of Buddhism. Prior to the establishment of Buddhism in China, images and relics were not venerated in the same manner and the idea that they had sacred power was not applicable. Indian Buddhists brought relics to China for the purposes of devotion, healing, and proselytizing. "Images and relics allowed the ordinary person to experience Buddhism in a manner that was at once powerful and intimate, without the immediate intervention of learned intermediaries explaining what should be felt, what should be understood" (p. 25).

The idea of images having sacred power may have its origins in India; however, material culture did not just come into China from India and remain Indian. Instead, it went through a process of sinicization, which does not imply a process of degeneration; rather, the sinicization of objects "is instead a history of growth and expansion of the potential of objects and conduits of expression" (p. 156). For example, in his chapter on symbolism Kieschnick provides the example that Chinese monks did not blindly adopt the Indian version of monk robes, but instead adapted them over time to their environmental and cultural needs.

Another example of sinicization comes in the chapter on merit. One method by which devotees accrued merit was by commissioning monks to copy Buddhist scriptures. Kieschnick traces the origin of this devotional activity to India; however, the actual making of books was quite popular and sophisticated in China prior to the advent of Buddhism. What Buddhism did was to change attitudes towards books, and it also became a driving force in some technological advances in the making of books. Kieschnick argues that the idea that religious merit could be derived from the production of Buddhist scriptures "fueled the spread and development of Buddhist books in China" (pp. 167–8). Books became objects of veneration for they were thought to have sacred power. Further, since there was high demand for books, monks began using paper and turned to printing methods rather than just copying.

Books were not the only objects altered by technological advances brought about by the advent of Buddhism. In his final chapter, "Accidents & Incidentals," Kieschnick highlights the way Buddhism influenced the non-religious, "less *Buddhist*" aspects of Chinese culture (p. 221). For example, Kieschnick demonstrates how the introduction of the chair into China from India by monks impacted other aspects of household manufacturing and arrangement. The chair is not an object of religious devotion, but instead an object that impacted the local Chinese culture. Kieschnick reminds us that when religion migrates, interacts, and mixes, not only beliefs about the sacred that change, but also the ways in which people arrange and interrelate with their environment.

What is interesting about Kieschnick is that he looks at the migration, the movement of material culture and the ways in which it impacts and is impacted by the local culture to which it travels. Though materials from distant places have their impact, the receiving culture is not merely a passive vessel; rather it is a dynamic organ that interacts with incoming ideas, people, and material culture. Kieschnick is aware that in pre-modern times, the impact of one culture upon another was a slow and diffuse process, one that needed a vehicle, a "powerful cultural force," and Buddhism was that force in China (p. 284). Studying pre-modern Chinese Buddhist material culture is

not only important for the study of Buddhism, it "also alerts us to the importance of objects in the social interactions of any complex, sophisticated culture" (p. 294).

Though Kieschnick's study is on Buddhist objects, it is not completely devoid of text. Evidence of how certain objects were used by Buddhists comes not only from ancient archeological evidence, but also from ancient text. He ascertains the attitudes towards and uses of ancient Buddhist objects from the writings of Indian and Chinese monks (as well as contemporary scholarship). Thus it is important to remember that Kieschnick's study revolves around male monks, who were probably elites since they knew how to write. Kieschnick does touch upon the gender discrepancy, admitting that he was unable to find any writings by nuns that address material culture, but he does not address the class issue. Perhaps a small section on sources and the point of views these sources illuminate or darken would have helped.

Kieschnick's book is a rich study, full of fascinating details, which come together to give a different picture of ancient Chinese Buddhism and a different view of what constitutes religion. The focus on material culture allows Kieschnick to criticize the view that Buddhism is a textual/philosophical tradition that does not engage in the material or profane world. Further, such a study contributes to the larger field of religion, for this material evidence forces the reader to question such binary categories as sacred/profane and official/popular religion. What we must look at when studying religion is no longer just text, belief or practice, but also object. *The Impact of Buddhism on Chinese Material Culture* is an important and interesting contribution which moves us forward in the study of Buddhism and religion.

outlook

creating *heaven & hell—and other worlds of the dead*
the curator's view

Heaven & Hell—and Other Worlds of the Dead was the name of the Millennium exhibition of the National Museums of Scotland (NMS), held at the Royal Museum in Edinburgh and on display from July 2000 to February 2001. Principal sponsorship was by the Heritage Lottery Fund, and the exhibition formed part of the Scottish Millennium Festival. It was accompanied by a book of the same name and a program of associated events. My involvement in these was as the Lead Curator of the exhibition, editor of the book, and presenter of talks; I was also interviewed in a television program about the exhibition that was made by Eyeline Media on their own initiative, and broadcast by Scottish Television. I took over the project 18 months into its 36-month preparation period, when the previous Lead Curator, ethnography curator Briony Crozier, left for a new job in Belfast. My own background, as the then Assistant Keeper of Archaeology at the NMS, was in the prehistoric archaeology of Britain and Ireland, but my first degree had been in Archaeology and Anthropology. This served me well in handling the wide range of material (mostly from the NMS's own collections, and including some specially commissioned pieces) and themes involved in the exhibition. My recent experience, as part of the curatorial team that created the Early People gallery of the Museum of Scotland in 1998, equipped me with the requisite rigor in the construction of a strong narrative for both the exhibition and the book.

The exhibition had been the joint brainchild of Briony and of Mark Jones, the then Director of the NMS. The choice of topic—people's beliefs about death and what happens afterwards—was a deliberately challenging one; the subject matter was potentially of universal interest, and it was thought that a Big Subject such as death would be a suitable way to mark the beginning of a new millennium. The intention was to create an exhibition that, by showing how people had approached and dealt with this topic around the world and across 6,000 years, opened visitors' eyes to the diversity of human responses and to certain recurrent concerns, practices, and beliefs. Pitching the exhibition correctly was of crucial importance: with such a sensitive subject, it was necessary to appeal to as wide an audience as possible in an accessible and entertaining way, while avoiding ghoulishness on the one hand and triviality on the other. The sensitivities of various faith groups were also a major consideration. Preparation for the exhibition involved much consultation with, and participation by, representatives of such groups in Scotland, with the net cast wide to include pagans and atheists.

The exhibition was held in the large Temporary Exhibition Gallery, and its entrance zone—that led the visitor away from the bustling Main Hall of the Royal Museum and into the quiet interior of the Gallery—was designed as a liminal, dream-like zone where pale-colored opaque panels asked the visitor "What happens after we die?" and offered quotes such as J.M. Barrie's "To die is an awfully big adventure." The exhibition's 500 square meters were structured into five themes (also followed in the book):

- *Farewell to the Dead* presented funerary practices as a rite of passage involving (*inter alia*) a separation of the dead from the living. It focused on funerals and on the treatment of the body. A Ghanaian "fantasy coffin" funeral, featuring a coffin shaped as a Mercedes-Benz, was contrasted with a traditional Scottish Presbyterian funeral, and various treatments of the deceased's bodies were presented, ranging from those that focused on maintaining the body's integrity (for example, traditional Judaeo-Christian-Islamic burial) to those featuring its disintegration, destruction or transformation (for example, cremation).
- *The Final Journey* covered the common belief that death involves some kind of journey

FIG 1
Miniature coffins found concealed on Arthur's Seat, Edinburgh. Photo: NMS

into another world or mode of existence. It covered transport imagery (for instance, Egyptian miniature boats); natural places portrayed as gateways to the Otherworld; devices designed to protect the deceased on his/her journey; and other items deemed necessary for the journey (such as food and drink).

FIG 2
Model of butchery and bakery, Sidment, Egypt. Photo: NMS

FIG 4
Si galegale funerary puppet from Sumatra. Photo: NMS

FIG 3
Finds from the graves of medieval bishops, Whithorn, Scotland. Photo: NMS

- *Otherworldly Possessions* dealt with the kind of material that accompanies the dead and explored the reasons for its choice. It covered the portrayal of identity; literal interpretations of the afterlife; and the inclusion of talismans to communicate the wishes of the living to the world of the dead, or to protect the living or the deceased.
- *Worlds of the Dead* investigated the ways in which the afterlife/Otherworld is conceptualized by those who believe in it, featuring four main variants of belief: 1) belief in an ultimate destination or state of existence (for example, Heaven or Hell); 2) belief in reincarnation; 3) belief that the deceased joins the world of the ancestors/spirits and gods; and 4) that death is the end. Finally
- *The Living and the Dead* examined various ways in which the worlds of the living and of the dead are intertwined, exploring the themes of commemoration and communication, and ending with a video of interviews where members of different faith groups presented their beliefs about what happens when we die, and a bulletin board where visitors could add their own versions.

The display material was chosen for maximum impact and memorability, and included a full-sized reconstruction of a Mexican Days of the Dead market stall, a set of Singaporean paper offerings for the dead (which included Bank of Hell money, travel tickets, and passport), and Sean Read's Elvis sculpture, *Return to Sender*, complete with its fluorescent halo. There were also some items to make the visitor laugh as well as think, such as an image of the gravestone of Mel Blanc, the voice of Donald Duck, with its epitaph: "That's All Folks". The book also contains a section on death-related humour.

Reaction to both the exhibition and the book was overwhelmingly positive: the exhibition

attracted a record-breaking 96,000 visitors, and reviews of the book were universally favorable. Visitor comments included those from people who had found the experience therapeutic and cathartic; criticisms were very sparse and predictably religious-fundamentalist; and spin-offs from the exhibition included the creation of a dance performance inspired by the exhibition, *The Dearly Departed* (sic), by Alan Greig's Xfactor Dance Company. Those involved in the "business" of death—such as undertakers and the Humanist Society—commented that the exhibition had helped to raise awareness and generate discussion; and the various contacts that had been forged in the preparation of the exhibition have served the NMS well in subsequent initiatives designed at cultural inclusivity. The impact of *Heaven & Hell*... continues to the present, some six years after the event, with curators, lecturers, and others involved in the intellectual "industry" of death-related studies still writing in with queries. The whole experience has convinced me that the careful preparation and effective communication of serious messages in a scholarly but accessible way are both possible and hugely rewarding.

Alison Sheridan
National Museums of Scotland

jewish heritage uk

2006 marks the 350th anniversary of the resettlement of the Jews in England. In 1656, during the Puritan Revolution, Jews returned to this country after an absence of nearly 400 years. Medieval Anglo-Jewry had been expelled by Edward I in 1290—the first recorded mass expulsion of the Jews in medieval Europe. Jews from Amsterdam came back to England in the wake of Rabbi Menasseh Ben Israel's petition to Oliver Cromwell, during the brief period when England was a republic. British Jewry has enjoyed a history of continuous settlement ever since, a record unrivalled anywhere else in Europe. According to the latest figures (2001 Census) the Jewish community comprises about 267,000 people, down from a peak of about 450,000 in the 1950s. Less than 1 percent of the total population of the UK, Anglo-Jewry in fact occupies the status of England's oldest non-Christian faith community.

Protecting the material cultural heritage of Britain's Jewish community—synagogues, cemeteries, archives, artefacts, and ritual silver—is the primary task of Jewish Heritage UK. Set up in 2004 with a grant from Hanadiv Charitable Foundation, Jewish Heritage UK fills an important gap by providing independent professional support to congregations, trustees, and synagogue organizations which are responsible for historic buildings, sites, and collections. They can turn to Jewish Heritage UK when faced with the challenges posed by such issues as maintenance and management of historic buildings, practicalities of carrying out repairs to conservation standards, guidance through the listing and planning processes and, above all, finding imaginative ways of keeping fine old buildings usefully alive.

In addition, Jewish Heritage UK seeks to promote British Jewry's cultural heritage to the wider public by encouraging participation in The Civic Trust's annual Heritage Open Days and the popular European Jewish Heritage Day in September. The latter event is organized by B'nai Brith, a Jewish voluntary service organization with members in fifty-eight countries.

The work of Jewish Heritage UK is underpinned by research carried out for the *Survey of the Jewish Built Heritage in the UK and Ireland*. This thematic building recording project was begun in 1997 with the support of English Heritage and the Heritage Lottery Fund and has attracted funding from, amongst others, the Royal Institute of British Architects (RIBA), The British Academy, and the Arts & Humanities Research Council through the University of Manchester.

Arising from the survey, a number of publications have already appeared including a full-color site guide titled *Bevis Marks Synagogue 1701–2001* published by English Heritage to mark the tercentenary of Britain's oldest synagogue in the City of London. In 2006, to mark the 350th anniversary of the Resettlement, English Heritage is publishing the first ever architectural guide to *Jewish Heritage in England*. This will include heritage trail maps of the old Jewish quarters of the East End of London, Manchester, Birmingham, and Brighton. A major academic study of British synagogue architecture, *The Synagogues of Britain and*

FIG 1
Middle Street Synagogue, Brighton (Thomas Lainson, 1874–5, Grade II Star Listed), with a sumptuous High Victorian interior, awarded English Heritage and Heritage Lottery Fund grant-aid in 2004. © English Heritage/ Nigel Corrie

Ireland: An Architectural History, is also in preparation, sponsored by The Paul Mellon Centre for Studies in British Art together with the Arts & Humanities Research Council.

Whilst the remit of Jewish Heritage UK is officially confined to the UK, the *Survey of the Jewish Built Heritage* has also conducted fieldwork in the Irish Republic, the Channel Islands, and Gibraltar, the latter in conjunction with the Gibraltar Heritage Trust. A separate guidebook, *Jewish Heritage in Gibraltar*, is planned to mark Gibraltar Jewry's own anniversary of 300 years of Jewish life under British rule. Gibraltar's 600-strong Jewish community, which, like England's, emerged unharmed from World War II, has four historic synagogues, the oldest of which, Shar HaShamayim ("Gate of Heaven") or the Gibraltar Great Synagogue, was founded in 1724 by Isaac Nieto of London. Rebuilt several times, the present building largely dates from 1812 and shares features with the parent Spanish and Portuguese synagogues of Amsterdam (1675) and London's Bevis Marks.

More information at www.jewish-heritage-uk.org

Sharman Kadish, *Director*

the rubin museum of art:
re-framing religion for aesthetic spirituality

Opened in New York on October 2, 2004, the Rubin Museum of Art (RMA)'s mission is "to establish, present, preserve and document a permanent collection that reflects the vitality, complexity and historical significance of Himalayan art."[1] The seed for the RMA was planted in 1979 when the founders, Shelley and Donald Rubin, purchased their first *thangka* painting—an image of White Tara. The museum's location, at 150 West 17th Street, was identified in 1998, and the museum was founded in 1999, as a 501(c) (3) not-for-profit trust. The RMA's collection of approximately 1,200 objects includes paintings, sculptures, and textiles that reflect the major periods and schools of Himalayan art from the twelfth century onward and stretches from Afghanistan in the west to Burma in the east. Commenting on the scope of the Rubin collection, dealer Carlton Rochell has described it as "a nearly encyclopedic collection [containing] every subject, every mahasiddha, lama, bodhisattva, and deity in every form you could imagine" (Wallis 2005, 77).

While the collection consists of sculptures and textiles, the majority of its collection is made up of *thangkas*—water-based paintings on cloth

FIG 1
The RMA entrance. Photo: G Grieve.

canvas, which consist of a picture panel which is painted or embroidered, a textile frame, and one or more of the following: a silk cover, leather corners, wooden dowels at the top and bottom and metal or wooden decorative knobs on the bottom dowel. *Thangkas*—which simply means "something that can be rolled up"—originally were produced to be mounted, seen from all angles, and used in religious and health-related rituals (see Leoshko 1993: 16). In their original context, the images were important not for what they meant or who made them, but for their efficaciousness at aiding in a particular situation. Accordingly, rather than emphasizing reversibility, the artist's original intent, or even conservation, the approach of most painters would have been to repaint a damaged image or simply to make a new one (see Bruce-Gardner 1988, 26–31).

One of the chief issues that the RMA has had to face is how to "translate" what are essentially Himalayan religious objects into the space of an American fine arts institution. The RMA, has by its own account, succeeded—at some cost—by transforming the images from ritual devices into aesthetic spiritual images. The clearest indicator of this aesthetic transformation is that the vast majority of the paintings have been literally "re-framed." Their original brocaded silk borders and dust curtains have been replaced with modern silver frames. Some of the reframing occurs simply because of conservation. The silk borders are the most vulnerable part of the paintings, and are quickly weakened by damp walls, the weight of the heavy bottom rod, and especially the repeated rolling and unrolling of the paintings for ritual display. Yet, as Jacques Derrida reminds us in *The Truth in Painting*, rather than mere ornament, the frame is the "decisive structure of what is at stake" (Derrida 1987, 61).

Two discourses are at play in the RMA's re-framing of the paintings. First, the *thangkha* paintings are now displayed as pieces of art to be hung on the museum's walls, and have been encapsulated in the discourse of fine art viewing. According to the opening curator, Rob Linrothe, the RMA did all it could to avoid creating a "faux Tibetan temple… We need to communicate that this is not a Buddhist Museum or a Tibetan Museum, it is an art museum" (Doran 2004: 34). Rather than being displayed as ethnographic curiosities particular to one culture, the paintings are shown as fine art pieces that reflect human creative genius. Museum co-founder Shelly Rubin states, "Certainly we would like people to appreciate this art not on the level of a curiosity but on the same level that they appreciate a Rembrandt or a Monet" (2004, 39).

If the RMA is displaying fine art, what differentiates it from, say, the display of Himalayan art at the Metropolitan Museum of Art? The answer is that the RMA seeks to underscore this fine art's spiritual dimension. The brochure that museum-goers receive along with their admission ticket re-frames *thangkas* in a "symbolic language [that] plays an important part in Himalayan art," one that "communicates directly to everyone."[2] One FAQ from the RMA website claims that the paintings answer the "probing enduring questions of humankind. Himalayan art engages modern consciousness with uncanny precision." And in a volume produced by the RMA, the Buddhist monk Matthieu Ricard argues that the "[a]rt awakens in the mind a direct experience deeper than our ordinary selves and the material world" (Linrothe and Watt 2004: XV). Museum co-founder Donald Rubin suggests that this engagement is possible because "[a]rt comes from the human unconscious… [It] speaks to anyone across cultures and across time" (Doran 2004, 38). At the heart of this interpretation is the notion that viewers of these works will experience an "emotional rush." In Mr. Rubin's words, viewing the paintings is "like when you fall in love—you take a step back and feel the emotional energy coming through" (Doran 2004: 37). This emotional rush is seen as important, because as Caron Smith, the Deputy director, Chief Curator, RMA suggests: "Art is not a thing, it is a Verb. It is something that happens between an individual and an object" (Huberman n/d).

For at least some practitioners of Tibetan Buddhism, the RMA's re-framing of the *thangkas* does not trouble their notions of cultural authenticity. For instance, when asked what they thought of the metal frames, a group of Tibetan monks simply wanted to know where they could purchase similar ones.[3] But because the paintings are re-framed as aesthetic objects,

FIG 2
Members of the Tibetan Women's Association, Tibetan Community of NY/NJ and Students for a Free Tibet outside the RMA. Photo: SFT.

they necessarily are extricated from their social use in religious ritual. On the one hand, the *thangkas* de-socialized display continues a romanticization of the Himalayas region as a timeless Shangrila. On the other hand, it leads to the RMA's genuine bafflement when encountering political protest to its exhibition, "Tibet: Treasures From the Roof of the World," a collaboration with the Peoples' Republic of China's Bureau of Cultural Relics.

> Gregory Price Grieve
> University of North Carolina, Greensboro
> Department of Religious Studies

Notes and References

[1] The official portal for the RMA is http://www.rmanyc.org/ (accessed April 11, 2005).

[2] From a Rubin Museum of Art Pamphlet, Designed by Milton Glaser, Inc [procured January 2005]).

[3] Personal communication with Lisa Schubert, Vice President of Special Projects RMA (April 5, 2005).

Bruce-Gardner, Robert. 1988. Himalayan Scroll Paintings: Conservation Parameters. *The Conservator* 12: 26–31.

Derrida, Jacques. 1987. *The Truth in Painting*. Trans. Geoff Bennington and Ian McLeod. Chicago, IL: University of Chicago Press, p. 61.

Doran, Valerie. 2004. Displaying Benevolence: The Rubin Museum of Art. *Orientations* 35: 34.

Huberman, Martin. No date. *Transformation: Building the Rubin Museum of Art*. DVD. New York: VideoArt Productions.

Leoshko, Janice. 1993. The History of the Art History of Tibetan Art. *Western Association for Art Conservation* 15: 16.

Linrothe, Rob and Watt, Jeff. 2004. *Demonic Divine: Himalayan Art and Beyond*. Chicago, IL: Serindia Publications, p. XV.

Wallis, Stephen. 2003. Fierce Protectors. *Art and Auction* April: 77.

glencairn museum, bryn athyn, pennsylvania

On the morning of 9-11 a group of history students from a Christian school in Pennsylvania traveled to Glencairn Museum for a lesson about Islamic thought and culture, including the nature of Allah, the importance of daily ritual prayer, and the role of women in Islamic countries. In the words of one of them, now a young woman in college,

> I learned about the attacks right after the trip. There was a lot of confusion, but when we figured out that the terrorists were Muslims, I never associated those people with what we had learned. The understanding of the religion I received at Glencairn made me sympathize with other Muslims—the ones who had nothing to do with the attacks. When I picture the rituals I picture good people, not bad people. I think that it was good to have that image established before all of the negative press the Islamic faith got.

Glencairn Museum stands on a hill in the picturesque borough of Bryn Athyn, just a mile from the Philadelphia border. Bryn Athyn was founded as a religious community in the late nineteenth century by members of a Christian denomination known as the New Church. Glencairn, a "castle" built between 1928 and 1939 in a style based on medieval Romanesque

FIG 1
Glencairn Museum, Bryn Athyn, Pennsylvania. Photo Glencairn Museum.

architecture, is the former home of Raymond and Mildred Pitcairn, two prominent members of the Bryn Athyn congregation. The building now serves as a museum of religious art and history. The New Church faith that inspired this unusual museum had its origins in eighteenth-century Sweden, with the spiritual journey of a scientist, philosopher, and theologian named Emanuel Swedenborg.

Emanuel Swedenborg (1688–1772) was born in Stockholm, Sweden. The son of a prominent Lutheran bishop, Swedenborg was

educated at the University of Uppsala. He went on to publish a series of books that established his reputation in Europe as a scientist and philosopher of the first rank. Then, in 1743, at the age of 55, Swedenborg began to experience a series of religious visions that completely changed his life. He shifted his focus away from science and philosophy, and spent the rest of his life writing twenty-five volumes of systematic theology. Although Swedenborg himself never attempted to found a religious organization, New Church groups based on his writings began to appear shortly after his death. His writings were especially well received in nineteenth-century America, and Philadelphia was one of the earliest centers of New Church activity.

In 1876, together with a small group of supporters, the Reverend William Henry Benade (1816–1905) and industrialist John Pitcairn (1841–1916) established the Academy of the New Church in Philadelphia. In an effort to develop a comprehensive system of New Church education, the Academy opened a Divinity School for training ministers, a College, a Boys' School and a Girls' School. In 1877 Benade and Pitcairn left the country on an extended tour of Europe, Egypt, and the Holy Land. Their purpose was to spread the word about the New Church and the Academy and to see for themselves the land of the Bible, which Swedenborg had written about. However, they returned home with something unexpected—more than 1,000 artifacts from the ancient world, purchased, according to Benade, "for the purposes of mythological study" (Rome, November 2, 1878). Benade wrote home that "these things will make the beginning of a Museum for the Academy. I hope that all our friends will bear in mind that we shall need a Museum, and will collect whatever they can find that may be of use for such a purpose" (Rome, December 4, 1878). Of their trip along the Nile, Benade wrote that "the pictures on the walls of some of the Temples, all of them religious, are lovely in the extreme, not so much as mere works of art, but as expressions of the sentiment of profound reverence for the Divine Being, coupled with a deep, confiding love" (Cairo, April 7, 1878).

Why would a nineteenth-century Christian minister admire the religion of ancient Egypt, with its perplexing variety of gods and goddesses? Instead of seeing Christianity as the only true religion, Benade accepted Swedenborg's teaching that the spiritual history of the world was a succession of *ecclesiae* ("churches") or spiritual epochs, each of which had received its own form of divine revelation. To Benade and Pitcairn, the tombs and temples of ancient Egypt were an inspiring attempt to connect with the one true God, a God who had been accessible to all people throughout human history. In New Church belief, God is effectively present in all religions, and people of all faiths are welcomed into heaven after death as long as they have lived a good life according to what they have sincerely believed to be God's will.

While Benade and Pitcairn could be considered co-founders of the museum, the most significant contribution to its history would be made half a century later by John's son, Raymond Pitcairn (1885–1966). When Raymond was still a boy, the Philadelphia New Church congregation and the Academy relocated to the countryside in the Pennypack Creek valley. They named their new community Bryn Athyn, or "Hill of Unity." A substantial donation from the Pitcairns made it possible to begin work on Bryn Athyn Cathedral in 1913. Raymond took over the supervision of this ambitious building project after his father's death in 1916, and the construction of a New Church cathedral was to become his chief occupation for the next twelve years. A cluster of shops for working stone, wood, and metal grew up around the cathedral. The subject matter of the stained glass windows was to be based entirely on New Church teachings, and Pitcairn was determined to duplicate the textures and pure colors of the medieval glass he had admired in European churches. To accomplish this, however, it soon became clear that the craftsmen would need hands-on access to actual medieval windows. Pitcairn began buying medieval glass panels at auctions in New York and from dealers in Europe and America. In time his glass collection would grow to include more than 260 panels

FIG 2
King from a thirteenth-century Tree of Jesse window depicting the royal genealogy of Jesus Christ (see Isaiah 11:1). From Soissons, France, Cathedral of Saint-Gervais-et-Saint-Protais. Photo Glencairn Museum.

and he became an art collector of international importance. Pitcairn continued to collect extensively throughout the 1920s and 1930s and broadened the scope of his collection by purchasing hundreds of examples of medieval sculpture. Bryn Athyn's stained glass artists and stone carvers were now provided with many works of art from the medieval period as a source of information and inspiration. Today the Pitcairn medieval collection is regarded as one of the finest in the country.

As a Christian, Pitcairn had a natural affinity for the religious symbolism found in many of the medieval works that he owned, especially ones depicting stories from the Bible. But as a member of the New Church, Pitcairn believed that God had been present in even the most ancient religions. It may have been for this reason that his collecting interests broadened as time went on. In addition to Christian art, Pitcairn acquired art from ancient Egypt, the ancient Near East, ancient Greece and Rome, and a few objects from Asian and Islamic cultures.

As the cathedral project began to wind down in the late 1920s, Pitcairn began to consider how to provide his art treasures with a proper setting. Above all else, Glencairn was intended as a home for his family, and it was designed so that the children's rooms would have an excellent view of Bryn Athyn Cathedral.

FIG 4
The north wall of Glencairn's Great Hall. The north and west walls feature six full-scale replicas of windows in Chartres Cathedral, five of which were reproduced from nineteenth-century tracings made directly from the glass at Chartres. The east wall is filled with original panels of French stained glass from the twelfth and thirteenth centuries. Photo Barry Halkin.

FIG 3
Raymond Pitcairn (1885–1966) looking at an early model of Glencairn. Photo Glencairn Museum.

Glencairn's Great Hall and Upper Hall feature dozens of medieval sculptures (built into the fabric of the walls and also freestanding), medieval stained glass panels mounted in windows to receive natural light (including six full-scale replicas of windows in Chartres Cathedral, some of which are 22 feet high), together with frescoes, paintings, tapestries and oriental rugs from a variety of periods. Pitcairn intended these works of art to exist in aesthetic harmony with the hundreds of images in stone, wood, stained glass, and mosaic that were inspired by the teachings of the New Church and created by Bryn Athyn craftsmen. The Pitcairn family moved into Glencairn in 1939. Raymond died in 1966 and the home remained in the family until the death of his wife, Mildred, in 1979. At this time the modest holdings of the Academy's museum (which until then had been housed in a room of the library) were moved to Glencairn and merged with the impressive Pitcairn collections to create what is now known as Glencairn Museum. Along with the new collections and the remarkable facility in which to preserve, exhibit, and interpret more than 10,000 objects, the Glencairn Foundation provided the

FIG 5
Glencairn's Great Hall and Upper Hall feature dozens of medieval Christian sculptures, some of which are built into the fabric of the building. Photo Christopher Smith.

museum with an endowment sufficient to hire a full-time, professional staff.

Today Glencairn Museum continues its primary role as a teaching museum, with a mission that has remained essentially unchanged since Benade and Pitcairn founded it. The opening paragraph of the most recent version of the mission statement reads as follows:

> Glencairn Museum exists to educate a diverse audience about the history of religion, using art and artifacts from a variety of cultures and time periods. We seek to build understanding between people of all beliefs through an appreciation of common spiritual history and values. The Museum's special focus is to preserve and interpret the art, culture, and history of the New Church.

In the 1990s the museum began to further explore the potential suggested by its mission. Glencairn began to offer more guided tours, concerts, lectures, and special events to the general public and it became a popular destination for classes from public and private schools. While the museum's staff welcomed the opportunity to reach out to new audiences, this development also presented certain challenges. American public schools have been downplaying the role of religion in the classroom since the 1970s. In the words of one Glencairn Museum educator, in the early years "public school teachers would say to me, 'You're not going to talk about God are you? We aren't allowed to talk about religion, you know.'"

This problem was complicated by the fact that the topic of religion has traditionally been avoided by our peer institutions. While museums contain many of the world's greatest examples of religious art and artifacts, it is difficult to leave a typical art museum having learned very much about the religious motivations that lie beneath the objects. Where was Glencairn, an institution with the expressed goal of being a "religion museum," to look for role models? We were delighted to discover the groundbreaking book *Godly Things: Museums, Objects and Religion* (edited by Crispin Paine, 2000). We also began to notice the opening of other "religion museums," notably the St. Mungo Museum of Religious Life and Art in Glasgow, Scotland (1993), and the Museum of World Religions in Taipei, Taiwan (2001). This seems to us to represent a tide change, a transformation we have also observed in talking to public school teachers, who now feel more free to include religion in their lesson plans. According to one of our museum educators, "I no longer hear objections to discussing religion; in fact, the teachers welcome a forum that ties religion into their history curriculum."

Glencairn Museum's galleries, many of which are housed in former family bedrooms, include spaces devoted to Ancient Egypt, the Ancient Near East, Ancient Greece, Ancient Rome, Asia, American Indians, and several galleries for medieval stained glass, sculpture, and treasury items. A special study gallery focuses on artists influenced by the writings of Emanuel Swedenborg. Over the past ten years, many of the galleries have been reinstalled to make the museum's religious focus more explicit. For example, the Egyptian gallery features special exhibits on mythology, the pantheon, and funerary magic, as well as two miniaturized dioramas—one illustrating the ritual aspects of mummification and another depicting the mythical judgment of the dead in the afterlife. In the Ancient Near East gallery, a detailed model of the tabernacle of Israel explains the biblical context of the tabernacle and the rituals associated with it. The Greek and Roman galleries focus on the role of religion in society by presenting religious objects within their broader cultural context. A new exhibit space is being planned that will accommodate two or three temporary exhibits per year, each on a different religious theme.

In the area of public programs, the "Highlights Tour" interprets Glencairn from two different (but complementary) perspectives: as a museum of religious art and as the former home of a New Church family. Several special "History of Religion Tours" (for example, "Life in the Afterlife" and "Angels, Devils and Spirits") have been designed to show how, throughout human history, art has served as a concrete expression of the religious worldview of the

artists who created it. Glencairn Museum also offers lectures, concerts, and a variety of other programs for the general public. Lecture topics have been wide-ranging, including Pre-Rabbinic marriage ritual, *The Da Vinci Code*, and Swedenborg's global influence, and a discussion was held about *Wisdom from World Religions* with the author, Sir John Marks Templeton.

However, we believe we have only begun to explore the possibilities implied by our mission statement. The interpretation of the visual culture of religions can be a tricky business and we often feel the need for outside help—not only from art historians, cultural historians, and modern adherents of these religions, but from other educators who find themselves on the "front lines." We would welcome a network or organization for professionals at museums and historic sites who are interested in interpreting religion for the general public.

Ed Gyllenhaal
Curator, Glencairn Museum, Bryn Athyn, Pennsylvania, USA

all about evil

The presence of evil is undeniable. However hard we try, our health, peace, and harmony are threatened all the time: by crime, accidents, tornadoes or failed crops. We fail our exams, loose our loves, and get sick. Difficult to understand, difficult to accept.

This existential struggle between good and bad has deeply influenced the views of life of humankind. It found an expression in origin myths, epic stories and religious texts as well as in children's stories and movies. In the same way it found its way into religious art and ritual objects.

In December 2004 a large exhibition was launched in the Tropenmuseum, Amsterdam, entitled *All about Evil*. More than 600 objects were brought together from different cultures, from ancient to contemporary times, from high art to popular culture. Egyptian papyri

FIG 2
The hero Rama fights the demon Ravana. Scene from the Ramayana, color lithograph, early twentieth century, 25 × 17.5 cm. Collection Tropenmuseum Amsterdam. Photo Irene de Groot.

FIG 1
A life-size Kali image at the entrance of the exhibition. Collection Tropenmuseum Amsterdam. Photo Tropenmuseum.

were shown next to comic books, Christian icons, Hollywood movies, Mexican masks and Islamic brochures. The exhibition was not about "real life evil" but about the human, cultural response to the existence of evil. How do people, in the sphere of religion, ritual and fantasy try to understand, visualize and cope with evil? This question formed the structure of the exhibition.

FIG 3
A Nigerian poster shows how witches can change themselves into all kind of animals. Design by R. Nkonta, ca. 2000, 91 × 62 cm. Collection Tropenmuseum Amsterdam. Photo Irene de Groot.

The Origin of Evil

In the first section of the exhibition objects were shown from four different cultural complexes: pre-Columbian art, Hindu and Buddhist art, African art and objects from the monotheist religions, Judaism, Christianity and Islam. The objects made clear that in most religions the concept of evil is not represented by a clearly defined character. Evil is often not seen as a separate, autonomous entity but as an integral aspect of the God(s) or spirits. Good and bad are two sides of the same coin. Kali, who is especially popular in the Indian state of Bengal, is a clear example. Every year during large festivals life-size images of Kali are venerated. Afterwards the images are thrown in the river, a process that in itself reflects the eternal balance of creation and destruction. Kali is represented as a horrifying figure, with black skin, her tongue sticking out of a bloody mouth, weapons in her six arms. Around her neck is a garland of decapitated heads. She dances madly on top of her husband, Shiva. A chilling spectacle.

Still, the message is not negative. For her followers Kali Ma is a maternal protectress. She destroys enemy demons. Her fury is directed to evil forces. But the scene also highlights the downside of fury: carried away by her own anger she ends up destroying everything, until finally she tramples on her husband. Then she stops in shame and sticks out her tongue. That is the moment that is depicted. When we look closer she does not even look that demonic. Her face is that of a female beauty with long hair.

The Face of Evil

Threats that cannot be seen are especially unnerving. To give a face to evil gives a certain control. Caught in a figure, a mask or a drawing, evil can be kept at a distance or even laughed at.

Part two of the exhibition formed a thrilling parade of devils, demons, and witches, from all parts of the world. In this line-up certain patterns became clear, such as the worldwide use of animal iconography. Everywhere depictions of supernatural evil are typified by the presence of fangs, claws, horns, tails, and wings. The reasons are clear. The animal world is seen as a world close to but also opposed to the human world. Supernatural evil has been connected to that other world. In the visualization people have used specific elements of animals that are somehow scary: violent predators, or bats or owls that move around at night.

Animal elements also typified the customary portrayal of the devil. In early Christian times he

FIG 4
The Balinese demon Kala Sangsung, gouache on paper, painted by I. Dewa Gede Soberat, ca. 1940, 32.5 × 24 cm. Collection Tropenmuseum Amsterdam. Photo Irene de Groot.

games the visualization of supernatural evil finds a dazzling variety of faces.

Dealing with Evil
The feeling that threats surround us leads people to look for protection. Supernatural evil requires supernatural protection, such as that provided by amulets. In the "house of amulets," centrally located in the exhibition, the magic–religious logic behind amulets becomes visible. Eye symbols to ward off the evil eye are to be found on ancient Greek drinking vessels and contemporary Turkish key rings. The use of hands is easy to understand, that of a tongue or phallus less so, but they too are common on sculptures that protect village houses. Protection is a way of magically influencing the forces that might bring evil upon us. It is usually seen as the work of priests or ritual specialists. They produce magical substances—the Congolese Ngangas for instance produce substances with which to load the *nkisi*, the power figures. They use texts and formulas, written down or chanted. They can cure people who are possessed through exorcism.

Contemporary youth culture seems far away from this ritual world where magic meets religion. Therefore it is striking that in different areas of youth culture, including rock music, gothic fashion, and tattoos, the themes, symbols, and appearances of evil seem to thrive. In many ways this is a rather harmless flirtation. One can wonder, however, whether the present-day obsession with horror is a sign that the ancient existential fears are still there. The eternal threats to our lives do not diminish, they simply take on another appearance. The public success of the show seems to underline this awareness. In nine months it received 130,000 visitors, including many young people.

FIG 5
The Dutch gothic couple Medusa and Crudelia, 2004. Photo Fabio Valliante.

was usually depicted as a dragon. Later on a more anthropomorphic character took shape. Ugly and scary, with black or red skin, fangs, claw-like hands, sometimes (bat) wings, goat legs, and horns, sometimes even with reptile scales.

Interestingly, it is especially outside the religious realm that demons, devils, and witches thrive. In movies, comic books, and computer

Paul Faber
Tropenmuseum, Amsterdam

new christian museums in kerala

In the last few years several Christian museums have opened, under episcopal patronage, in the South Indian state of Kerala. These institutions have the laudable objectives first of educating local Christians in their religious and cultural heritage, and second of preserving objects which might otherwise disappear into the antiques trade. However, the museums also have a propaganda role, reflecting Kerala's complicated ecclesiastical politics.

Christians compose a fifth of Kerala's population, and visitors to the southern half of the state may be forgiven for thinking that they have arrived in a Christian country. However, the community is split into numerous denominations which often have discordant mutual relations. In one dimension it is split confessionally into Catholic, Syrian Orthodox, Reformed, and Nestorian. Equally important is the division

between the so-called St. Thomas Christians and the rest. The St. Thomas Christians, also know as "Syrians" after their Syriac rite, predate the arrival of the Portuguese and believe that their church was originally founded by St. Thomas the Apostle ("Doubting Thomas"). Kerala's other Christians are all ultimately descended from the converts of Catholic or Protestant missions. At the root of all this, as with so much in India, is caste. On the eve of Vasco da Gama's landfall in 1498 the Syrians were an endogamous aristocracy accepted by the dominant Hindu caste, the Nairs, as their caste equals. To say that they were lukewarm about the efforts of St. Francis Xavier and others to widen the Christian fold to include large numbers of untouchable fisher-folk would be an understatement. To this day intermarriage between, say, a Syrian Catholic and a Latin Catholic is uncommon.

Much the best of the recent museums is the Indo-Portuguese Museum in Fort Cochin. The dream-child of the former Latin bishop of Cochin, the late Joseph Kureethara, the museum is housed in a specially constructed building in the grounds of Cochin Bishop's House. Bishop Kureethara was a forceful prelate who was extremely conscious that his was a Padroado see, founded by the Portuguese. The walls of Bishop's House were painted with maps and tables all showing Cochin as one of the centers of the ecclesiastical universe. Kureethara was a regular visitor to Portugal, and the reason that the museum is so well appointed is that he persuaded the Gulbenkian Foundation to set it up. He died in 1999, a year before the museum opened.

Despite its name, the museum does not really devote much attention to explaining the Portuguese ecclesiastical or artistic legacy. This is perhaps better addressed by the Museum of Christian Art in Goa. What the Cochin museum does achieve is to bring together a fine collection of Kerala's religious artefacts including carved votive images, paintings, liturgical vessels, crosses, crucifixes, candlesticks, altar decorations, medallion reliquaries, vestments, early missals, and bibles. There are also a few larger objects including part of the altarpiece saved from St. Francis's church when it was converted by the Dutch for Calvinist worship in the seventeenth century. A hexagonal pulpit, known in Malayalam as "pushpa" ("flower"), does indeed look like a flower growing out of a curved stem debouching from the mouth of an animal set into the wall. All these items are well displayed and clearly captioned (though unaccountably in English but not the vernacular) so that provenance and realistic estimates of date are given. A number of much higher profile

FIG 1
Seventeenth-century altarpice from St. Francis's Church, Cochin, with a display of *ramshetti* (gilded wooden altar decorations). *Source*: Author

museums in the subcontinent could profitably learn from this small museum's example.

The other three recent museums are all under the aegis of the Syro-Malabar Church, the main Syrian Catholic denomination. The first is located at St. Thomas Mount, the seat of the Cardinal Archbishop of Ernakulam, at Kakkanad, about 7 kilometers east of Cochin. Unlike the Cochin museum, this is well off the tourist track and is aimed more at groups from schools and religious institutions. Again there is a display of devotional items, but the museum also includes an ethnographic collection of objects used in the everyday lives of the St. Thomas Christians. These are not hugely different from those used by other communities, but since they are not adequately represented in Kerala's state museums the Christian museum is here plugging an important gap.

With an eye to the school groups, the museum also has plaster tableaux, lit with son-et-lumière theatricality, illustrating important episodes in the history of the St. Thomas Christians. Naturally St. Thomas himself plays the central role. Here again there is an element of propaganda. A crucial event is St. Thomas's conversion of a group of Nambudiri Brahmins. The idea that the early converts were Brahmins is central to the Syrians' caste identity, and

until recent times the church was dominated by important priestly families claiming descent from these converts. Recently the eminent historian M.G.S. Narayanan has challenged this tradition, arguing that the spread of Brahminism from northern India did not reach Kerala before the seventh century CE, so that in the first century there would have been no Nambudiris to convert. Such quibbles have made little impact on the Syrian community's self-perception.

The place where this conversion is thought to have taken place is Palayur, near Chavakkad, about 70 kilometers north of Cochin. This is one of seven churches which St. Thomas is believed to have founded. Now rebranded as the St. Thomas Archdiocesan Shrine, it is being developed as a sort of St. Thomas theme park, and as part of this a grandiose museum building in "hotel-vernacular" style was opened in 2004. At present the project is still at an early stage, with an uneven collection of votive images and ecclesiastical paraphernalia spread out on tables, and minimalist captions. There is also a group of largely unexplained but intriguing stone objects including a prehistoric umbrella stone. At present the small collection rattles around in the large display space, but no doubt in time it will expand and improve.

If Palayur has a display area too big for its collection, the reverse situation exists at Palai, a remote but beautiful Indo-Portuguese cathedral situated, again well off the tourist trail, about 30 kilometers north-east of the Christian center at Kottayam. The Golden Jubilee Museum once again has a small but interesting collection combining devotional objects with everyday artefacts. However, in the absence of a dedicated building, this is exiled to some upstairs rooms in the St. Thomas Printing Press on the Ettumanur road about a kilometer away from the cathedral. To have three Syro-Malabar museums in Kerala is to spread the available material a bit thinly and there is a strong case for amalgamation. However, this seems unlikely, not least because Palai is in a different archdiocese from the others.

Anyone touring Kerala's churches cannot fail to be impressed by the level of devotion and local pride shown by the Christian community. However, this pride now often takes the form of a passion for "renovation" of church buildings, with the result that Kerala's architectural heritage is rapidly disappearing. The reversal of this trend will require a revived interest in the community's artistic heritage, and museums clearly have a role to play in fostering this. They could also provide a focus for interaction with the state archaeological department and for much needed training in conservation techniques, an area where Western countries could provide vital support. But the best place to preserve church art is in churches and it will be a sad irony if in fact the museums' main purpose is to offer a home for objects displaced in the current frenzy for reconstruction.

Henry Brownrigg

FIG 2
The Indian Christian Historical Museum in Palayur. *Source*: Author

howard finster retrospective exhibition, lehigh university, pennsylvania, usa, october 2004

From the day of Howard Finster's famous January 1976 vision of the face on his paint-smeared thumb and a voice commanding him to "make sacred art," to the day of his death in October 2001, he was making objects with sacred messages, if not always sacred visual subjects. Since Finster placed numbers on almost all of his artworks, we know the approximate result of this quarter-century of activity: more than 31,000 pieces. Some are unique images, but for the latter half of that time, most were made with markers on pre-cut templates produced for Finster by members of his family.

The immense range and quantity involved in Finster's achievement made the curation of Lehigh University Art Galleries' *Howard Finster (1916–2001): Revealing the Masterworks* (September 29–December 19, 2004) a doubly unique challenge. It was the first scholarly exhibition of Finster since his death, and was assuredly the first ever attempt to define what a masterwork might be in the career of a self-taught artist who once called his art "bad and nasty," and produced for its religious message rather than for aesthetic enjoyment.

Finster's collectors, however, found the untutored pictorial style visually appealing and ignored the messages laboriously printed across the back (or, in older works, the front). This text varied with world events and seasons, even when the angel, Elvis, or jungle animal on the front was functionally identical to the previous one in an unlimited series. Professors and curators Norman Girardot, Diane LaBelle, and Ricardo Viera recognized this implicitly by variations on conventional museum presentation: Finster's paintings were hung on the wall, rather than installed in vitrines that would have revealed the text—and, in the mass-produced works, the price—inscribed on the back of many pieces. But when it was relevant, the text was reproduced, at least in the catalogue.

In other words, they set out to tell both the religio-visionary and the aesthetic story of Howard Finster. The masterworks revealed in the larger of two galleries were borrowed from two dozen individual and museum collections, and were arranged in the style of an ordinary exhibition. In the adjacent gallery, *The Finster Cosmology: Howard's Brain* was a work of installation art in itself, a timeline in which characteristic Finster imagery was reproduced on the wall by Joanne DeCheser in a linked collection of artworks and documentary photos that told the story of Finster's evolution as a nationally recognized self-taught artist and occasional artist-in-residence at Lehigh University. The adroit mix of genuinely major pieces and routine but well-done cut-out figures set the context for the more ambitious pieces the curators defined as masterworks. The painted silhouettes suggested the unconventional range of the Finster cosmology, featuring life on other intermediate worlds between the earth and the Cathedral in Heaven pictured on one of the masterworks. As Finster asserted in the poem on the lower segment of the 1981 *Portrait of William Shake Spear* (#2,216, which also featured Eli Whitney and presidents Roosevelt and Madison), "God is Eternity He is around for ever more / no planet in space is far from his door."

FIG 1
Howard Finster, *The Angel Staff*, 1981. Pyrograph, glitter and paint on board. Collection of Stephanie and Bob Tardell. Photo Diane LaBelle

Finster developed his iconography early; the 1981 *The Angel Staff* presents careful black-outline drawings of various angels and the self-portrait that would recur on innumerable (albeit numbered) full-color cut-outs. He also developed seriality early, in Plexiglas boxes featuring paintings of clouds and angels, as in the 1984 *Vision of Heaven West Wing* in the Lehigh exhibition. Most of the masterworks on display dated from the first decade of Finster's production, with one of the latest being the extraordinary 1988 chronology *The History of Howard*, a panel featuring mounted examples of the various cut-outs, along with photos and artist's commentary on the growth of the oeuvre that then numbered 7,487.

This implies, as Norman Girardot wryly puts it, that the work of the "Tractor Enamel" period is to be valued above that of the Sharpie period, in which the less than permanent colored markers supplanted paint. This was also the time that such individual forays as the elaborately painted discarded television parts from 1979 were almost completely displaced by iconic mass production. The use of objects at hand didn't end with such pieces as the 1986 *I Come Here as a Second Noah*, painted and inscribed all over a pair of discarded canvas sneakers, but the level of ambition visibly diminished. However, the work from both halves of the quarter-century demonstrates the same marks of outsiderdom that Girardot's excellent catalogue essay discusses under the rubric of "Formalist and Anthropological Considerations."

FIG 2
Howard Finster, *I Come Here as a Second Noah*, 1986. Enamel on tennis shoes. Courtesy of Rick Berman. Photo Diane LaBelle.

"Formal and anthropological" is a canny combination of terms: Girardot *et al.* are out to get Finster considered seriously as an artist at the same time that he is presented as an appropriate subject for the history of religion. It is precisely because he comes out of, but does not at all typify, a specific Southern Protestant tradition that he is of interest conceptually; it is precisely because he so often succeeds in producing visually coherent work while neglecting (or at most intuiting) the aesthetics of composition that he is of interest as far more than an example of vernacular religious art production.

The anthropological considerations jump out at once as intriguing: beginning with conventional religious language and imagery, Finster's work invites cross-cultural parallels with shamanic visions and other altered states of consciousness, though the visions are expressed in a distinctly twentieth-century American idiom of space travel and life on other worlds. The hybridized quality of his creations identifies him as a singularly down-home and can-do version of the visionary imagination, unafraid to embrace techniques for increasing efficiency and constructing a World Folk Art Church (seen at Lehigh in documentary photographs) alongside visionary statuary recycling what a well-known sign from his Paradise Garden environment calls "the pieces you threw away." (The sign, long since acquired for Atlanta's High Museum, was featured in the Lehigh exhibition.)

Fortunately, the exhibition catalogue reproduces most of the masterworks in sufficient detail to allow the interested reader to peruse the intricacies of the images and the text inscribed in almost every available corner of the earlier work. There is also ample evidence for Finster's singular accomplishment as a vernacular visionary artist; though Finster was as much showman as shaman, his legacy is far more than the recollection of a colorful personality, and this exhibition and its accompanying documentation constitute a significant first step in considering Finster's oeuvre as a significant contribution to religious and artistic history rather than a moment in the easily marginalized category of "American folk art."

Jerry Cullum

New in 2006! | **Special introductory subscription offers!**

The Senses & Society

A heightened interest in the role of the senses in society is sweeping the social sciences, supplanting older paradigms and challenging conventional theories of representation. Shaped by culture, gender and class, the senses mediate between mind and body, idea and object, self and environment.

This pioneering journal provides a crucial forum for the exploration of this vital new area of inquiry. It brings together groundbreaking work in the social sciences and incorporates cutting-edge developments in art, design and architecture. Every volume contains something for and about each of the senses, both singly and in all sorts of novel configurations.

Edited by:
Michael Bull, University of Sussex
Paul Gilroy, London School of Economics
David Howes, Concordia University
Douglas Kahn, University of California, Davis

Published 3 times a year from 2006 March, July, November

Prospective readership
+ Sociology & Anthropology
+ Cultural & Media Studies
+ History
+ Visual & Non Visual Arts
+ Psychology

+ Multi-disciplinary
+ Multi-sensory
+ International coverage
+ Special issues on ground breaking topics
+ Book, exhibition and sensory design reviews

Print: ISSN 1745-8927
Online: ISSN 1745-8935

Get 20% off when you subscribe for 2 years!

	Individuals	Institutions
1 year subscription	$70 £40	$289 £155
2 year subscription	$112 save $28 £64 save £16	$462 save $116 £248 save £62

All institutional subscriptions include free online access

1 year online only subscription $235 £125 +vat
Please quote order code SS05.

BERG

Please call +44 (0) 1767 604 951 to place your order or order online at www.bergpublishers.com

PiQUANT editions

The Complete Works of Hans Rookmaaker
Marleen Hengelaar-Rookmaaker (ed.)

STUDENT PRICE:
$190.00 / £150.00
RRP $295.00 / £190.00

Order on-line:

UK, Europe & World outside North America:
www.piquanteditions.com

US, Canada & World outside Europe:
www.piquanteditions.us

or email: info@piquant.net

The Collection

1. Art, Artists and Gauguin
2. New Orleans Jazz, Mahalia Jackson and the Philosophy of Art
3. The Creative Gift, Dürer, Dada and Desolation Row
4. Western Art and the Meanderings of a Culture
5. Modern Art and the Death of Culture
6. Our Calling and God's Hand in History

Set ISBN: 1-903689-04-X
6 volumes, h/b, 234x156mm
With black-and-white illustrations

"It is a wonderful thought that this man's rare wisdom, which so radically changed the lives of those who knew him, can now find its way to a wider audience."

Jeremy Begbie, Theology Through the Arts, Cambridge & St Andrews

A Profound Weakness:
Christians and Kitsch
Betty Spackman

An 'image journal' and textbook that interacts sensitively with visual representations of the Christian faith in popular culture.

For teachers, preachers, spiritual leaders and parents

$50.00 / £30.00

Also available at ONLY $2.99 / £1.99 each:
TWO MINI SAMPLE CHAPTERS
* ch 2 (Re Worded, ISBN 1-903689-34-1, 150x150mm, 24pp)
* ch 13 (Construct, ISBN 1-903689-35-X, 150x150mm, 24pp)

ISBN: 1-903689-13-9
448 pp, p/b, 250x250mm
With full-colour reproductions, photos and computer composites

The Complete Works of Hans Rookmaaker CD-ROM

CD-ROM Information:
ISBN: 1-903689-38-4
Searchable PDF text of all 6 volumes
Unabridged
PC 98 SE
Mac OS X

$50.00 / £30.00

NEW!

info@piquant.net
www.piquanteditions.com